LETTERHEAD & LOGO DESIGNS 2

CREATING THE CORPORATE IMAGE

ROCKPORT PUBLISHERS • ROCKPORT, MASSACHUSETTS

Distributed by North Light Books • Cincinnati, Ohio

Art Director
Stephen Bridges

Design
Carolyn Letvin

Production Manager
Barbara States

First published in the United States of America by:
Rockport Publishers, Inc.
146 Granite Street
Rockport Massachusetts 01966
Telephone: (508) 546-9590
Fax: (508) 546-7141

Distributed to the book trade and art trade in the U.S. and Canada by:
North Light, an imprint of
F & W Publications
1507 Dana Avenue
Cincinnati, Ohio 45207
Telephone: (513) 531-2222

Other distribution by:
Rockport Publishers, Inc.
Rockport, Massachusetts 01966

ISBN 1-56496-121-4

5 7 9 10 8 6 4

Printed in China

Procrustes was a fabulous robber of Greek mythology, a giant who enticed travelers into his bed, cutting off the legs or stretching his victims until they fit.

The proliferation of influences on graphic design, the welter of styles and strategies, have spawned an era in which the graphic designer has too often become a Procrustes. Most designers wrangle with the problem of borrowing from the image bank. They feel the imperiative to adapt and shape their work, to balance personal expression and stylistic effect. Yet there is a persistent seduction to produce soulless work sustained only by fragments of styles or past cultures appropriated without real understanding. In effect the assignment is mutilated to fit the bedstead.

To drag out any style or image not related to the job brief is a process yielding only pastiche. As designers we are supposed to navigate the waters of style and function, of pre-packaged solutions and originality, of self-expression and marketing demands. An essential delight of graphic design is that there are few rules. But this notion of borrowing has become tricky. How far can the designer go with arbitrary usage of historical styles and still address the needs of the job? Are there limits to adaptation? The headlong evolution of styles, the development of new technologies compounded by the exigencies of deadlines and client needs mean we cannot avoid occasionally forcing a design problem to recline in a Procrustean bed.

Technique and borrowing reach their limits at the point where real creativity is called for. Kant defined genius as the ability to produce something over and above any rules: genuine creativity has no set recipe. This collection offers evidence that many designers avoid the traps and speak their own honest language, marshaling visual and verbal elements skillfully to speak with force and eloquence. The best of them rescue concepts from Procrustes' bed, preserving intact original meanings as well as originality. Their grammar of design is highly wrought, yet beyond paradigms.

Walter McCord

Walter McCord runs a one-man design studio in Louisville Kentucky. His work has been recognized by Graphis, AIGA, Idea, Print, New York Art Directors, Communications Arts, Type Directors Club, STA and others, and is in the collection of the Library of Congress.

1. RETAIL

TWIGS

Twigs, Inc.
381 Bleecker Street
New York, New York 10014

TWIGS

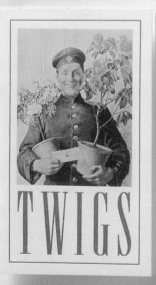

TWIGS

Twigs, Inc. 381 Bleecker Street New York, New York 10014 212 620 8188 · 3 World Financial Center New York, New York 10281 212 385 2660

Client: Twigs, Inc.
Design Firm: Lewin/Holland, Inc.
Art Director: Cheryl Lewin
Designer: Cheryl Lewin
Paper/Printing: Four colors

SEASONS
FLORAL DESIGN

SEASONS
FLORAL DESIGN

164 Beacon Street
Andover, MA 01810

Ronni Michel
164 Beacon Street
Andover, MA 01810
508. 470.3620

SEASONS
FLORAL DESIGN

164 Beacon Street
Andover, MA 01810
508.470.3620

Client: Seasons Floral Design
Design Firm: Portfolio
Art Director: Bonnie Mineo
Designer: Busha Husak
Paper/Printing: Two colors on Strathmore Writing

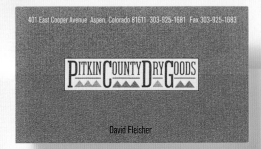

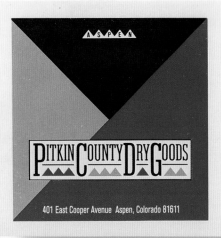

Client: Pitkin Country Dry Goods
Design Firm: Milton Glaser, Inc.
Art Directors: Milton Glaser, David Freedman
Designers: David Freedman, Chi-ming Kan
Paper/Printing: Five colors on Strathmore Writing Laid

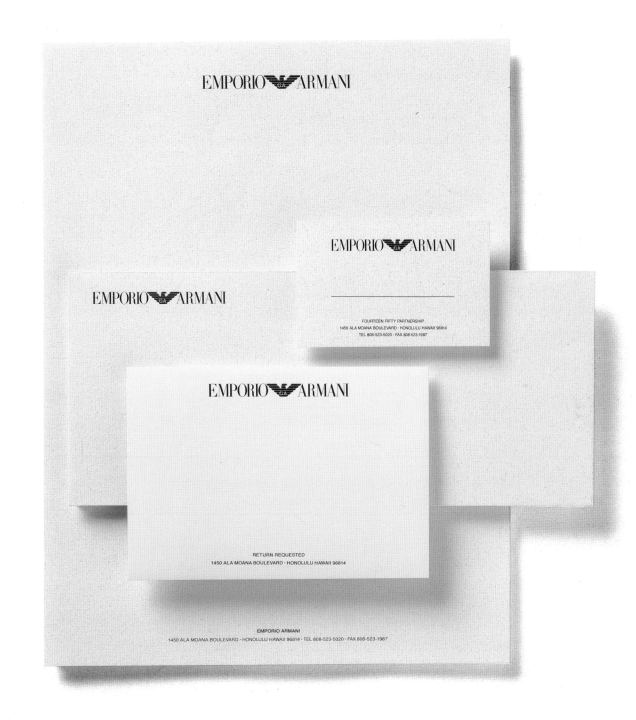

Client: Emporio Armani
Design Firm: Anthony McCall Associates
Art Director: Anthony McCall
Designer: Wing Chan
Paper/Printing: One color on French Speckletone

Products for Children

Promoting Self-Esteem

Peace & Ecology

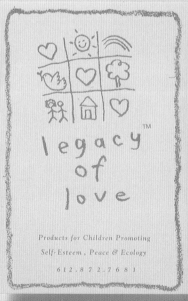

legacy
of
love

2400

Harriet Ave. So.

Suite 201

Minneapolis

MN 55405

legacy
of
love

Products for Children
Promoting Self-Esteem
Peace & Ecology

612.872.7681

legacy
of
love

Products for Children Promoting
Self-Esteem, Peace & Ecology

612.872.7681

2400

Harriet Ave. So.

Suite 201

Minneapolis

MN 55405

612.872.7681

Client: Legacy of Love
Design Firm: Peggy Lauritsen Design
Art Director: Anocha Ghoshachandra
Designer: Anocha Ghoshachandra
Paper/Printing: Two colors on French Speckletone

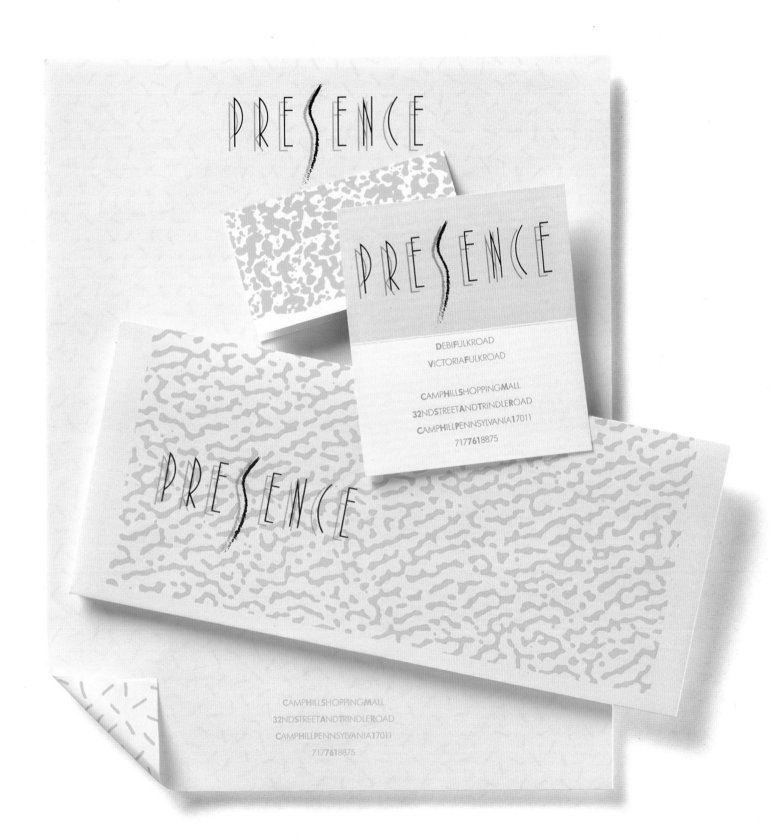

Client: Presence Fashions
Design Firm: Musser Design
Art Director: Musser
Designer: Musser
Paper/Printing: Three colors on Curtis Brightwater

Client: Cambridge Commercial Carpet
Design Firm: Turpin Design Associates
Art Director: Tony F. Turpin
Designers: Joseph E. Whisnant, Tony F. Turpin
Paper/Printing: One color plus foil on Strathmore Writing Kromekote Cover

Client: Caledonian Inc.
Design Firm: Michael Stanard Inc.
Art Director: Michael Stanard
Designer: Lisa Fingerhut
Paper/Printing: Four colors on Strathmore Writing

Client: Baby ZZZ's/Pawley Island Pub
Design Firm: Mark Palmer Design
Art Director: Mark Palmer
Designer: Mark Palmer
Computer Production: Curtis Palmer
Paper/Printing: Three colors on Strathmore Writing Wove

Client: Jasper Oriental Rugs
Design Firm: McCord Graphic Design
Art Director: Walter McCord
Designer: Walter McCord
Paper/Printing: Tritone plus one color on Neenah Classic Crest

SAN FRANCISCO CLOTHING 975 Lexington Avenue New York, N.Y. 10021 (212) 472-8740

Howard Partman

SAN FRANCISCO CLOTHING
975 Lexington Avenue New York, N.Y. 10021 (212) 472-8740

SAN FRANCISCO CLOTHING
975 Lexington Avenue New York, N.Y. 10021

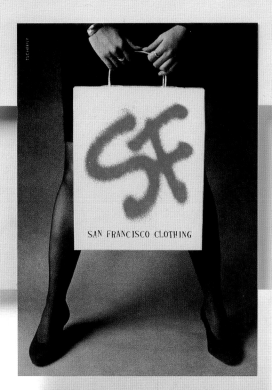

Client: San Francisco Clothing
Design Firm: George Tscherny, Inc.
Art Director: George Tscherny
Designer: George Tscherny

THE L·S COLLECTION, INC.
745 FIFTH AVENUE
NEW YORK, NEW YORK
10151 USA

TELEPHONE 212 593 3856
FACSIMILE 212 371 9256
TELEX 426 059 GREC

THE L·S COLLECTION

THE L·S COLLECTION

745 FIFTH AVENUE
NEW YORK, NEW YORK
10151 USA

THE L·S COLLECTION

765 MADISON AVENUE
NEW YORK, NEW YORK
10021 USA

THE L·S COLLECTION

Client: The L·S Collection
Design Firm: Designframe Inc.
Art Director: James A. Sebastian
Designers: James A. Sebastian, John Plunkett, David Reiss, Junko Thomas Schneider
Paper/Printing: Two colors on Curtis Brightwater

B'CUBED. 4115 N.W. 24th Way Boca Raton Florida 33431 Phone 407 734 0040

B'CUBED. 4115 N.W. 24th Way Boca Raton Florida 33431 Phone 407 997 0040

Mary Lou Baker
President

Jewelry
Accessories
Apparel

B'CUBED. 4115 N.W. 24th Way Boca Raton Florida 33431

Jewelry
Accessories
Apparel

Jewelry
Accessories
Apparel

Client: B'Cubed Jewelry
Design Firm: Creative Works
Art Director: Bob Jahn
Designer: Bob Jahn
Illustrator: David Wright
Paper/Printing: Two colors on Strathmore Writing

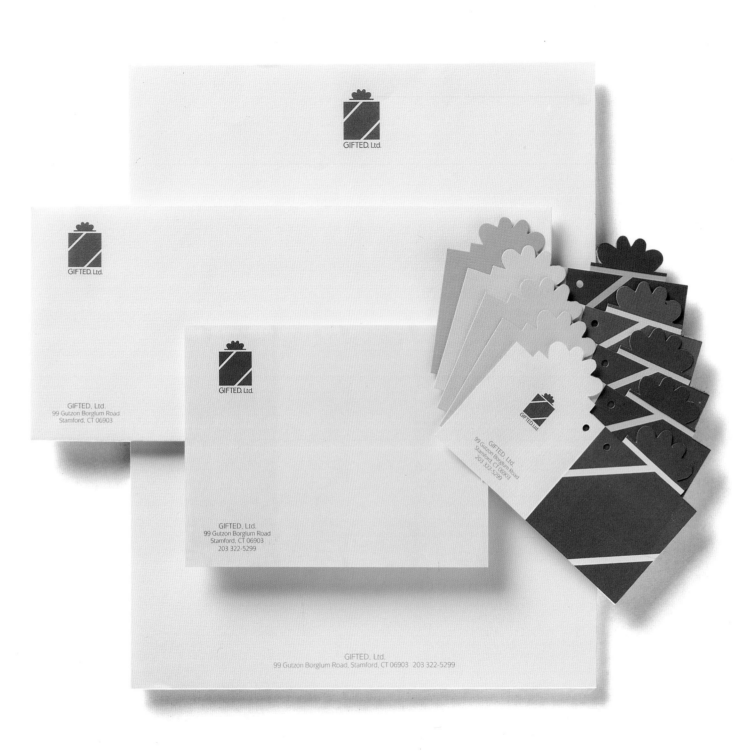

Client: Gifted Ltd.
Design Firm: Friday Saturday Sunday, Inc.
Designer: Linda Casale
Illustrator: Linda Casale
Paper/Printing: Two colors on Gilbert Oxford

FrankFiore

FRANK FIORE DESIGN INC. | 488 SEVENTH AVENUE | NEW YORK CITY 10018 | PHONE 212.643.8133 | FAX 212.643.8643

FrankFiore

FRANK FIORE DESIGN INC. | 488 SEVENTH AVENUE | NEW YORK CITY 10018 | PHONE 212.643.8133 · FAX 212.643.8643

FrankFiore

Nadine Costa, Sales & Marketing

FRANK FIORE DESIGN INC. | 488 SEVENTH AVENUE | NEW YORK CITY 10018

FrankFiore

Client: Frank Fiore Design Inc.
Design Firm: Designframe Inc.
Art Director: James A. Sebastian
Designer: Eric Pike
Paper/Printing: One color on Strathmore Writing White Wove

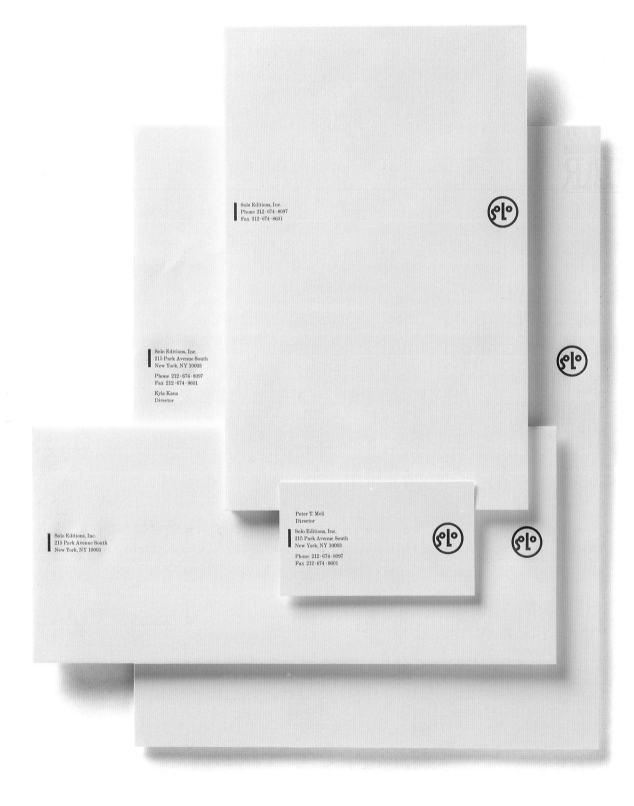

Client: Solo Editions
Design Firm: The Pushpin Group
Art Director: Seymour Chwast
Designer: Greg Simpson

Client: Pilar
Design Firm: Bob Korn Design
Art Director: Bob Korn
Designer: Bob Korn
Illustrator: Bob Korn

Client: Eaglemoor
Design Firm: Hornall Anderson Design Works
Art Director: Jack Anderson
Designers: Jack Anderson, Mary Hermes, David Bates
Illustrator: Nancy Gellos

Client: K2 Corporation
Design Firm: Hornall Anderson Design Works
Art Director: Jack Anderson
Designers: Jack Anderson, David Bates
Illustrator: David Bates

Client: Mother Nature's Gallery
Design Firm: Tollner Design Group
Art Director: Lisa Tollner
Designer: Don Barns
Illustrator: Don Barns

Client: JBL International
Design Firm: Fitch Richardson Smith
Art Director: Ann Gildea
Designers: Kate Murphy, Beth Novitsky

Client: The Tree House
Design Firm: Bob Korn Design
Art Director: Bob Korn
Designer: Bob Korn
Illustrator: Bob Korn

2. FOOD

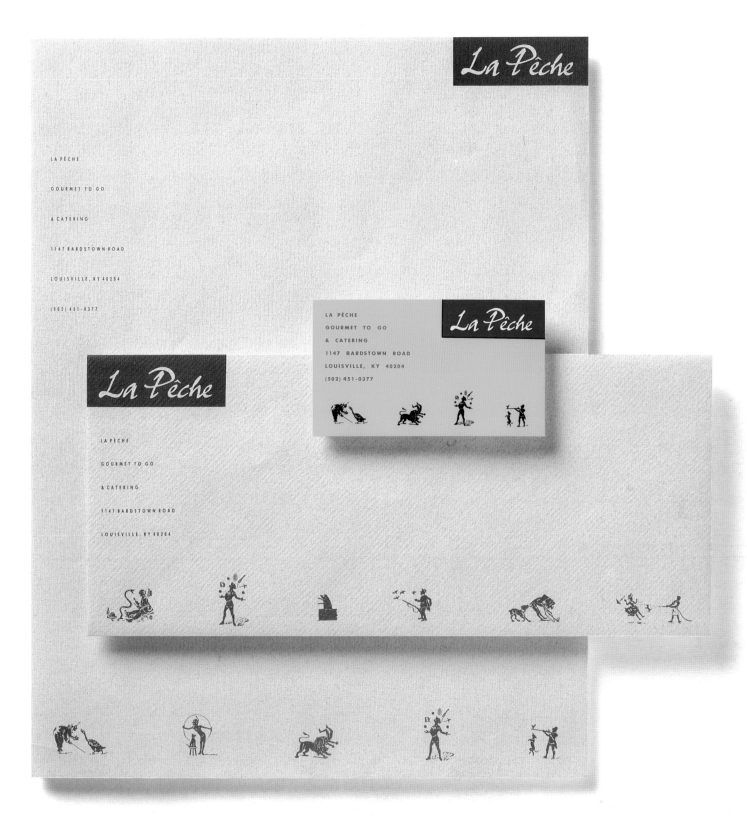

Client: La Pêche
Design Firm: McCord Graphic Design
Art Director: Walter McCord
Designer: Walter McCord
Illustrator: McCord Graphic Design
Paper/Printing: Letterhead - Two colors on Simpson Gainsborough
Business Card - Four colors on Champion Kromekote

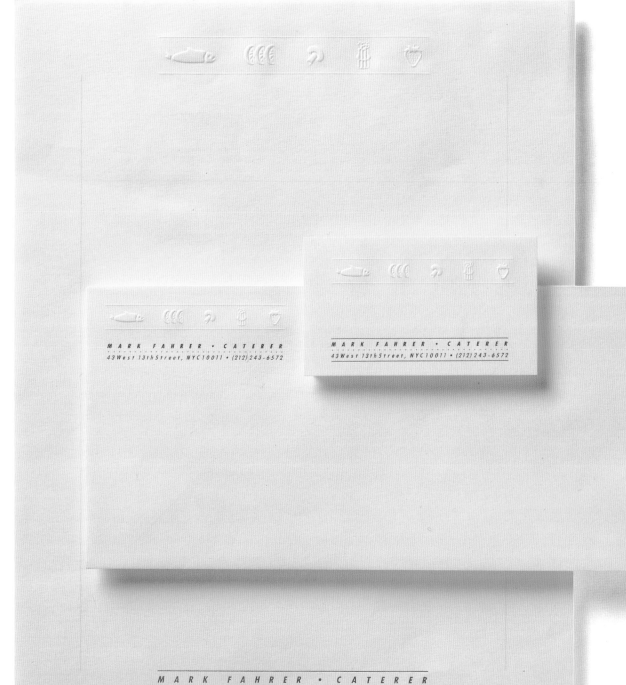

MARK FAHRER • CATERER
43 West 13th Street, NYC 10011 • (212) 243-6572

MARK FAHRER • CATERER
43 West 13th Street, NYC 10011 • (212) 243-6572

MARK FAHRER • CATERER
43 West 13th Street, NYC 10011 • (212) 243-6572

Client: Mark Fahrer Caterer
Design Firm: Designed To Print + Associates, Ltd.
Art Directors: Tree Trapanese, Peggy Leonard
Designer: Tree Trapanese
Illustrators: Tree Trapanese, Peggy Leonard
Paper/Printing: One color on Strathmore Writing

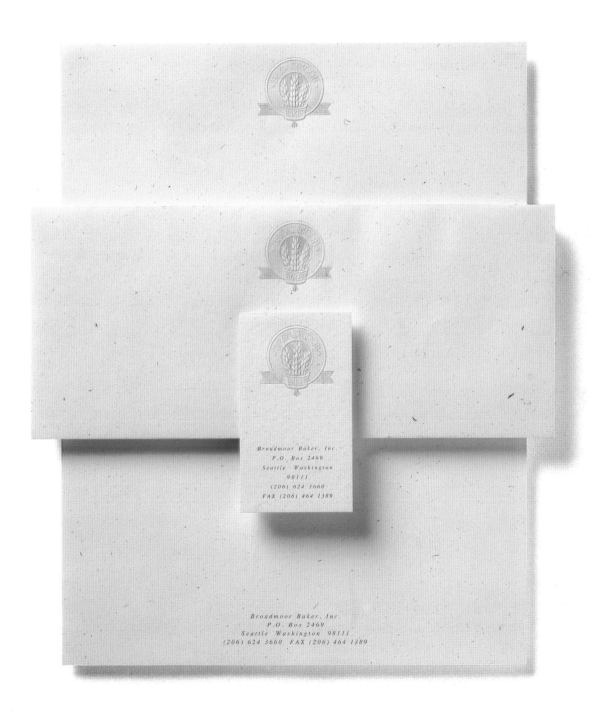

Broadmoor Baker, Inc.
P.O. Box 2469
Seattle Washington
98111
(206) 624 3660
FAX (206) 464 1389

Broadmoor Baker, Inc.
P.O. Box 2469
Seattle Washington 98111
(206) 624 3660 FAX (206) 464 1389

Client: Broadmoor Baker
Design Firm: Hornall Anderson Design Works
Art Director: Jack Anderson
Designers: Jack Anderson, Mary Hermes
Paper/Printing: One color on Speckletone

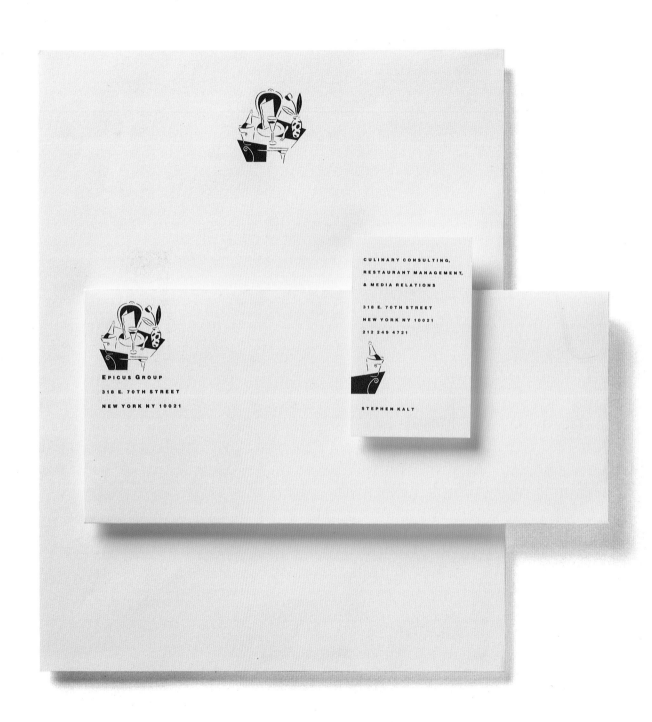

CULINARY CONSULTING,

RESTAURANT MANAGEMENT,

& MEDIA RELATIONS

318 E. 70TH STREET

NEW YORK NY 10021

212 249 4721

STEPHEN KALT

EPICUS GROUP

318 E. 70TH STREET

NEW YORK NY 10021

Client: Epicus Group
Design Firm: Lewin/Holland, Inc.
Art Director: Cheryl Lewin
Designer: Cheryl Lewin
Illustrator: Mary Lynn Blasutta

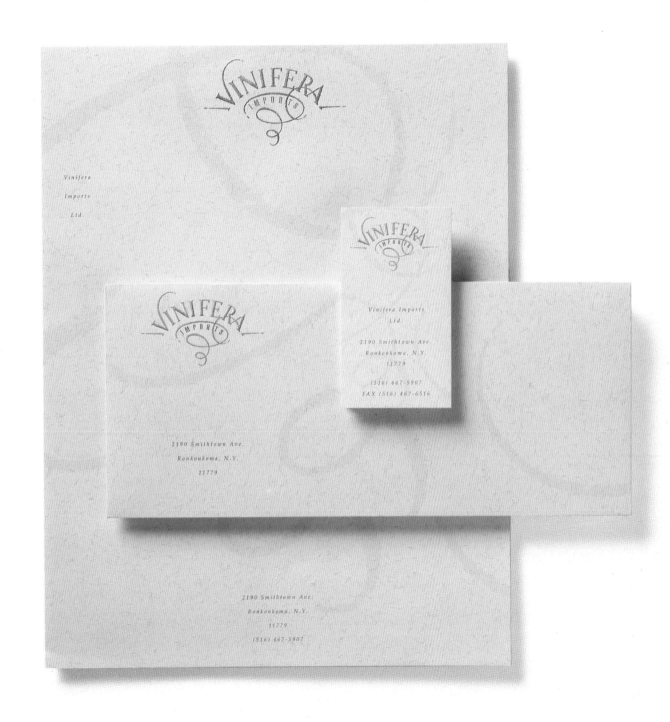

Client: Vinifera Imports
Design Firm: Hornall Anderson Design Works
Art Director: Jack Anderson
Designers: Jack Anderson, David Bates
Illustrator: David Bates
Paper/Printing: Two colors on Tuscan Terra

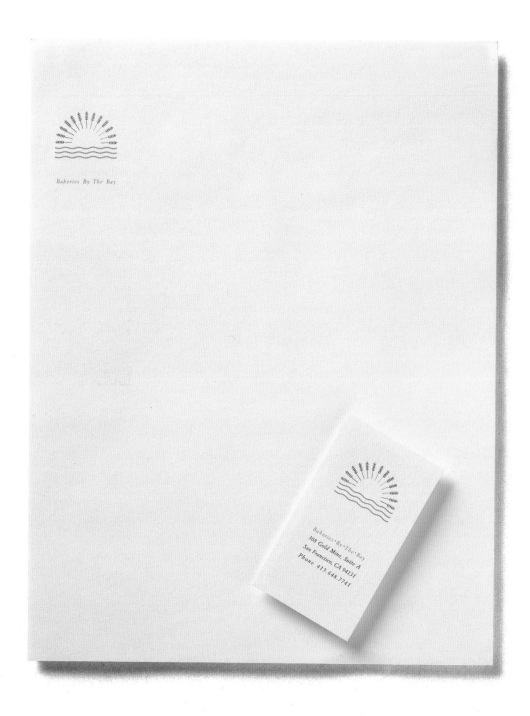

Client: Bakeries By The Bay
Design Firm: Tharp Did It • Los Gatos/San Francisco
Art Director: Rick Tharp
Designers: Jean Mogannam, Rick Tharp
Paper/Printing: Two colors with copper foil on Simpson Starwhite Vicksburg

THE
ROCKEFELLER
CENTER
CLUB

THE
ROCKEFELLER
CENTER
CLUB

30 ROCKEFELLER PLAZA
NEW YORK, NY 10112

THE ROCKEFELLER CENTER CLUB

HOWARD DIXON
Director, World Concierge Services

30 ROCKEFELLER PLAZA / NEW YORK, NY 10112 / 212-632-5059

30 ROCKEFELLER PLAZA / NEW YORK, NY 10112 / 212-632-5005

Client: The Rockefeller Group
Design Firm: Milton Glaser, Inc.
Art Director: Milton Glaser
Designer: Milton Glaser
Paper/Printing: Four colors on Strathmore Writing Laid

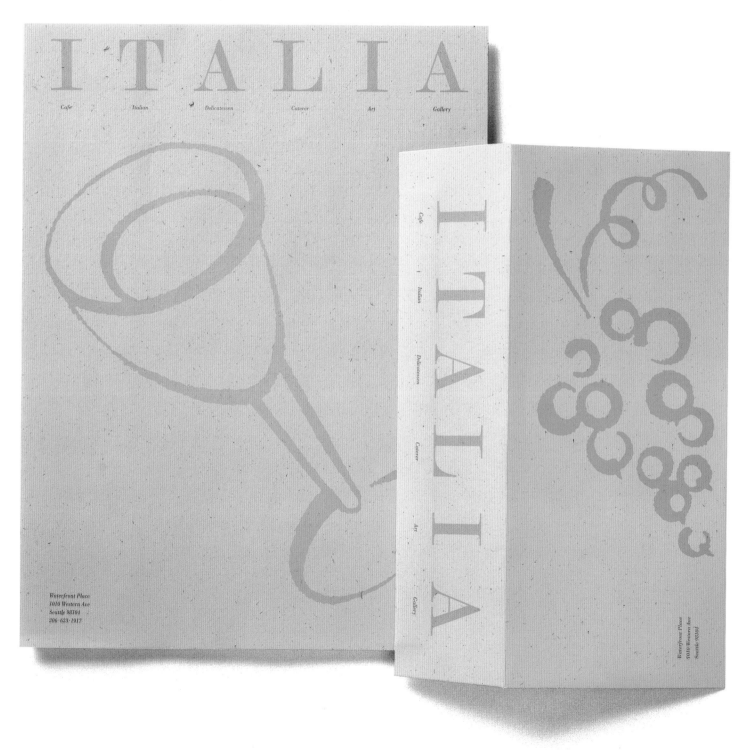

Client: Italia Restaurant
Design Firm: Hornall Anderson Design Works
Art Director: Jack Anderson
Designers: Jack Anderson, Julia LaPine
Paper/Printing: Three colors on Speckletone

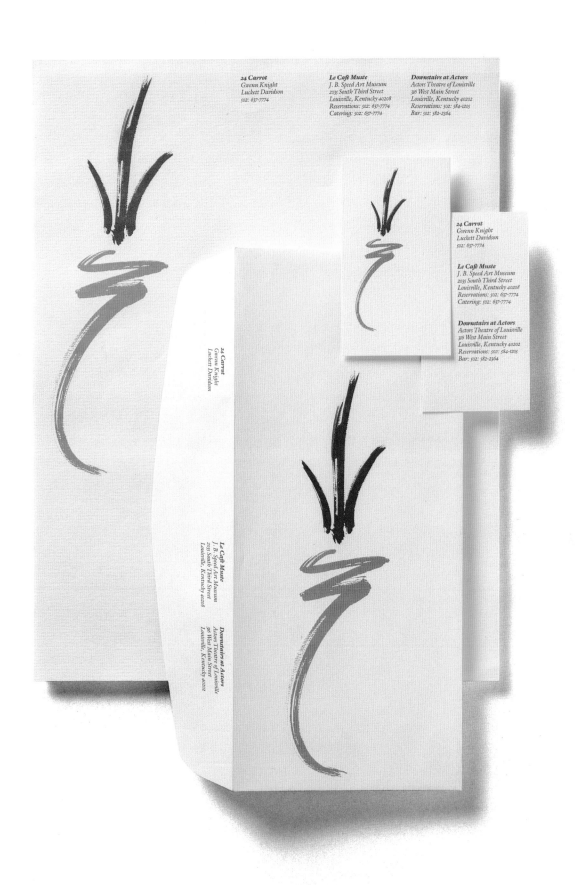

24 Carrot
Gwenn Knight
Luckett Davidson
502: 637-7774

Le Café Musée
J. B. Speed Art Museum
2035 South Third Street
Louisville, Kentucky 40208
Reservations: 502: 637-7774
Catering: 502: 637-7774

Downstairs at Actors
Actors Theatre of Louisville
316 West Main Street
Louisville, Kentucky 40202
Reservations: 502: 584-1205
Bar: 502: 582-2364

Client: 24 Carrot, Inc.
Design Firm: McCord Graphic Design
Art Directors: Walter McCord, Julius Friedman
Designers: Walter McCord, Julius Friedman
Illustrator: Walter McCord
Paper/Printing: Three colors on Strathmore Writing

Client: California Bound
Design Firm: Page Design, Inc.
Art Director: Paul Page
Designer: Tracy Titus
Illustrator: Tracy Titus
Paper/Printing: Four colors on Strathmore Writing

Client: Brooklyn Brewery
Design Firm: Milton Glaser, Inc.
Art Director: Milton Glaser
Designer: Milton Glaser
Paper/Printing: Two colors on Weston Merit Bond

Client: Chauncey's Chili
Design Firm: Clark Keller
Art Director: Neal Ashby
Designer: Neal Ashby
Illustrator: Neal Ashby
Paper/Printing: One color on Kraft Speckletone

Client: Mercury Services
Design Firm: Whitney • Edwards Design
Art Director: Charlene Whitney • Edwards
Designer: Charlene Whitney • Edwards
Computer Output: In Tandem Design
Paper/Printing: Two colors on Neenah Classic Laid Writing Whitestone

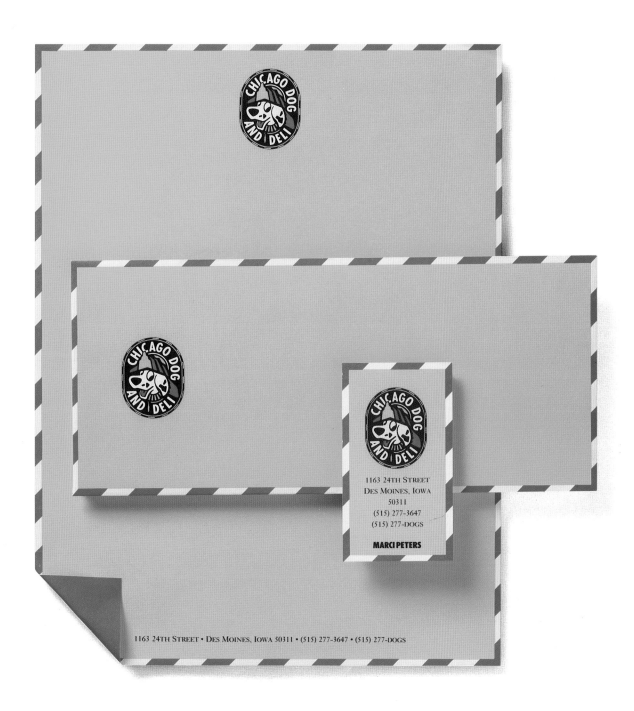

Client: Chicago Dog & Deli
Design Firm: Sayles Graphic Design
Art Director: John Sayles
Designer: John Sayles
Paper/Printing: Three colors on Neenah Classic Crest

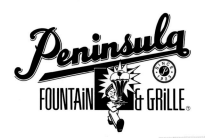

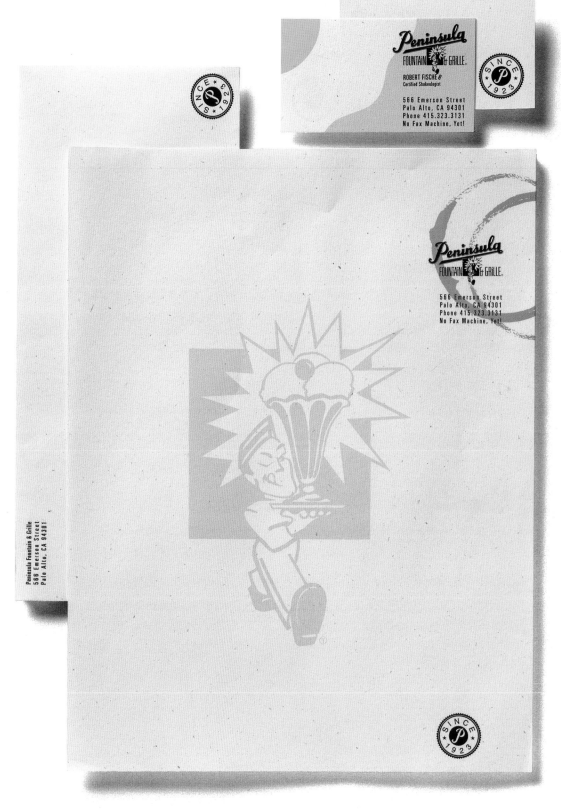

Client: Peninsula Fountain & Grille
Design Firm: Tharp Did It • Los Gatos/San Francisco
Art Director: Rick Tharp
Designer: Jana Heer, Jean Mogannam, Rick Tharp
Illustrator: Jana Heer
Paper/Printing: Two colors on Simpson EverGreen Recycled

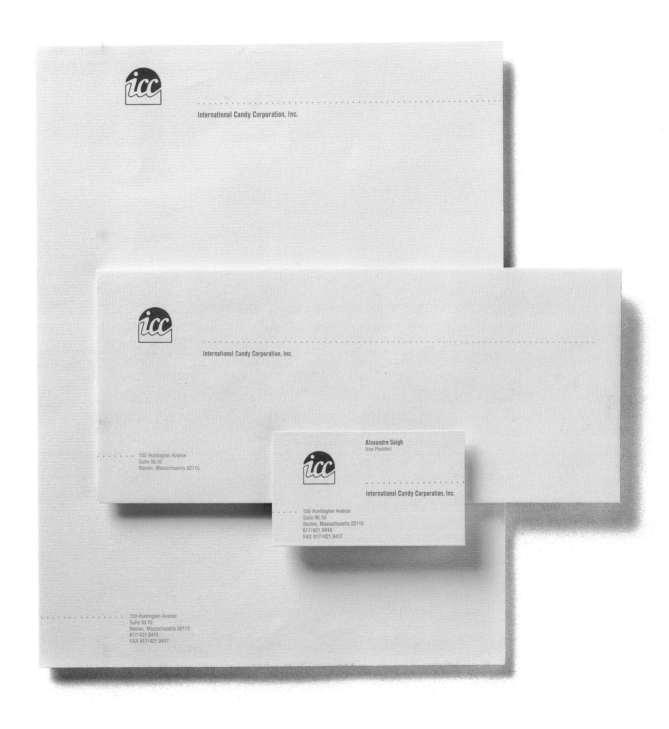

International Candy Corporation, Inc.

International Candy Corporation, Inc.

150 Huntington Avenue
Suite NL10
Boston, Massachusetts 02115

Alexandre Saigh
Vice President

International Candy Corporation, Inc.

150 Huntington Avenue
Suite NL10
Boston, Massachusetts 02115
617/421.9416
FAX 617/421.9417

150 Huntington Avenue
Suite NL10
Boston, Massachusetts 02115
617/421.9416
FAX 617/421.9417

Client: International Candy Corp.
Design Firm: Charrette Inc. Art Department
Art Director: Kevin Sheehan
Designer: Kevin Sheehan
Paper/Printing: Two colors on Strathmore Writing

MESA

GRILL
102 Fifth Ave.
NY, NY 10011
212-807-7400

MESA

GRILL
102 Fifth Ave.
NY, NY 10011
212-807-7400

DON M. SISEMORE

Client: Mesa Grill
Design Firm: Alexander Isley Design
Art Director: Alexander Isley
Designer: Alexander Knowlton
Paper/Printing: Four colors

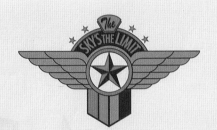

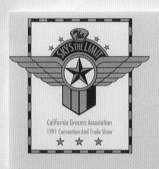

California Grocers Association ★ P.O. Box 2671, Sacramento, CA 95812-2671 ★ Tel: (916) 448-3545 Fax: (916) 448-2793
1991 Convention And Trade Show ★ October 12-14, 1991 ★ Reno Convention Center

Client: Sky's The Limit
Design Firm: Page Design, Inc.
Art Director: Paul Page
Designer: Laurel Bigley
Illustrator: Laurel Bigley
Paper/Printing: Four colors on Strathmore Writing

KEEP
IT
COOL

THE DANDY CANDY MAN

Purveyor of Condommints

POST OFFICE BOX 2151
LOS GATOS, CA 95031
PHONE · 408.378.5600
TELEFAX · 408.354.1450

THE DANDY CANDY MAN
POST OFFICE BOX 2151
LOS GATOS, CA 95031

KELLY O'CONNOR
HEAD CANDY MAN

THE DANDY CANDY MAN

Purveyor of Condommints

POST OFFICE BOX 2151
LOS GATOS, CA 95031
PHONE · 408.378.5600
TELEFAX · 408.354.1450

Client: The Dandy Candy Man
Design Firm: Tharp Did It • Los Gatos/San Francisco
Art Director: Rick Tharp
Designer: Rick Tharp
Illustrator: Kim Tomlinson
Paper/Printing: Two colors on Strathmore Writing

P.O. Box 22146 • 6566 SE Lake Rd • Portland, OR 97222 (503) 652-5600 • (800) 777-3602 • Fax: (503) 652-5699

P.O. Box 22146
6566 SE Lake Rd
Portland, OR 97222-0146

Address Correction Requested

DAN NOVAK
Resident Agent

U.G. Insurance, Inc.
1152 Hartnell Avenue
Redding, California 96002
(916) 223-3470
(800) 547-5973 Ext. 265
Fax: (916) 223-3885

Thank You

U.G. Insurance, Inc. • United Employers Insurance Company • United Rehabilitation Services • U.G.I.C. Ltd.

Client: Grocers Insurance
Design Firm: Robert Bailey Inc.
Art Director: Robert Bailey
Designer: Michael Lancashire
Illustrator: Carolyn Coghlan
Paper/Printing: Five colors on Classic Crest

Client: Rikki Rikki	**Client:** American Health Products	**Client:** Kaplan Hat Co. Restaurant
Design Firm: Hornall Anderson Design Works	**Design Firm:** Kollberg/Johnson Associates	**Design Firm:** J. Brelsford Design, Inc.
Art Director: Jack Anderson	**Art Director:** Gary Kollberg	**Art Director:** Jerry Brelsford
Designers: Jack Anderson, David Bates, Lian Ng		
Illustrator: David Bates		

Client: The Trolley Restaurant	**Client:** Sisley	**Client:** Tucker Farm
Design Firm: Bob Korn Design	**Design Firm:** Josh Freeman/Associates	**Design Firm:** Rick Eiber Design (RED)
Art Director: Bob Korn	**Art Director:** Josh Freeman, Vickie Sawyer Karten	**Art Director:** Rick Eiber
Designer: Bob Korn	**Designer:** Greg Clarke	**Designer:** Rick Eiber
Illustrator: Bob Korn	**Illustrator:** Greg Clarke	**Illustrator:** John Fortune

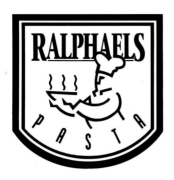

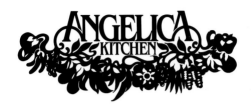

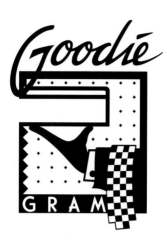

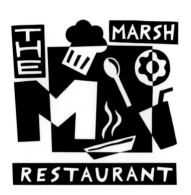

Client: Ralphaels
Design Firm: May Design Associates
Art Director: Frederick Mozzy
Designer: Frederick Mozzy
Illustrator: Frederick Mozzy

Client: Angelica Kitchen
Design Firm: Frank D'Astolfo Design
Art Director: Frank D'Astolfo
Designer: Frank D'Astolfo

Client: Goodie Gram
Art Director: Adam, Filippo & Associates
Design Firm: Adam, Filippo & Associates

Client: Marsh Restaurant
Design Firm: Design Center
Art Director: John C. Reger
Designer: Kobe

Client: Consolidated Restaurants
Design Firm: Hornall Anderson Design Works
Art Director: Jack Anderson
Designers: Jack Anderson, Mary Hermes, David Bates
Illustrators: George Tanagi/Hornall Anderson Design Works

Client: Let The Flower Fly
Design Firm: Design Center
Art Director: John Reger
Designer: Kobe

3. REAL ESTATE

BUCKHEAD
PLAZA

BUCKHEAD
PLAZA

3060 Peachtree Rd. NW/Atlanta, GA 30305

Leasing & Management by Taylor & Mathis/3060 Peachtree Rd. NW/Atlanta, GA 30305/404-231-0222
A Joint Development of Taylor & Mathis and Metropolitan Life Insurance Company

Client: Taylor & Mathis
Design Firm: Rousso+Associates Inc.
Art Director: Steve Rousso
Designer: Steve Rousso
Illustrator: Steve Rousso

Xerox Realty Corporation
P.O. Box 2000
Route 7 and 659
Leesburg, Virginia 22075
703 478.1013

LANSDOWNE

Xerox Realty Corporation
P.O. Box 2000
Route 7 and 659
Leesburg, Virginia 22075

LANSDOWNE

Client: Xerox Realty Company
Design Firm: Richard Danne & Associates Inc.
Art Director: Richard Danne
Designer: Gary Skeggs
Paper/Printing: Two colors on Simpson Protocol Writing

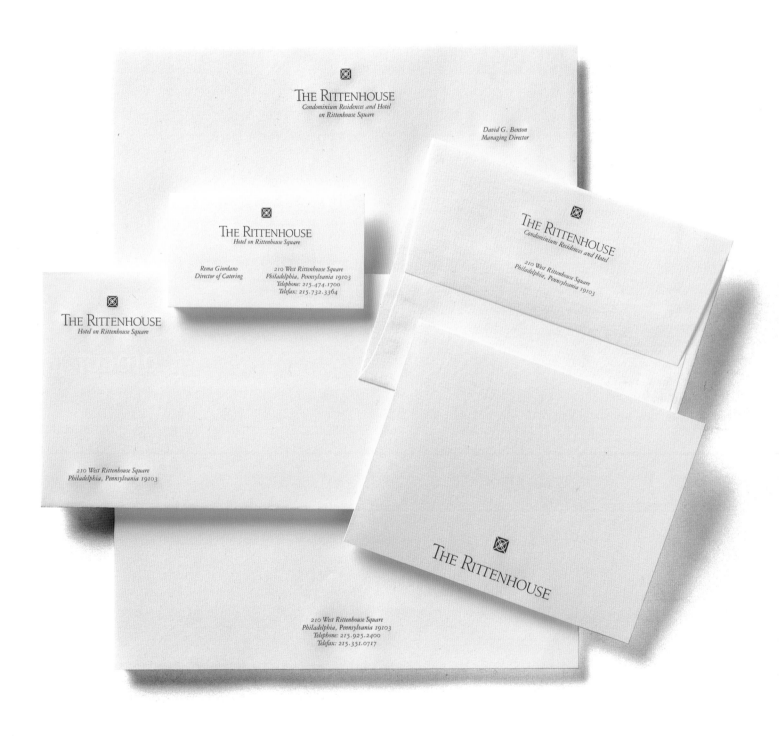

Client: Rittenhouse Hotel & Condominiums
Design Firm: Katz Wheeler Design
Art Director: Joel Katz
Designer: Joel Katz
Paper/Printing: Two colors on Protocol 100

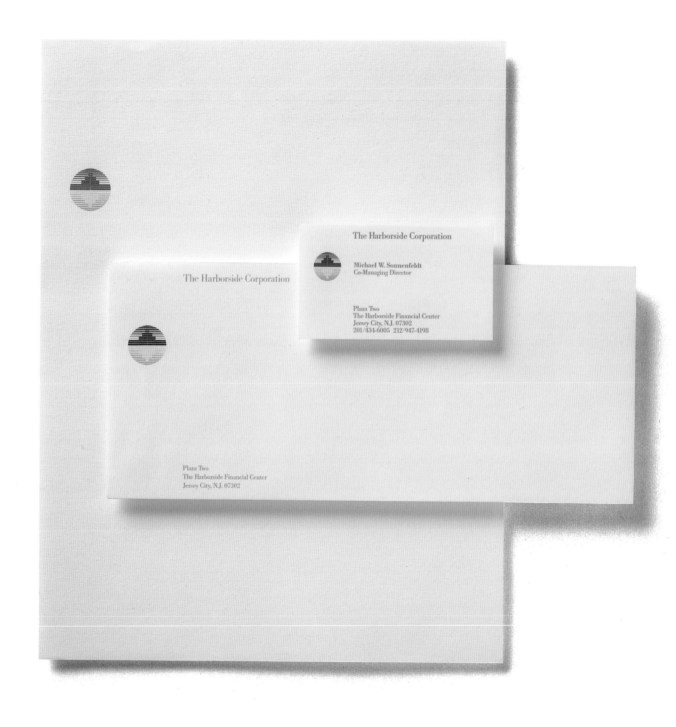

Client: The Harborside Corporation
Design Firm: Donovan and Green
Art Director: Michael Donovan
Designer: Peter Galperin
Paper/Printing: Two colors on Strathmore Writing Bright White Wove

THE POLO FIELDS

Polo Fields, Inc. 2309 Watterson Trail Louisville, Kentucky 40299

Polo Fields, Inc. 2309 Watterson Trail Louisville, Kentucky 40299 502-266-6001

Client: J.D. Cooper Builder
Design Firm: Sequel, Inc.
Art Director: Denise Olding
Designer: Denise Olding
Illustrator: Denise Olding
Paper/Printing: Three colors on Kimberly Writing Classic Crest Solar White

Client: Center City District
Design Firm: Katz Wheeler Design
Art Director: Joel Katz
Designer: Joel Katz
Paper/Printing: Two colors on Strathmore Renewal

Client: Church Metro
Design Firm: Steve Lundgren Graphic Design
Art Director: Steve Lundgren
Designer: Steve Lundgren
Paper/Printing: Two colors on Neenah Classic Crest

Client: Western Development Corp.
Design Firm: Milton Glaser, Inc.
Art Director: Milton Glaser
Designer: Milton Glaser
Paper/Printing: Two colors on Strathmore Writing Laid

Client: Los Angeles Center
Design Firm: Davies Associates
Art Director: Noel Davies
Designers: Cathy Tetef, Meredith Kamm
Paper/Printing: Two colors and embossing on Crane's Crest

CITYGATE ASSOCIATES

1400 K Street, Suite 206 ■ Sacramento, CA 95814 ■ PH 916-446-1510 ■ FAX 916-448-9397

CITYGATE ASSOCIATES

Roger C. Bunting
Senior Associate

■

177 Webster Street, #3701
Monterey, CA 93940
PH 408-373-0215
FAX 408-373-0661

CITYGATE ASSOCIATES

177 Webster Street, #3701
Monterey, CA 93940

SACRAMENTO ■ MONTEREY

Client: Citygate Associates
Design Firm: Page Design, Inc.
Art Director: Paul Page
Designer: Laurel Bigley
Illustrator: Laurel Bigley
Paper/Printing: Two colors and clear foil on Circa Select

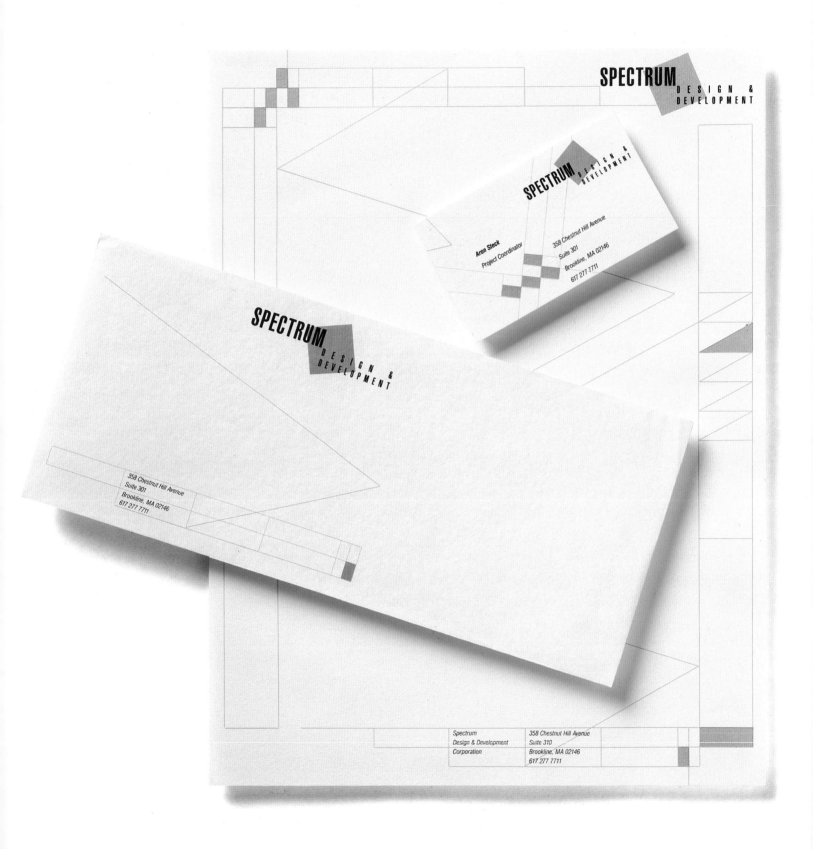

Client: Spectrum
Design Firm: Marc English: Design
Art Director: Marc English
Designer: Marc English
Paper/Printing: Two colors on Strathmore Writing

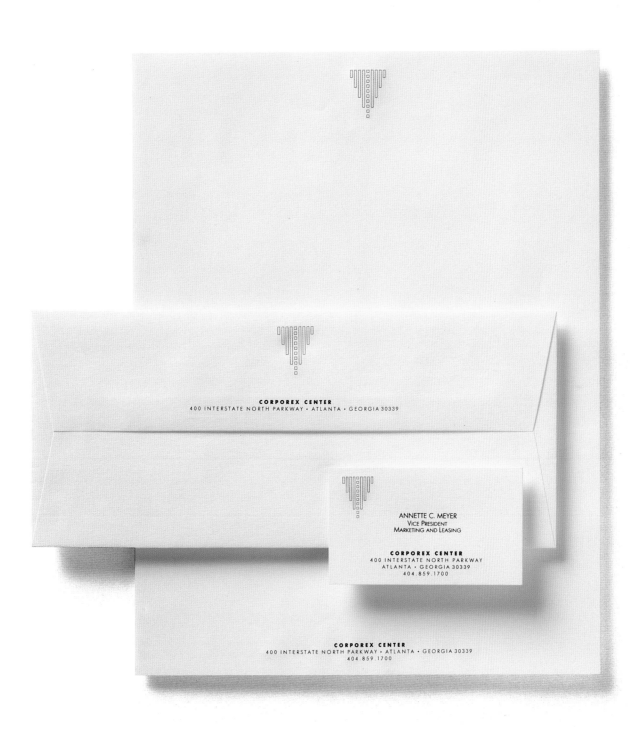

CORPOREX CENTER
400 INTERSTATE NORTH PARKWAY • ATLANTA • GEORGIA 30339

ANNETTE C. MEYER
VICE PRESIDENT
MARKETING AND LEASING

CORPOREX CENTER
400 INTERSTATE NORTH PARKWAY
ATLANTA • GEORGIA 30339
404.859.1700

CORPOREX CENTER
400 INTERSTATE NORTH PARKWAY • ATLANTA • GEORGIA 30339
404.859.1700

Client: Corporex Center
Design Firm: Michael Aron and Company
Art Director: Michael Aron
Designer: Michael Aron
Paper/Printing: One color on Strathmore Bright White Wove

THE ARBORETUM

THE ARBORETUM

THE ARBORETUM

Lisa A. Goldstein

2000 Colorado Ave. ▪ Santa Monica, CA 90404 ▪ 215/828 5551 ▪ Fax 215/515 5071

2000 Colorado Avenue ▪ Santa Monica, California 90404 ▪ 215/828 5551 ▪ Fax 215/515 5071

Client: Lowe Development Corporation
Design Firm: Josh Freeman/Associates
Art Directors: Josh Freeman, Vickie Sawyer Karten
Designers: Vickie Sawyer Karten, Jennifer Bass
Illustrator: Vickie Sawyer Karten
Paper/Printing: Three colors

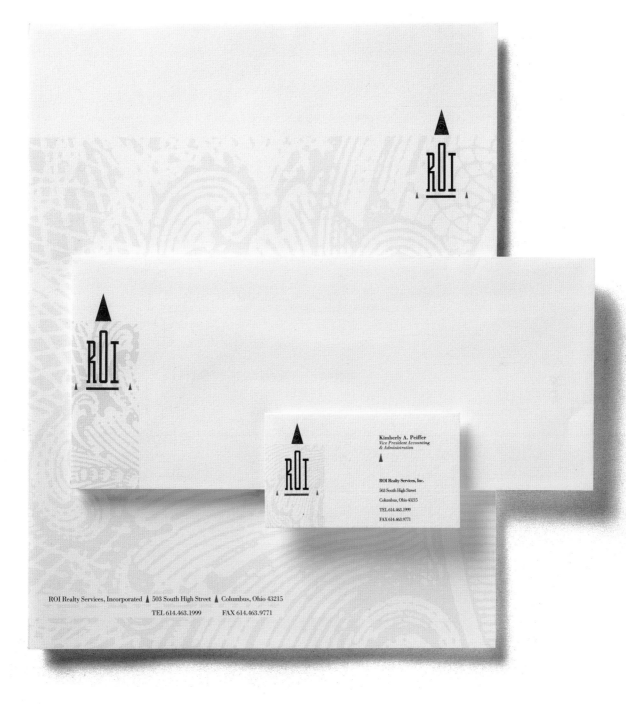

Client: ROI Realty Services, Inc.
Design Firm: Integrate, Inc.
Art Directors: John Galvin, Stephen Quinn
Designers: John Galvin, Stephen Quinn
Paper/Printing: Two colors on Gilbert Writing

E. SPEER
& ASSOCIATES

E. Speer & Associates • 1300 Indian Street • Stuart, Florida 34997

E. SPEER
& ASSOCIATES

Erling D. Speer
President

1300 Indian Street
Stuart, FL 34997

Real Estate
Development and
Management

(407) 283-2900
Fax: (407) 286-9446

E. Speer & Associates • 1300 Indian Street • Stuart, Florida 34997 • (407) 283-2900 • Fax: (407) 286-9446

Client: E. Speer & Associates
Design Firm: Design/Joe Sonderman, Inc.
Art Director: Tim Gilland
Designer: Andy Crews
Paper/Printing: Three colors on Classic Crest

MCDONALD
DEVELOPMENT

MCDONALD
DEVELOPMENT

McDonald Development Company
300 Northcreek, Suite 650
3715 Northside Parkway
Atlanta, Georgia 30327
(404) 239-0885 (Fax) 239-0877

John R. McDonald

MCDONALD
DEVELOPMENT

McDonald Development Company
300 Northcreek, Suite 650
3715 Northside Parkway
Atlanta, Georgia 30327

McDonald Development Company
300 Northcreek, Suite 650
3715 Northside Parkway
Atlanta, Georgia 30327
(404) 239-0885 (Fax) 239-0877

Client: McDonald Development Company
Design Firm: Turpin Design Associates
Art Director: Tony F. Turpin
Designers: James K. Whitely, Tony F. Turpin

Continental Development Group Inc.

Continental Development Group Inc.

488 Madison Avenue, New York, N.Y. 10022

Continental Development Group Inc.

Richard A. Kahan
Managing Director

488 Madison Avenue
New York, N.Y. 10022
(212) 303-1477

Continental Development Group Inc.

488 Madison Avenue, New York, N.Y. 10022

Richard A. Kahan, Managing Director, 488 Madison Avenue, New York, N.Y. 10022 (212) 303-1477

Client: Continental Development Group, Inc.
Design Firm: Donovan and Green
Art Director: Michael Donovan
Designer: Dan Miller
Paper/Printing: Two colors on Protocol Writing Bright White

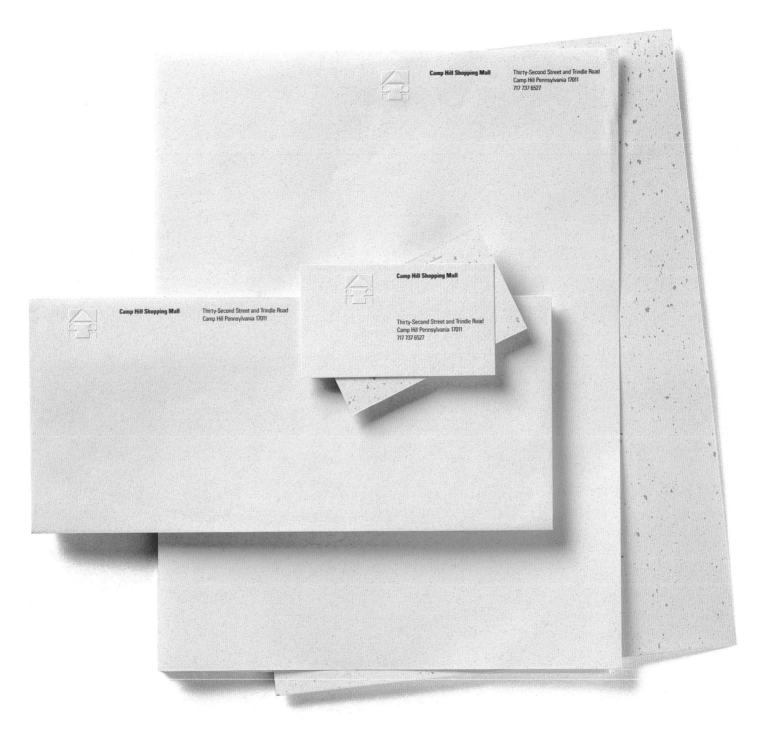

Camp Hill Shopping Mall

Thirty-Second Street and Trindle Road
Camp Hill Pennsylvania 17011
717 737 6527

Client: Camp Hill Shopping Mall
Design Firm: Musser Design
Art Director: Musser
Designer: Musser
Illustrator: Musser
Paper/Printing: Two colors plus embossing on Curtis Flannel

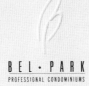

BEL·PARK
PROFESSIONAL CONDOMINIUMS

BEL·PARK
PROFESSIONAL CONDOMINIUMS

1005 Belmont Ave.
Youngstown, Ohio
4 4 5 0 4

1005 Belmont Ave.
Youngstown, Ohio
4 4 5 0 4
216·743·1118
216·743·5228

Client: Bell-Park Condominiums
Design Firm: May Design Associates
Art Director: Frederick Mozzy
Designer: Frederick Mozzy
Illustrator: Frederick Mozzy
Paper/Printing: Two colors and embossing on Gilbert Neu-Tech

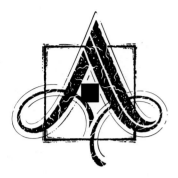

MEADŌWGATE

RIVERSIDE

O X F O R D

SILVER SERVICE

Client: Northwest Building Corporation
Design Firm: Hornall Anderson Design Works
Art Director: Jack Anderson
Designers: Jack Anderson, Cliff Chung, David Bates
Illustrators: Bruce Hale, David Bates

Client: Community Dynamics, Inc.
Design Firm: Josh Freeman/Associates
Art Directors: Josh Freeman, Vickie Sawyer Karten
Designer: Vickie Sawyer Karten
Illustrator: Bob Maile

Client: Bedford Properties
Design Firm: Vanderbyl Design
Designer: Michael Vanderbyl

Client: Stern Development
Design Firm: Adam, Filippo & Associates
Art Director: Robert Adam
Designers: Barbara S. Peak, Ralph James Russini

Client: Oxford Development
Design Firm: Adam, Filippo & Associates
Art Director: Adam, Filippo & Associates
Designer: Ralph James Russini

Client: The Callison Partnership
Design Firm: Hornall Anderson Design Works
Art Director: Jack Anderson
Designers: Jack Anderson, Mary Hermes
Illustrator: Mary Hermes

4. PROFESSIONAL SERVICES

S O F T W A R E

S O F T W A R E

LeeAnn Zahner

Suite 101
2200 Sixth Avenue
P.O. Box 19479
Seattle, WA 98119
(206) 623-9664

S O F T W A R E

Suite 101
2200 Sixth Avenue
P.O. Box 19479
Seattle, WA 98119

S O F T W A R E

Suite 101
2200 Sixth Avenue
P.O. Box 19479
Seattle, WA 98119

Suite 101
2200 Sixth Ave
P.O. Box 19479
Seattle, WA
98119

Suite 101
2200 Sixth Avenue
P.O. Box 19479
Seattle, WA 98119
(206) 623-9664

Client: Sunstone Software
Design Firm: Hornall Anderson Design Works
Art Director: Jack Anderson
Designers: Jack Anderson, Cliff Chung
Paper/Printing: Two colors, gold hot stamp, and blind embossing on Strathmore Writing

Velocity Software
*XA Products
and Services for VM*

*60 Alban Street
Boston, MA 02124*
617·825·3599

Velocity Software
*60 Alban Street
Boston, MA 02124*

Romney White *Vice President*

Velocity Software
*XA Products
and Services for VM*

*60 Alban Street
Boston, MA 02124*
617·825·3599

Client: Velocity Software, Inc.
Design Firm: Unlimited Swan, Inc.
Art Director: Jim Swan
Designer: Rob Swan
Illustrator: Rob Swan
Paper/Printing: Two colors on Strathmore Writing

BLUE SKY
s y s t e m s

BLUE SKY
s y s t e m s

David Orr

1308 Bardstown Rd
Louisville, Ky 40204
Tel (502) 452-2401
Fax (502) 452-2414

1308	Louisville		
Bardstown	Kentucky		
Road	40204		

BLUE SKY
s y s t e m s

1308	Louisville	(502)	Fax
Bardstown	Kentucky	452	452
Road	40204	2401	2414

Client: Blue Sky Systems
Design Firm: McCord Graphic Design
Art Director: Walter McCord
Designers: Walter McCord, Julia Comer
Illustrator: Walter McCord
Paper/Printing: Three colors on Strathmore Writing

BRADLEY group

6646 hollywood

BRADLEYgroup

BRADLEY group

6646 hollywood boulevard suite 229 hollywood california 90028 213-465-7593 fax 213-465-7679

Client: Bradley Group
Design Firm: Margo Chase Design
Art Director: Margo Chase
Designer: Margo Chase
Paper/Printing: Three colors on Mohawk Superfine

SERENGETI SOFTWARE
16769 HICKS ROAD
LOS GATOS, CA 95032
PHONE 408.268.0408
FAX 408.268.0847
ALINK: SERENGETI

SERENGETI SOFTWARE
16769 HICKS ROAD
LOS GATOS, CA 95032

MICHAEL R. BURKE
PRESIDENT

SERENGETI SOFTWARE
16769 HICKS ROAD
LOS GATOS, CA 95032
PHONE 408.268.0408
FAX 408.268.0847
ALINK: SERENGETI

Client: Serengeti Software
Design Firm: Tharp Did It • Los Gatos/San Francisco
Art Director: Rick Tharp
Designers: Rick Tharp, Jean Mogannam
Paper/Printing: Three colors on Simpson EverGreen Recycled

Client: Under The Umbrella
Design Firm: Mark Palmer Design
Art Director: Mark Palmer
Designer: Mark Palmer
Computer Production: Curtis Palmer
Paper/Printing: Two colors on Classic Crest Wove

Client: Incrementum, Inc.
Design Firm: Richard Danne & Associates
Art Director: Richard Danne
Designer: Richard Danne
Paper/Printing: Two colors on Simpson Protocol Writing

Client: The Ceres Group
Design Firm: Flagg, Brothers Inc.
Designer: Richard Scalzo, Jr.
Illustrator: Richard Scalzo, Jr.
Paper/Printing: Two colors on Neenah Environment

Client: Asymetrix Corporation
Design Firm: Hornall Anderson Design Works
Art Director: Jack Anderson
Designers: Jack Anderson, Greg Walters
Calligrapher: Bruce Hale
Paper/Printing: Four colors on Strathmore Writing

**VULCAN
VENTURES**

110 • 110th Ave. N.E.
Suite 717
Bellevue, WA
98004

206 • 451 • 8989

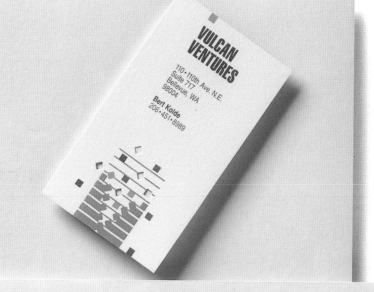

**VULCAN
VENTURES**

110 • 110th Ave. N.E.
Suite 717
Bellevue, WA
98004

Client: Vulcan Ventures
Design Firm: Hornall Anderson Design Works
Art Director: Jack Anderson
Designers: Jack Anderson, Mary Hermes
Paper/Printing: Four colors on Strathmore Writing

COMTRAIN
COMPUTER TRAINING SYSTEMS

103 Providence Mine Rd., #202
Nevada City, California 95959
(916) 265-0300
FAX (916) 265-6550

. .

COMTRAIN
COMPUTER TRAINING SYSTEMS

. .

103 Providence Mine Rd., #202
Nevada City, California 95959

Client: ComTrain
Design Firm: LeeAnn Brook Design
Art Director: LeeAnn Brook
Designer: LeeAnn Brook
Paper/Printing: Two colors on Strathmore Writing

EMMES

Michael Sonnenfeldt
President

Emmes & Co., Inc.
62 Park Street
Tenafly, NJ 07670

Mailing address:
P.O. Box 549
Tenafly, NJ 07670

Tel: 201·871·4030
Fax: 201·871·0024

EMMES

Emmes & Co., Inc.
P.O. Box 549
Tenafly, NJ 07670

Michael Sonnenfeldt	Emmes & Co., Inc.	Mailing address:	Tel: 201·871·4030
President	62 Park Street	P.O. Box 549	Fax: 201·871·0024
	Tenafly, NJ 07670	Tenafly, NJ 07670	

Client: Emmes and Company
Design Firm: Donovan and Green
Art Director: Nancye Green
Designer: Clint Morgan
Paper/Printing: Two colors and blind embossing on Crane's Crest Fluorescent White

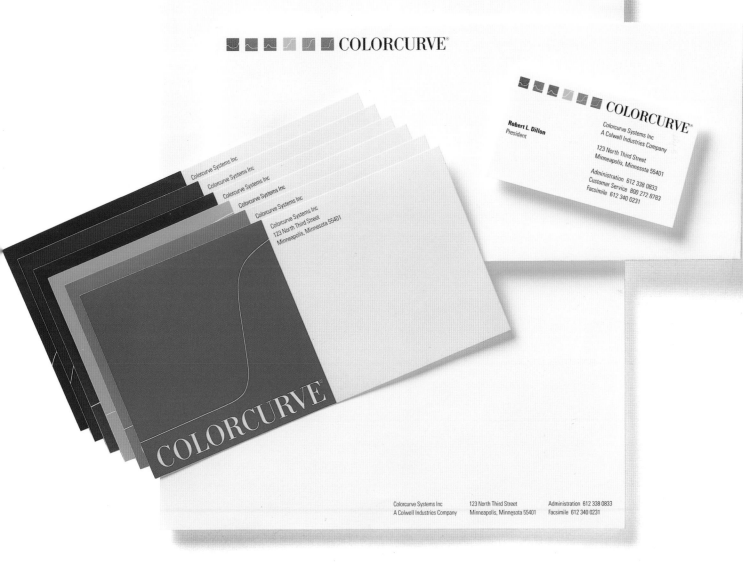

Client: Colorcurve Systems Inc.
Design Firm: Designframe Inc.
Art Director: James A. Sebastian
Designer: James A. Sebastian, John Plunkett, Frank Nichols
Paper/Printing: Seven colors on Simpson Starwhite Vicksburg Tiara Text Vellum

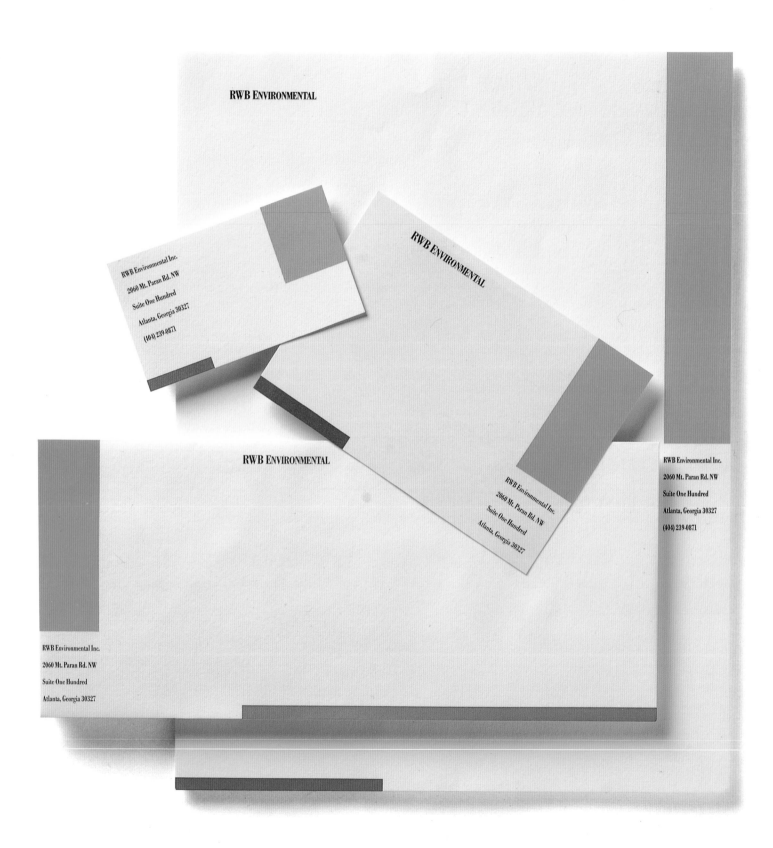

Client: RWB Environmental
Design Firm: Rousso+Associates Inc.
Art Director: Steve Rousso
Designer: Steve Rousso
Paper/Printing: Three colors on Strathmore Writing

RENAISSANCE PARTNERS

306 Plaza Building

Yost Boulevard

Pittsburgh, PA 15221

(412) 829-2588

RENAISSANCE PARTNERS

306 Plaza Building

Yost Boulevard

Pittsburgh, PA 15221

Client: Renaissance Partners
Design Firm: Adam, Filippo & Associates
Art Director: Robert Adam
Designer: Adam, Filippo & Associates
Paper/Printing: Two colors on Crane's Distaff Linen White Laid

One Hillendale Road
Perkasie, PA 18944
215.453.3022

Blake H. Eisenhart
General Auditor

Independence Bancorp

Independence Bancorp

One Hillendale Road
Perkasie, PA 18944

One Hillendale Road
Perkasie, PA 18944
215.453.3049

Independence Bancorp

John T. Blough

Corporate Officer
Treasury Division

Client: Independence Bancorp
Design Firm: Katz Wheeler Design
Art Director: Alina R. Wheeler
Designer: Dan Picard
Paper/Printing: Two colors and embossing on Protocol Writing

ENGINEERED
LIGHTING PRODUCTS

10768 LOWER AZUSA ROAD
EL MONTE, CALIFORNIA 91731
818/579-0943 FAX 818/579-6803

Eugene L. Mosley Evan G. Perkins
Dennis M. Clare Norma C. Miller
J. Bruce Miller Mark A. Sipek
W. Waverley Townes Judith E. McDonald-Burkman
Larry C. Ethridge Anthony L. Schnell
Victor L. Baltzell
William J. Nold

Miller, Mosley, Clare & Townes

File No.

Suite 500, The Hart Block Building 730 West Main Street Louisville, Kentucky 40202 502 583-7600 502 589-4997 Facsimile

AVIATION
MANAGEMENT
INTERNATIONAL
Western Region

ROCKY MOUNTAIN AIR RENDEZVOUS

Airshow Production & Promotions

Corporate Headquarters
Box 2407
Lake Oswego, Oregon
97035-0093
(503) 684-6000
FAX: (503) 620-2000

Denver Office
Suite 700
4600 S. Ulster Pkwy.
Denver, Colorado
80237-2833
(303) 424-7766

Judicial Resources Inc.

1750 Montgomery St.
San Francisco, California 94111
415-954-8554

JUDICIAL
RESOURCES

Client: Aviation Management International
Design Firm: Robert Bailey, Inc.
Designer: John Williams
Paper/Printing: Two colors and foil on Classic Crest

Client: Judicial Resources Inc.
Design Firm: Cognata Associates
Art Director: Richard Cognata
Designer: Richard Cognata
Paper/Printing: Two colors

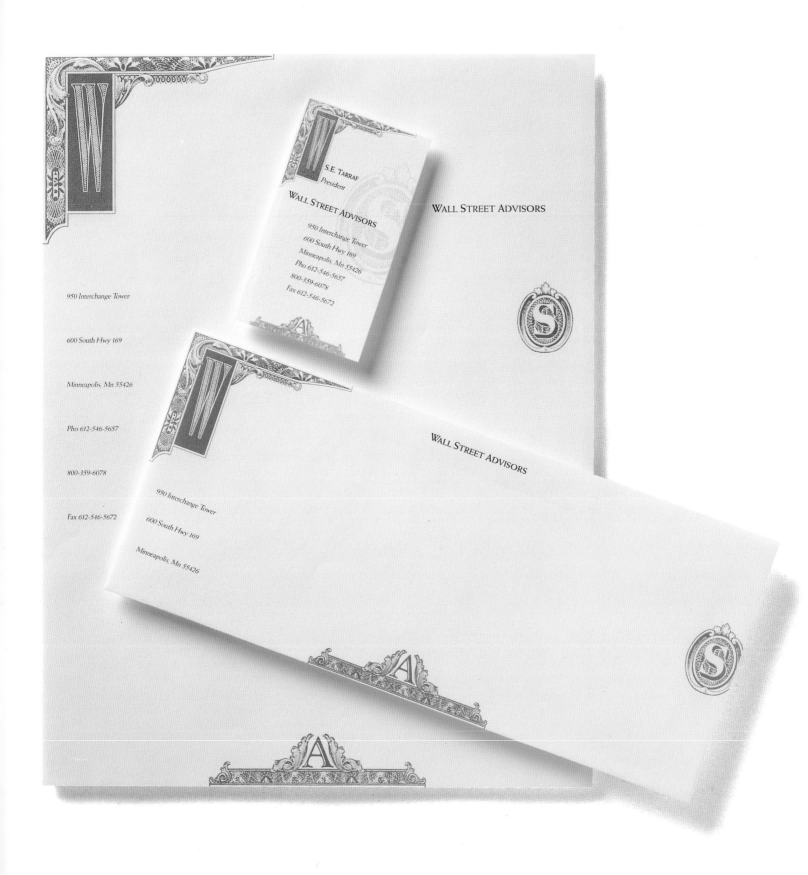

Client: Wall Street Advisors
Design Firm: Design Center
Art Director: John Reger
Designer: Todd Spichke
Paper/Printing: Four colors

A R E N A D E R H O H A N N E S I A N & A S S O C I A T E S

A R E N A D E R H O H A N N E S I A N & A S S O C I A T E S

26 Towle Farm Rd., Suite 14, Hampton, NH 03842

A R E N A D E R H O H A N N E S I A N & A S S O C I A T E S

26 Towle Farm Rd., Suite 14
Hampton, NH 03842
Tel: 603.926.4007 Fax: 603.929.1425

26 Towle Farm Rd., Suite 14
Hampton, NH 03842
Tel: 603.926.4007
Fax: 603.929.1425

Master Planning
Selection Process Planning
Terminal Planning
ARFF/Emergency Planning
Security Planning

A R E N A D E R H O H A N N E S I A N
& A S S O C I A T E S

Charles T. Arena
Senior Partner

183 State, St., 7th Floor
Boston, MA 02109
Tel: 617.523.3700 Fax: 617.523.5969

Client: Arena Derhohannesian
Design Firm: Cipriani Kremer Design
Art Director: Robert Cipriani
Paper/Printing: Two colors on Crane's Crest

ARBOR
SYSTEMS
GROUP

ARBOR
SYSTEMS
GROUP

Sloan Plaza
505 East Huron
Ann Arbor, Michigan 48104
313 761-9740/FAX 313 761-9666

Sallie S. Findlay
President

Sloan Plaza
505 East Huron
Ann Arbor, MI
48104

ARBOR
SYSTEMS
GROUP

Sloan Plaza • 505 East Huron • Ann Arbor, Michigan 48104 • 313 761-9740 • FAX 313 761-9666

Client: Arbor Systems Group
Design Firm: Perich + Partners
Art Director: Ernie Perich
Designers: Janine Thielk, Steve Atkinson
Paper/Printing: Two colors

LANE POWELL MOSS & MILLER

RAYMOND W. HAMAN, P.S.
G. KEITH GRIM, P.S.
D. WAYNE GITTINGER
BARRY H. BIGGS
RICHARD F. ALLEN, P.S.
ROBERT V. THOMAS
HARTLEY PAUL
DAVID C. LYCETTE
ROBERT J. FREDERICK, P.S.
JOHN R. TOMLINSON
FRANK W. DRAPER
ROBERT L. ISRAEL, P.S.
ROBERT R. DAVIS, JR.
EUGENE R. NIELSON
DALE E. KREMER, P.S.
CHARLES R. EKBERG, P.S.
KENYON P. KELLOGG, P.S.
MICHAEL D. DWYER
MARK EDWIN JOHNSON
JAMES L. ROBART**
C. WILLIAM BAILEY
EVAN O. THOMAS III
MICHAEL E. MORGAN
KERMIT E. BARKER, JR.**
WAYNE W. HANSEN
JAMES B. STOETZER**
RICHARD C. SIEFERT
LARRY S. GANGNES, P.S.
MICHAEL L. COHEN, P.S.
DAVID G. JOHANSEN
MICHAEL H. RUNYAN
DEBORAH O. WRIGHT
DALE W. HOUSE**
ANNE MCDONALD
H. PETER SORG, JR.

Law Offices

*Evergreen Plaza
Building
711 Capitol Way
Olympia, WA
98501-1231*

(206) 754-6001

*Facsimile:
(206) 754-1605*

*A Partnership
Including
Professional
Corporations*

*1420 Fifth Ave.
Suite 4100
Seattle, WA
98101-2338*

Patricia H. Welch
Attorney at Law

*1420 Fifth Ave.
Suite 4100
Seattle, WA
98101*

(206) 223-7000

Telex: 32-8808

*Facsimile:
(206) 223-7107*

*Seattle, WA
Anchorage, AK
Bellevue, WA
Mount Vernon, WA
Olympia, WA
London, England*

MICHAEL K. NAHI
JOHN R. NEELEMAN
MICHAEL A. NESTEROFF
CHRISTIAN N. OLDHAM
JOHN E.D. POWELL
ALBERT M. RAINES
D. MICHAEL REILLY
ELIZABETH A. RICHARDSON
CHERYLL RUSSELL
MARK W. SCHEER**
DAVID M. SCHOEGGL
RICHARD W. SEARS
DOUGLAS E. SMITH
STEPHEN C. SMITH
DAVID C. SPELLMAN
CATHY A. SPICER
LAWRENCE W. STEVENS
PAUL D. SWANSON
COLEEN D. THOMPSON
THOMAS W. TOP
KAREN VEDDER
TIM D. WACKERBARTH
JAMES P. WAGNER**
RAYMOND S. WEBER
BRUCE P. WEILAND
PATRICIA H. WELCH
WM. BRADFORD WELLER
DOUGLAS E. WHEELER
MARK WHEELER
BRUCE WINCHELL
MARY ELLEN ZALEWSKI*

COUNSEL TO THE FIRM
WILBUR J. LAWRENCE
EUGENE H. KNAPP, JR.
JEFFREY D. GOLTZ

OF COUNSEL
GEORGE V. POWELL
BRUCE SHORTS
WILLIAM J. WALSH, JR.
GORDON W. MOSS

* ADMITTED IN ALASKA
** ADMITTED IN ALASKA
AND WASHINGTON.
ALL OTHERS ADMITTED
IN WASHINGTON.

Client: Lane Powell Moss & Miller
Design Firm: Hornall Anderson Design Works
Art Director: Jack Anderson
Designers: Jack Anderson, Mary Hermes, Juliet Shen
Paper/Printing: One color on Protocol Writing

MOSS·ADAMS

CERTIFIED PUBLIC ACCOUNTANTS

1001 - 4th Avenue, Suite 2830
Seattle, Washington 98154-1199

Phone 206.223.1820
FAX 206.622.9975

Offices in Principal Cities of
Washington, Oregon and California
Internationally, Moores Rowland Intl.

ARLENE PAULSON

MOSS·ADAMS

Administrative Office

1001 - 4th Ave., Suite 2830
Seattle, WA 98154-1106

Phone 206.223.1820
FAX 206.622.9975

MOSS·ADAMS

Client: Moss Adams
Design Firm: Rick Eiber Design (RED)
Art Director: Rick Eiber
Designer: Rick Eiber
Paper/Printing: Two colors on Classic Crest

DAVIS
The Davis Company

DAVIS
The Davis Company

1400 K Street, Suite 311 Sacramento, CA 95814

DAVIS
The Davis Company

Michael M. Davis

1400 K Street, Suite 311 Sacramento, CA 95814
916.444.6150 FAX 916.447.4011

1400 K Street, Suite 311 Sacramento, CA 95814
916.444.6150 FAX 916.447.4011

Client: The Davis Company
Design Firm: Marketing By Design
Art Director: Joel Stinghen
Designer: Joel Stinghen
Illustrator: Joel Stinghen
Paper/Printing: Two colors on Protocol Writing

72-880
Fred Waring Drive
Suite D-17
Palm Desert, CA
92260
(619) 346-2253
FAX (619) 346-7133

PROMOTION

72-880
Fred Waring Drive
Suite D-17
Palm Desert, CA
92260

PROMOTION

72-880
Fred Waring Drive
Suite D-17
Palm Desert, CA
92260
(619) 346-2253
FAX (619) 346-7133

PROMOTION

SILVIA STABILE
Marketing Director

Client: Promotion
Design Firm: Mark Palmer Design
Art Director: Mark Palmer
Designer: Mark Palmer
Paper/Printing: Two colors on Strathmore Writing Laid

Client: Lincx Inc.
Design Firm: Michael Stanard Inc.
Art Director: Michael Stanard
Designers: Michael Stanard, Marcos Chavez
Paper/Printing: Two colors on Strathmore Writing

Client: Atlantic Mutual Companies
Design Firm: Richard Danne & Associates Inc.
Art Director: Richard Danne
Designer: Eric Atherton
Paper/Printing: Two colors on Strathmore Writing

LINCX

Two North Park Suite 600
3600 Park Lane
Dallas, Texas 75231
214.340.3400

 **AtlanticMutual
Companies**

Atlantic Mutual Insurance Company
Centennial Insurance Company
430 Mountain Avenue
Murray Hill, New Jersey 07974
201 771.0660

 MANHATTAN MANAGED
FUTURES, INC.

1285 Avenue of the Americas
35th Floor
New York, NY 10019
212·237·2828

SUMMIT
RISK MANAGEMENT &
INSURANCE SERVICES
INCORPORATED

Principals:
Theodore L.K. Yeh, Jr., ARM
Jon G. DeLucia
André J. Olivan
Cheryl S. Downey
Marlene Stephenson

P.O. Box 255097
Sacramento, CA 95865
425 University Ave. Suite 300
Sacramento, CA 95825
(916) 649-8500
FAX (916) 649-0890
(800) 444-2720

Client: Manhattan Managed Futures
Design Firm: Stark Design Associates
Art Director: Adriane Stark
Designer: Adriane Stark
Paper/Printing: Two colors on Strathmore Writing

Client: Summit Risk Management
Design Firm: Marketing By Design
Art Director: Joel Stinghen
Designer: Joel Stinghen
Illustrator: Joel Stinghen
Paper/Printing: Two colors on Gilbert Writing

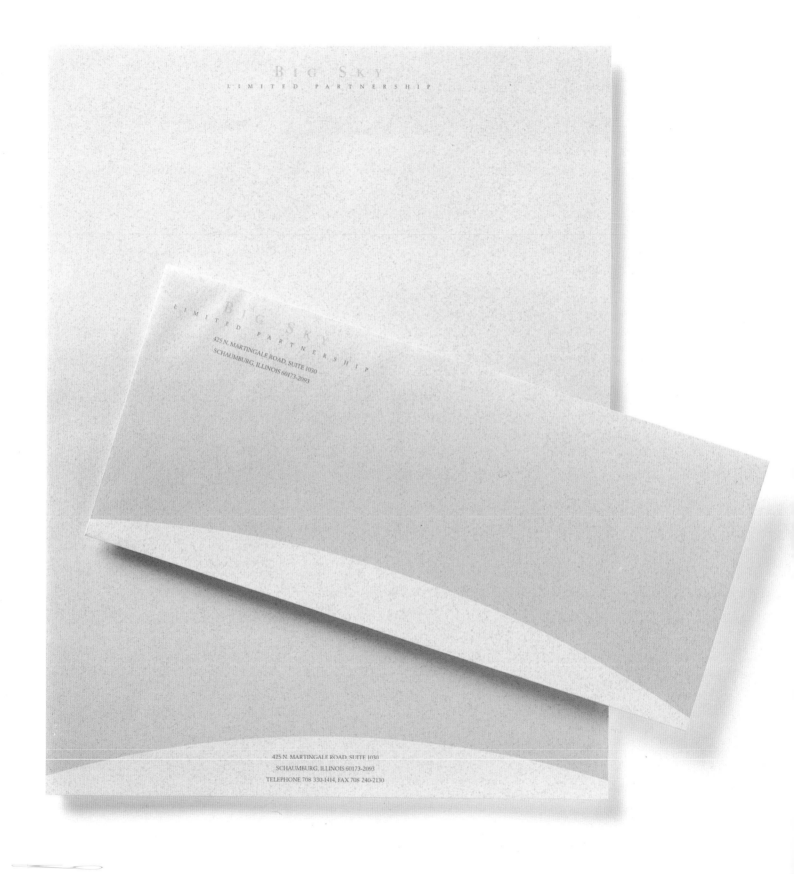

Client: Big Sky Limited Partnership
Design Firm: Identity Center
Art Director: Wayne Kosterman
Designer: John Anderson
Paper/Printing: Two colors

McIntyre Rowan
Executive Recruitment & Selection

415 Yonge Street

Suite 1101

Toronto, Ontario

M5B 2E7

Tel 416.598.8838

Fax 416.598.3088

McIntyre Rowan
Executive Recruitment & Selection

415 Yonge Street

Suite 1101

Toronto, Ontario M5B 2E7

McIntyre Rowan
Executive Recruitment & Selection

415 Yonge Street
Suite 1101
Toronto, Ontario M5B 2E7
Tel 416.598.8838
Fax 416.598.3088

Lawrence Foerster, B.A., C.P.C.
Partner

Client: McIntyre Rowan
Design Firm: Burns Connacher & Waldron
Art Director: Nat Connacher
Designers: Nat Connacher, Maria Carluccio
Illustrator: Nat Connacher
Paper/Printing: Two colors on Strathmore Writing

CHARLES R. DRUMMOND

17095 Crescent Drive

Los Gatos, CA 95030

408.354.3387

Strategic Communications

Client: Drummond Strategic Communications
Design Firm: Tharp Did It • Los Gatos/San Francisco
Art Directors: Rick Tharp, Charles Drummond
Designers: Rick Tharp, Thom Marchionna
Paper/Printing: Two colors and foil embossing on Simpson Protocol

THURSTON
ACCOUNTING

THURSTON
ACCOUNTING

Small Business Specialists

118 Parker Street
P.O. Box 2662
Acton, MA 01720

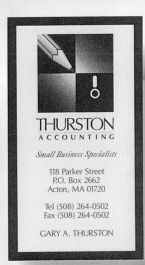

THURSTON
ACCOUNTING

Small Business Specialists

118 Parker Street
P.O. Box 2662
Acton, MA 01720

Tel (508) 264-0502
Fax (508) 264-0502

GARY A. THURSTON

Client: Thurston Accounting
Design Firm: Mace Messier Design Associates
Art Director: Marilyn Messier
Designer: Christopher Pallotta
Illustrator: Christopher Pallotta
Paper/Printing: Two colors on Strathmore Bond

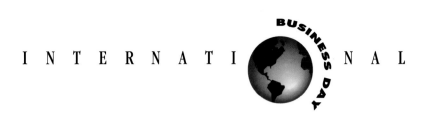

I N T E R N A T I O N A L

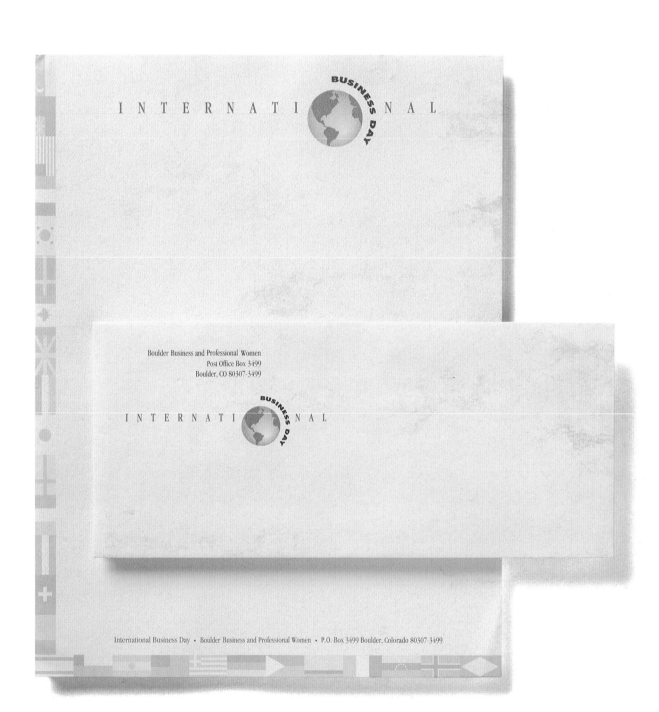

Client: Boulder Business and Professional Women
Design Firm: Pollman Marketing Arts Inc.
Art Director: Jennifer Pollman
Designers: Jennifer Davis, Jeanine Menefee
Paper/Printing: Two colors on Passport Recycled Text #80 Gypsum

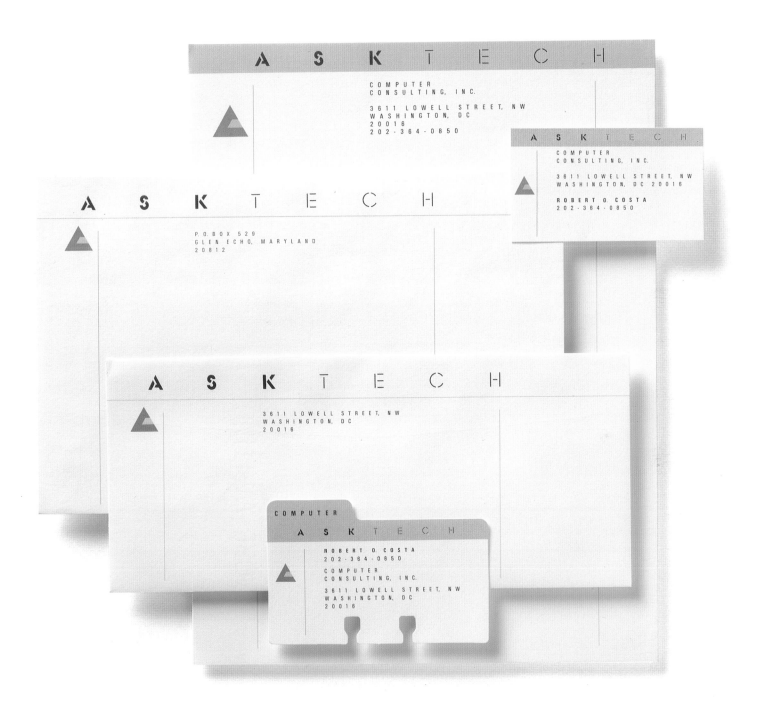

Client: Ask Tech Computer Consulting
Design Firm: Wilsonworks
Art Director: Clare Wilson
Designer: Barry Moyer
Paper/Printing: Three colors on Strathmore Writing Bright White

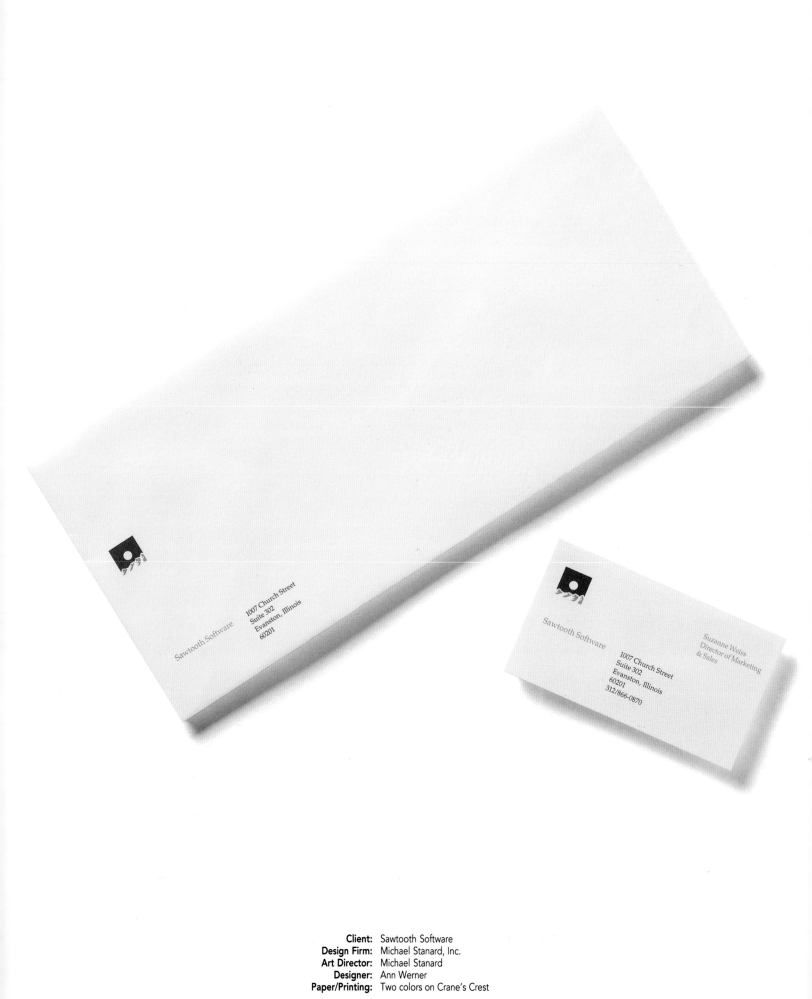

Sawtooth Software

1007 Church Street
Suite 302
Evanston, Illinois
60201

Sawtooth Software

1007 Church Street
Suite 302
Evanston, Illinois
60201
312/866-0870

Suzanne Weiss
Director of Marketing
& Sales

Client: Sawtooth Software
Design Firm: Michael Stanard, Inc.
Art Director: Michael Stanard
Designer: Ann Werner
Paper/Printing: Two colors on Crane's Crest

Client: Arch Financial Systems
Design Firm: Design Center
Art Director: John Reger
Designers: Kobe, D.W. Olson

Client: Asymetrix Corporation
Design Firm: Hornall Anderson Design Works
Art Director: Jack Anderson
Designers: Jack Anderson, Julie Tanagi-Lock,
Mary Hermes, Heidi Hatlestad
Illustrator: Brian O'Neill

Client: Rabbit Copier and Service
Design Firm: Tollner Design Group
Art Director: Lisa Tollner
Designer: Karen Saucier
Illustrator: Karen Saucier

Client: Muehling Associates
Design Firm: J. Brelsford Design, Inc.
Art Director: Jerry Brelsford
Designer: Robert Whitmer

Client: Varitronics Systems Inc.
Design Firm: Design Center
Art Director: John Reger
Designer: C.S. Anderson

Client: Bossardt Corporation
Design Firm: Design Center
Art Director: John Reger
Designer: Todd Spichke

CEREUS

| | | | |
|---|---|---|
| **Client:** Chemical Bank | **Client:** Valid Logic Systems | **Client:** Kumar Consulting |
| **Design Firm:** De Martino Design Inc. | **Design Firm:** Tollner Design Group | **Design Firm:** Kuo Design Group |
| **Art Director:** Erick De Martino | **Art Director:** Lisa Tollner | **Art Director:** Samuel Kuo |
| **Designer:** Erick De Martino | **Designer:** Kim Tucker | **Designer:** Samuel Kuo |
| **Illustrator:** Erick De Martino | **Illustrator:** Kim Tucker | |

Client: Matthew Bender	**Client:** Iris System	**Client:** Monetary Consultants Corp.
Design Firm: De Martino Design Inc.	**Design Firm:** Michael Stanard, Inc.	**Design Firm:** J. Brelsford Design, Inc.
Art Director: Dick Smith	**Art Director:** Michael Stanard	**Art Director:** Jerry Brelsford
Designer: Erick De Martino	**Designer:** Ann Werner	**Designer:** Jerry Brelsford
Illustrator: Erick De Martino		

5. GRAPHIC DESIGN / ADVERTISING

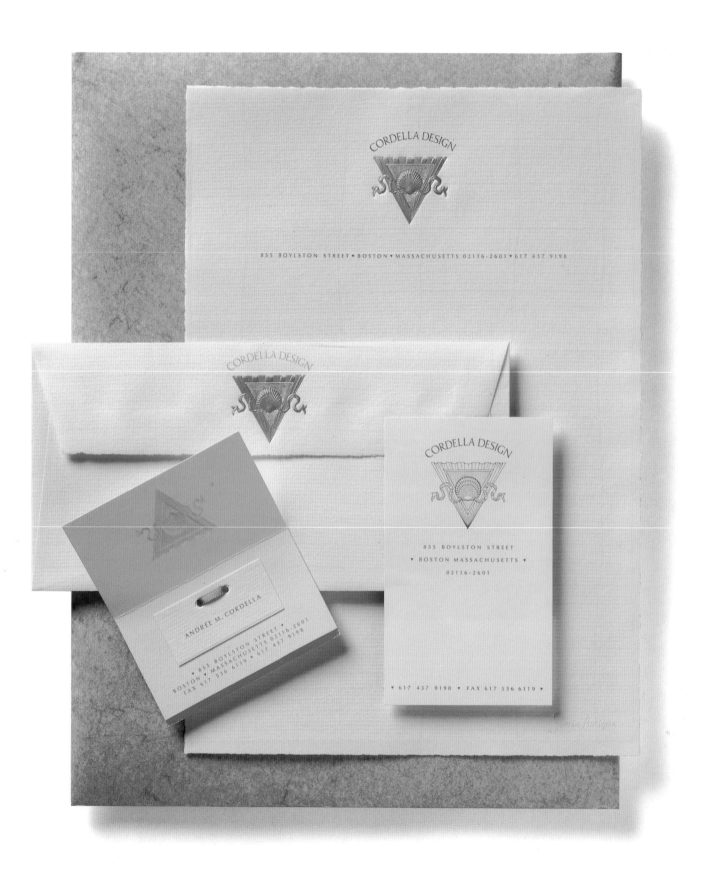

Client: Cordella Design
Design Firm: Cordella Design
Art Director: Andreé Cordella
Designer: Andreé Cordella
Paper/Printing: One color and foil

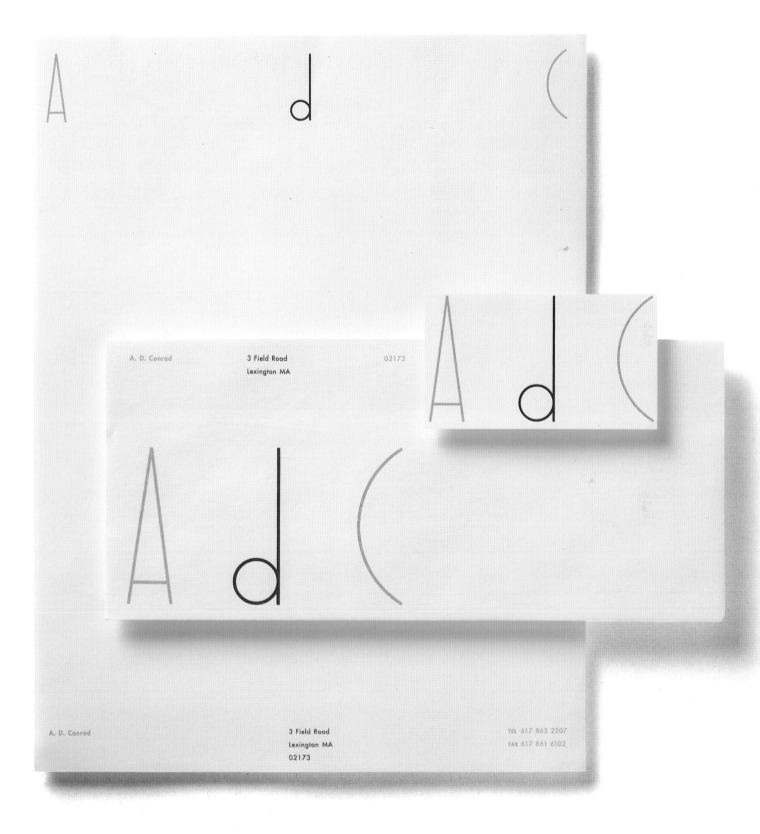

A. D. Conrad 3 Field Road 02173
Lexington MA

A. D. Conrad 3 Field Road TEL 617 862 2207
Lexington MA FAX 617 861 6102
02173

Client: A.d. Conrad
Design Firm: Clifford Selbert Design
Art Director: Clifford Selbert
Designer: Liz Rotter
Typography: Liz Rotter
Paper/Printing: Three colors on Strathmore Writing Bright White Wove

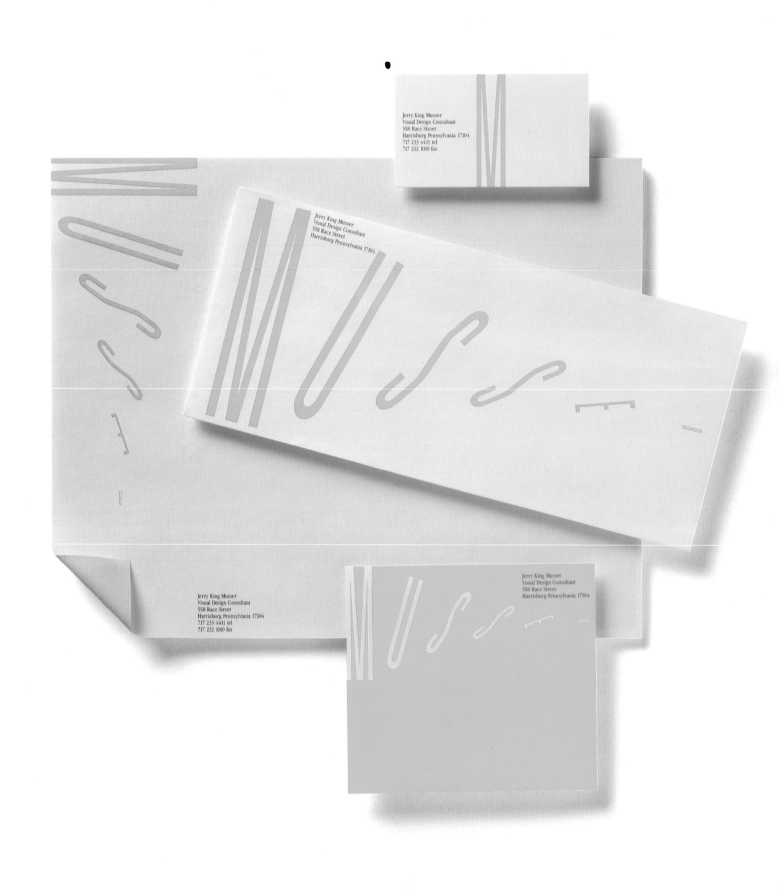

Client: Musser Design
Design Firm: Musser Design
Art Director: Musser
Designer: Musser
Paper/Printing: Two colors on Neenah Bond

REINER *Design Consultants, Inc.*

26 East 22nd. Street, 8th Floor.

New York, NY 10010.

Telephone: 212.673.1302

Fax No. 212.353.2690

REINER *Design Consultants, Inc.*

26 East 22nd. Street

New York, NY 10010.

Telephone: 212.673.1302

Fax No. 212.353.2690

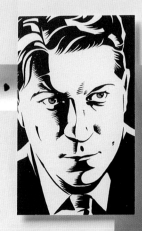

REINER *Design Consultants, Inc.*
26 East 22nd Street
New York, NY 10010
Telephone: 212.673.1302
Fax No. 212.353.2690

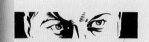

Client: Reiner Design Consultants, Inc.
Design Firm: Reiner Design Consultants, Inc.
Art Director: Roger J. Gorman
Designer: Roger J. Gorman
Paper/Printing: Two colors on Strathmore Writing Bright White Wove

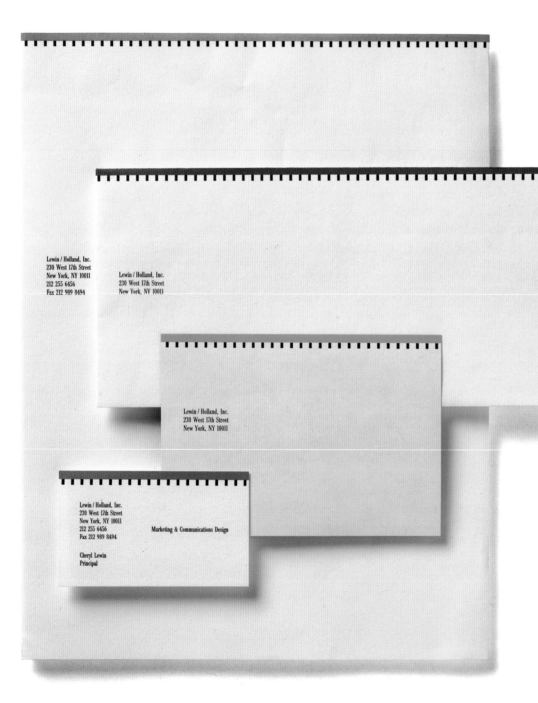

Lewin / Holland, Inc.
230 West 17th Street
New York, NY 10011
212 255 6456
Fax 212 989 8494

Lewin / Holland, Inc.
230 West 17th Street
New York, NY 10011

Lewin / Holland, Inc.
230 West 17th Street
New York, NY 10011

Lewin / Holland, Inc.
230 West 17th Street
New York, NY 10011
212 255 6456
Fax 212 989 8494 Marketing & Communications Design

Cheryl Lewin
Principal

Client: Lewin/Holland, Inc.
Design Firm: Lewin/Holland, Inc.
Art Director: Cheryl Lewin
Designer: Cheryl Lewin
Paper/Printing: Two colors

Client: The Dinosaur Group Inc.
Design Firm: The Dinosaur Group Inc.
Art Director: Bill Logan
Designer: Bill Logan
Illustrator: Bill Logan
Paper/Printing: Five colors on Strathmore Writing Grey Laid

Client: Notovitz Design, Inc.
Design Firm: Notovitz Design, Inc.
Art Directors: Joe Notovitz, Gil Livne
Designer: Gil Livne
Paper/Printing: Three colors on Neenah Avon Brilliant White

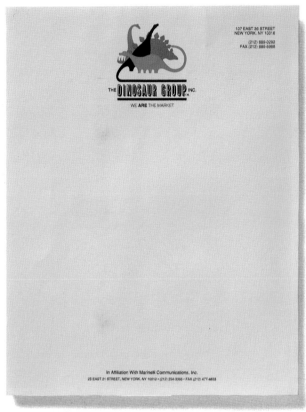

Client: Marketing By Design
Design Firm: Marketing By Design
Art Director: Joel Stinghen
Designer: Linda Clark Johnson
Illustrator: Linda Clark Johnson
Paper/Printing: Four colors on Clasic Crest

Client: Jack Tom Design
Design Firm: Jack Tom Design
Art Director: Jack Tom
Designer: Jack Tom
Illustrator: Jack Tom
Paper/Printing: Two colors on Gilbert Bond 25% Cotton

Rowe & Ballantine

Rowe & Ballantine

Edward L. Rowe, Jr.

Graphic Design Consultants
P.O. Box 293
8 Galloping Hill Road Tel: 203-775-7887
Brookfield, CT 06804 Fax: 203-775-7881

Rowe & Ballantine

P.O. Box 293
8 Galloping Hill Road
Brookfield, CT 06804

Rowe & Ballantine

P.O. Box 293
8 Galloping Hill Road
Brookfield, CT 06804

Rowe & Ballantine P.O. Box 293 Tel: 203-775-7887
Graphic Design Consultants 8 Galloping Hill Road Fax: 203-775-7881
 Brookfield, CT 06804

Client: Rowe & Ballantine
Design Firm: Rowe & Ballantine
Art Director: Edward L. Rowe, Jr.
Designer: John H. Ballantine
Paper/Printing: Two colors on Strathmore Writing

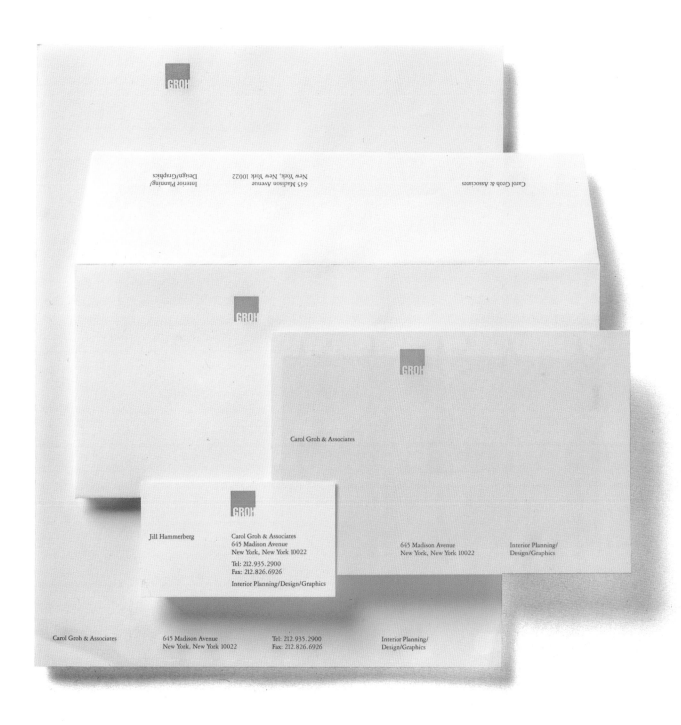

Client: Carol Groh & Associates
Design Firm: Donovan and Green
Art Director: Nancye Green
Designer: Clint Morgan
Paper/Printing: Six colors on Protocol 100 Warm White Wove

STAN **B** ARD

STAN **B** ARD

Michael Stanard, Inc.
One Thousand Main Street
Evanston, Illinois 60202
708.869.9820
708.869.9826 *f*

Michael Stanard, Inc.
One Thousand Main Street
Evanston, Illinois 60202
708.869.9820
708.869.9826 *f*

STAN **B** ARD

Marcos Chavez
Designer

Michael Stanard, Inc.
One Thousand Main Street
Evanston, Illinois 60202
708.869.9820
708.869.9826 *f*

STANDARD

Michael Stanard, Inc.
One Thousand Main Street
Evanston, Illinois 60202

STAN **B** ARD

Michael Stanard, Inc.
One Thousand Main Street
Evanston, Illinois 60202

Client: Michael Standard, Inc.
Design Firm: Michael Stanard
Art Director: Michael Stanard
Designer: Michael Stanard
Paper/Printing: Two colors on Strathmore Writing

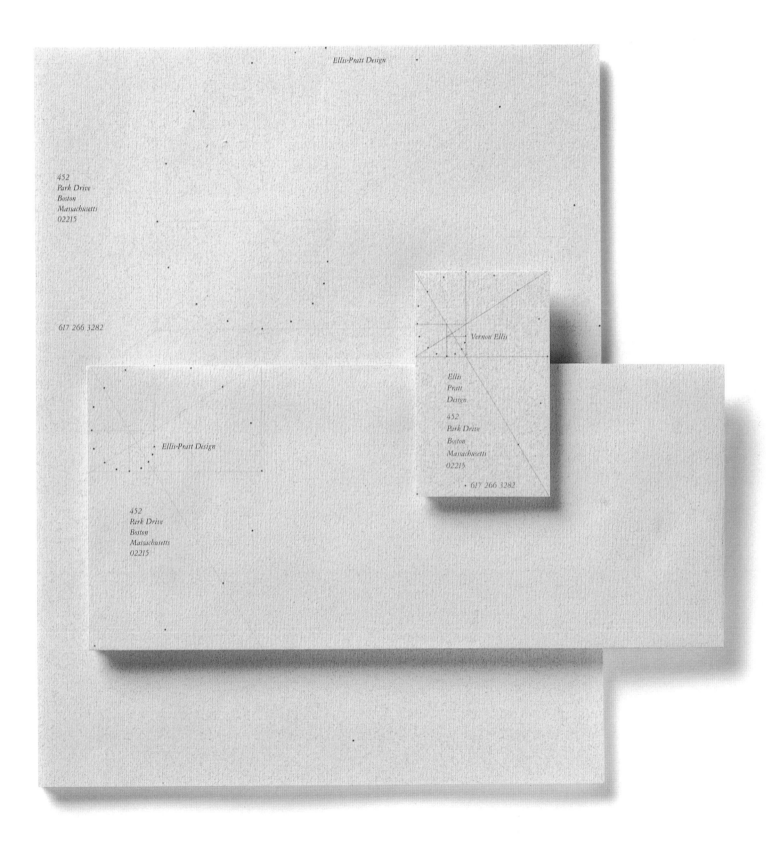

Client: Ellis • Pratt Design
Design Firm: Ellis • Pratt Design
Art Directors: Vernon Ellis, Elaine Pratt
Designers: Elaine Pratt, Vernon Ellis
Paper/Printing: Two colors on Simpson Gainsborough

333 EAST 69TH STREET TOWNHOUSE 11 NEW YORK, NY 10021

333 EAST 69TH STREET TOWNHOUSE 11
NEW YORK, NY 10021
TELEPHONE 212.737.2997
FACSIMILE 212.650.0092

333 EAST 69TH STREET TOWNHOUSE 11 NEW YORK, NY 10021 TELEPHONE 212.737.2997 FACSIMILE 212.650.0092

Client: I Pezzi Dipinti
Design Firm: M Plus M Incorporated
Art Directors: Takaaki Matsumoto, Michael McGinn
Designer: Takaaki Matsumoto

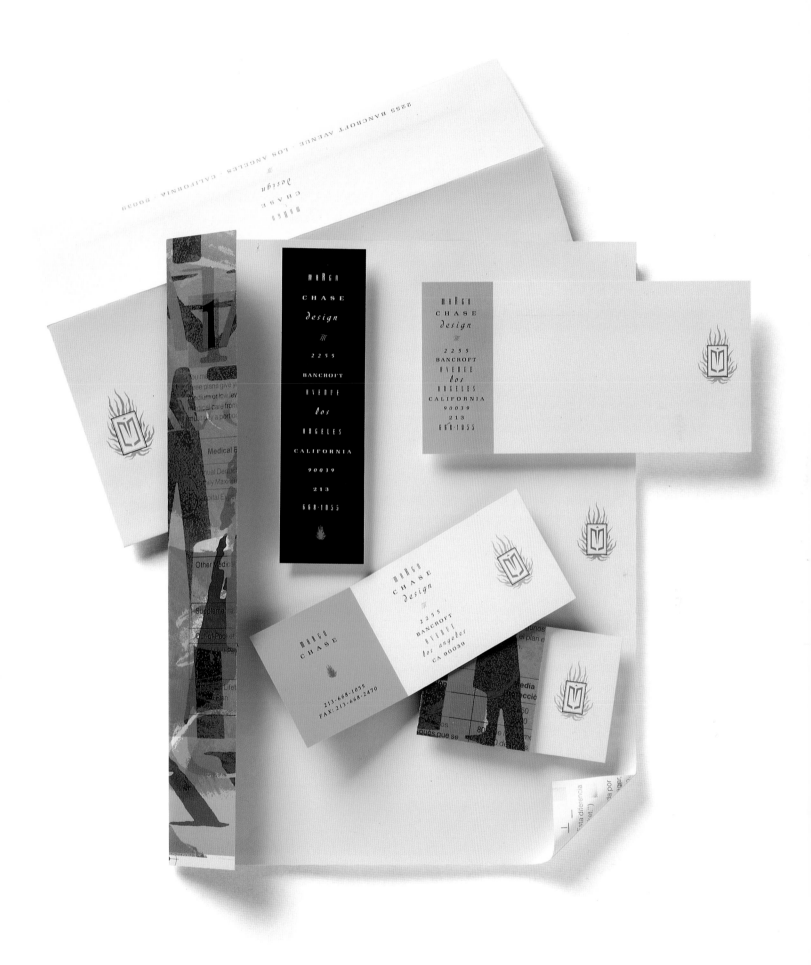

Client: Margo Chase Design
Design Firm: Margo Chase Design
Art Director: Margo Chase
Designer: Margo Chase
Paper/Printing: Three colors on Mountie Matte White

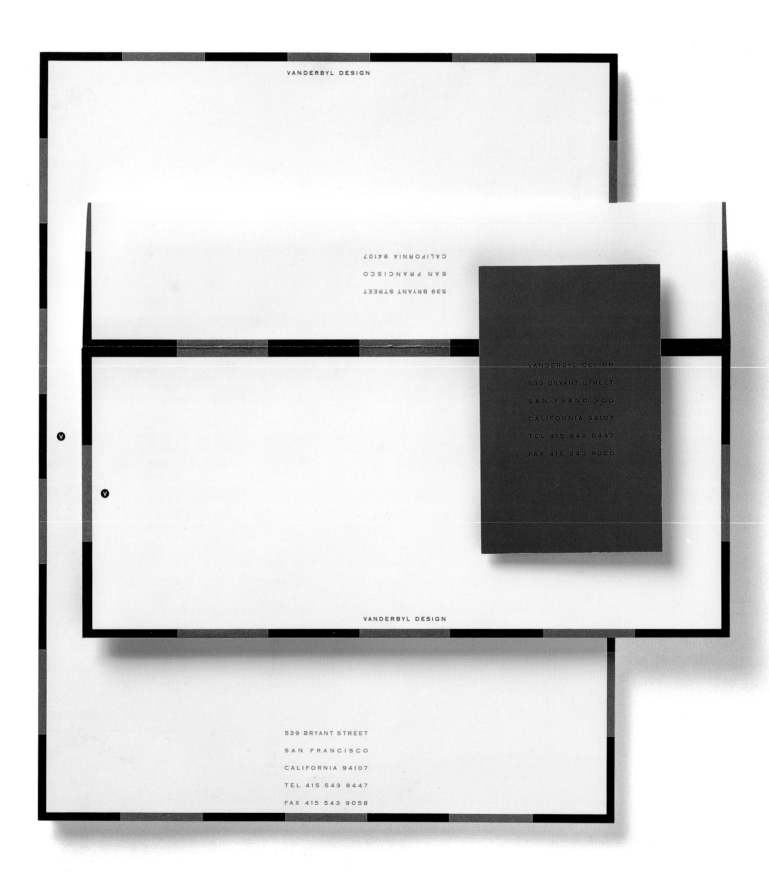

VANDERBYL DESIGN

CALIFORNIA 94107
SAN FRANCISCO
539 BRYANT STREET

VANDERBYL DESIGN
539 BRYANT STREET
SAN FRANCISCO
CALIFORNIA 94107
TEL 415 543 8447
FAX 415 543 9058

VANDERBYL DESIGN

539 BRYANT STREET

SAN FRANCISCO

CALIFORNIA 94107

TEL 415 543 8447

FAX 415 543 9058

Client: Vanderbyl Design
Design Firm: Vanderbyl Design
Designer: Michael Vanderbyl
Paper/Printing: Two colors on Starwhite Vicksburg

Client: James Strange
Design Firm: Culver & Associates
Art Director: James Strange
Designer: James Strange
Illustrator: James Strange
Paper/Printing: One color on Speckletone Chalk White

Client: Adam, Filippo & Associates
Design Firm: Adam, Filippo & Associates
Art Directors: Robert Adam, Louis Filippo
Designer: Barbara S. Peak
Paper/Printing: Two colors and blind embossing on Strathmore Writing Ultimate White Laid Finish

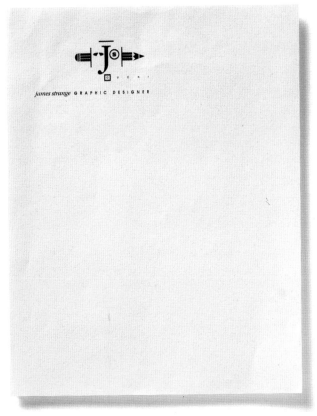

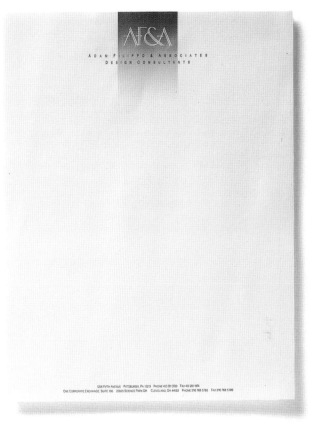

Client: Jones Design & Advertising
Design Firm: Jones Design & Advertising
Art Director: Scott Marsh
Designer: Scott Marsh
Illustrator: Melissa Latham-Stevens
Paper/Printing: Three colors on EverGreen Script

Client: Robert Cook Design
Design Firm: Robert Cook Design
Art Director: Robert Cook
Designer: Robert Cook
Paper/Printing: Four colors on Strathmore Writing

CLARK
KELLER
I N C

Advertising

CLARK
KELLER
I N C

Advertising

Marketing

Marketing

Design

1160 Spa Road, Annapolis, MD. 21403

CLARK
KELLER
I N C

Jane Keller
Creative Director

1160 Spa Road,
Annapolis, MD. 21403
Baltimore/Annapolis 269.1856
Washington, DC 261.2894
Baltimore Fax 301.269.7921
DC Fax 301.261.2918

Design

1160 Spa Road, Annapolis, MD. 21403

Baltimore/Annapolis 301.269.1856 Washington, DC 301.261.2894

Baltimore Fax 301.269.7921 DC Fax 301.261.2918

Client: Clark Keller, Inc.
Design Firm: Clark Keller, Inc.
Art Director: Jane Keller
Designer: Neal M. Ashby
Paper/Printing: Six colors on Eloquence Strathmore Bond

Client: Design Office of Emery/Poe
Design Firm: Emery/Poe Design
Art Director: David Poe
Designer: David Poe
Paper/Printing: Three colors on Zanders

Client:	Perich + Partners
Design Firm:	Perich + Partners
Art Director:	Ernie Perich
Designers:	Carol Mooradian, Scott Pryor
Paper/Printing:	Four colors on Neenah Environment

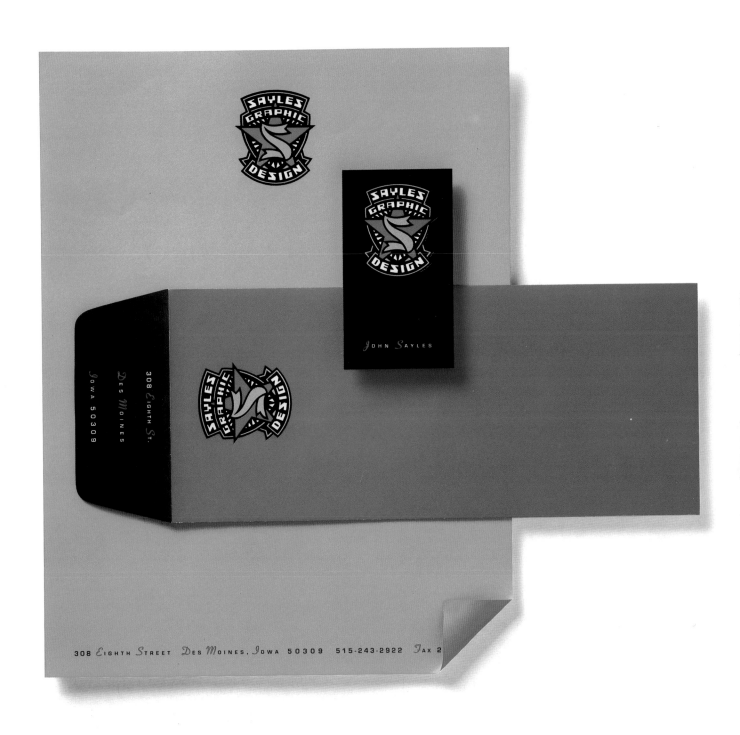

308 EIGHTH STREET DES MOINES, IOWA 50309 515-243-2922 FAX 2

JOHN SAYLES

308 EIGHTH ST.
DES MOINES
IOWA 50309

Client: Sayles Graphic Design
Design Firm: Sayles Graphic Design
Art Director: John Sayles
Designer: John Sayles
Paper/Printing: Three colors and foil on Neenah Classic Crest

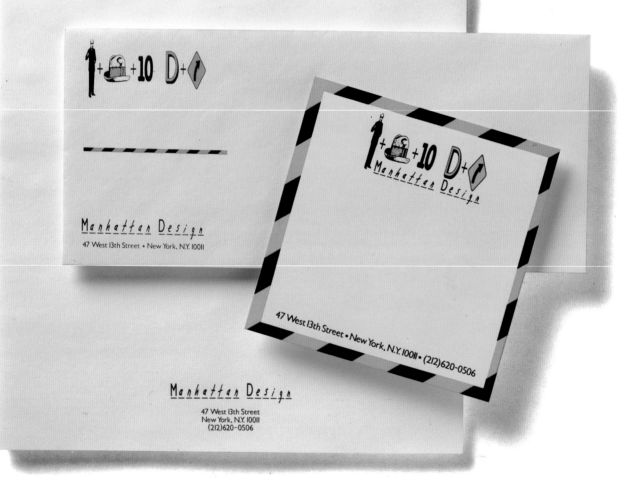

Client: Manhattan Design
Design Firm: Manhattan Design
Designer: Frank Olinsky
Illustrator: Frank Olinsky
Paper/Printing: Two colors

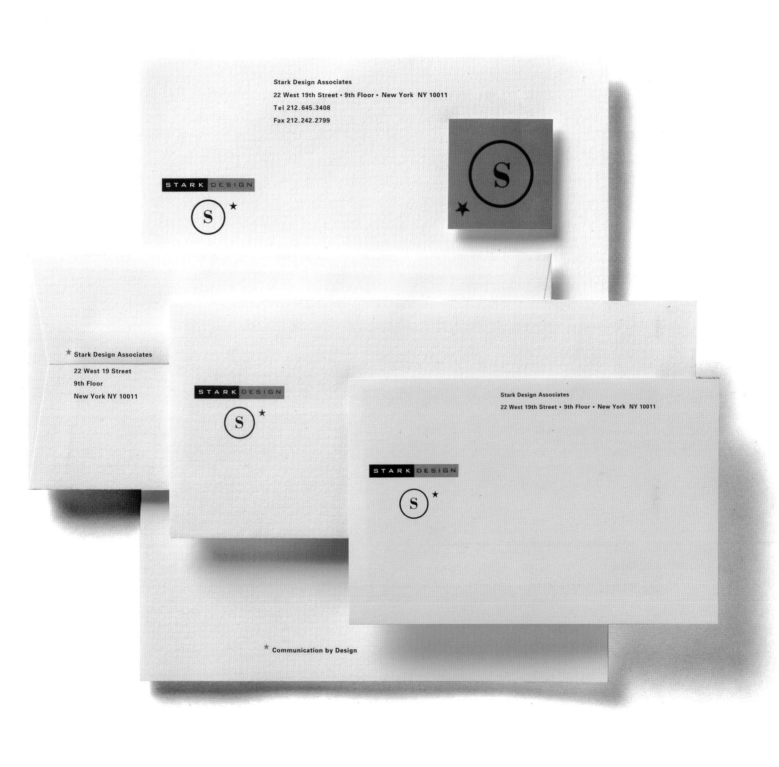

Client: Stark Design Associates
Design Firm: Stark Design Associates
Art Director: Adriane Stark
Designer: Adriane Stark
Paper/Printing: Two colors on Gilbert Esse

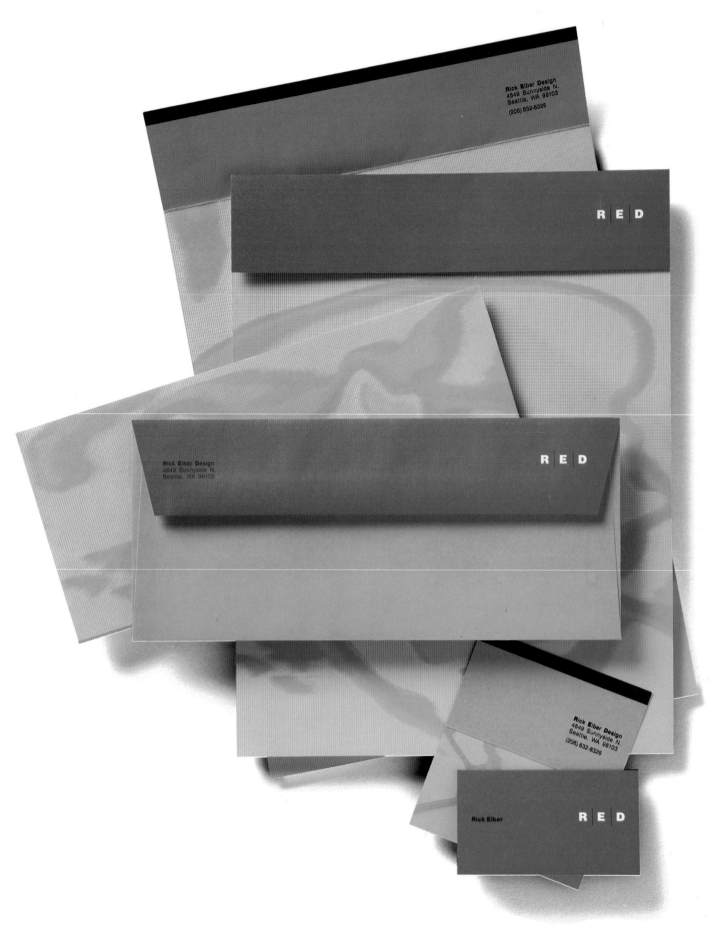

Client: Rick Eiber Design (RED)
Design Firm: Rick Eiber Design
Art Director: Rick Eiber
Designer: Rick Eiber
Paper/Printing: Four colors on Starwhite Vicksburg Vellum

Client: Qually & Company Inc.
Design Firm: Qually & Company Inc.
Art Director: Robert Qually
Designer: Robert Qually
Illustrator: Alex Murawski
Paper/Printing: Four colors on Mead

Client: De Martino Design Inc.
Design Firm: De Martino Design Inc.
Art Director: Erick De Martino
Designer: Carol Maisto
Illustrator: Carol Maisto
Paper/Printing: Two colors on Strathmore Writing Bright White

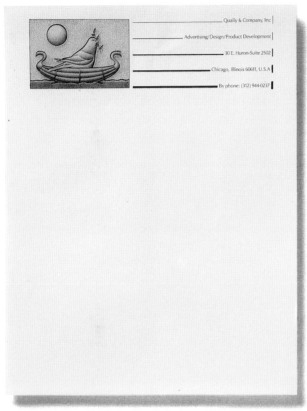

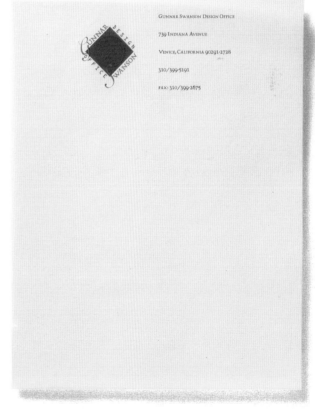

Client: Hafeman Design Group
Design Firm: Hafeman Design Group
Art Director: William Hafeman
Designers: William Hafeman, Gabrielle Schubart
Paper/Printing: Two colors on Gilbert Neu-Tech

Client: Gunnar Swanson Design Office
Design Firm: Gunnar Swanson Design Office
Art Director: Gunnar Swanson
Designer: Gunnar Swanson
Paper/Printing: Letterhead - Three colors on Curtis Parchkin Riblaid,
Envelopes - Simpson Evergreen,
Business Card - Regal PCW

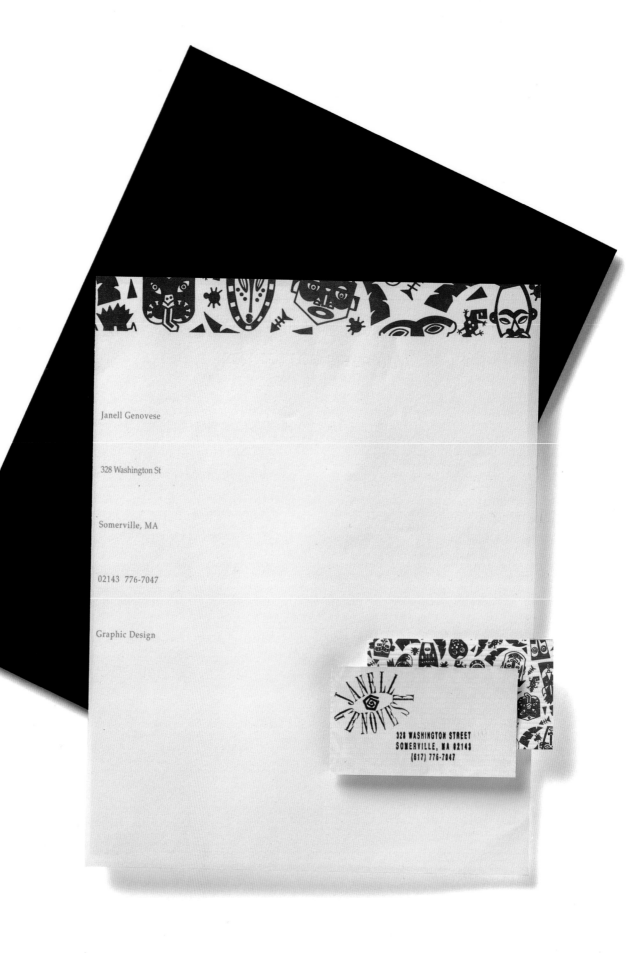

Janell Genovese

328 Washington St

Somerville, MA

02143 776-7047

Graphic Design

Client: Janell Genovese
Design Firm: Janell Genovese Design
Art Director: Janell Genovese
Designer: Janell Genovese
Paper/Printing: Two colors and varnish on Strathmore White Wove Groove

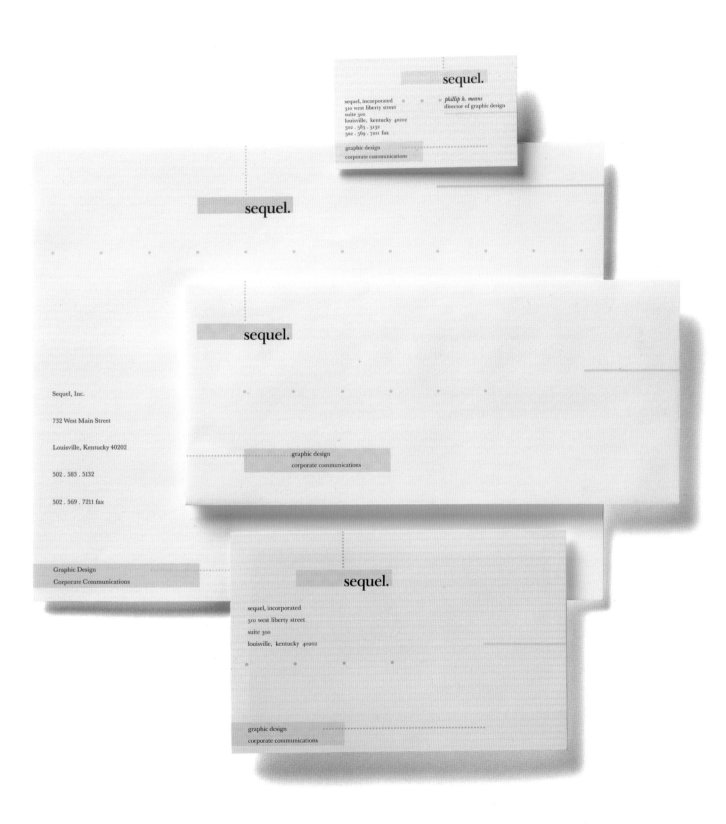

Client: Sequel, Inc.
Design Firm: Sequel, Inc.
Art Directors: Denise Olding, Phil Means
Designer: Denise Olding
Paper/Printing: Two colors on Curtis Brightwater Writing Riblaid

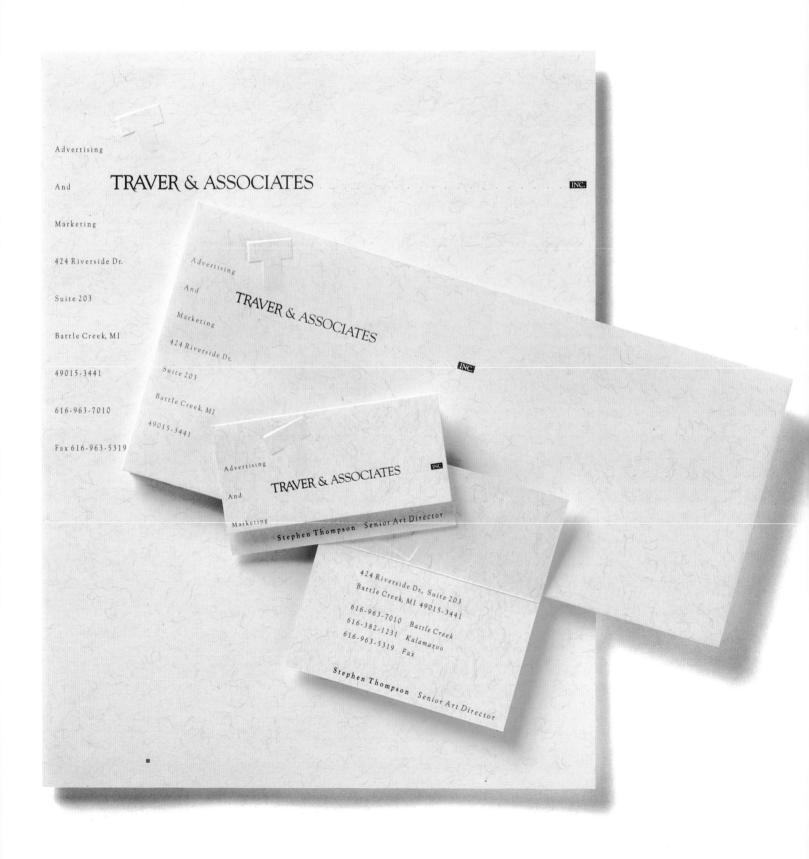

Client: Traver & Associates
Design Firm: Traver & Associates
Art Director: Stephen Thompson
Designer: Stephen Thompson
Paper/Printing: Two colors on French Rayon

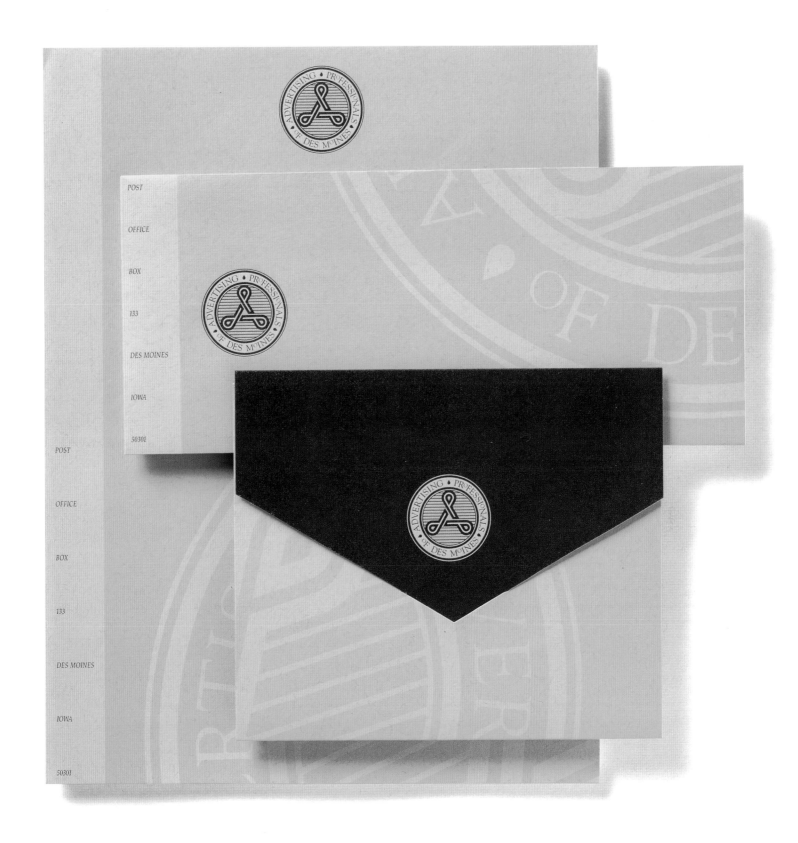

Client: Advertising Professionals of Des Moines
Design Firm: Sayles Graphic Design
Art Director: John Sayles
Designer: John Sayles
Paper/Printing: Two colors on James River Tuscan Terra

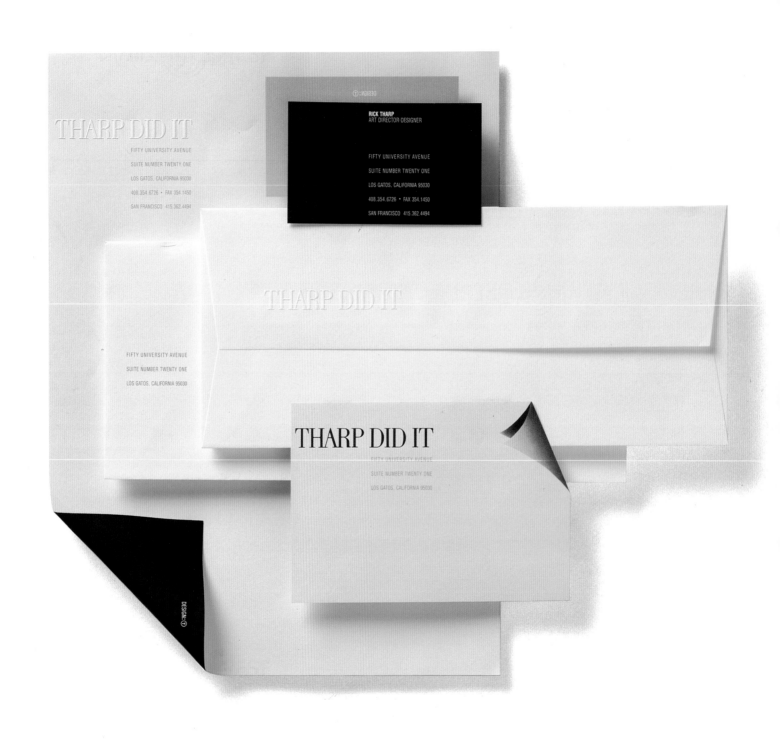

THARP DID IT

FIFTY UNIVERSITY AVENUE

SUITE NUMBER TWENTY ONE

LOS GATOS, CALIFORNIA 95030

408.354.6726 • FAX 354.1450

SAN FRANCISCO 415.362.4494

RICK THARP
ART DIRECTOR·DESIGNER

FIFTY UNIVERSITY AVENUE

SUITE NUMBER TWENTY ONE

LOS GATOS, CALIFORNIA 95030

408.354.6726 • FAX 354.1450

SAN FRANCISCO 415.362.4494

THARP DID IT

FIFTY UNIVERSITY AVENUE

SUITE NUMBER TWENTY ONE

LOS GATOS, CALIFORNIA 95030

THARP DID IT

FIFTY UNIVERSITY AVENUE

SUITE NUMBER TWENTY ONE

LOS GATOS, CALIFORNIA 95030

Client: Tharp Did It
Design Firm: Tharp Did It • Los Gatos/San Francisco
Art Director: Rick Tharp
Designers: Rick Tharp, Karen Nomura, Jana Heer, Jean Mogannam
Paper/Printing: Two colors, foil, and embossing on Crane's Crest and Simpson Starwhite Vicksburg

Client: Clarion Marketing and
Communications
Design Firm: Clarion Marketing and
Communications
Art Director: Kurt Gibson
Designer: Kurt Gibson
Illustrator: Linda Bleck

Client: Insite Design Inc.
Design Firm: De Martino Design Inc.
Art Director: Erick De Martino
Designer: Erick De Martino
Illustrator: Erick De Martino

Client: Unlimited Swan, Inc.
Design Firm: Unlimited Swan, Inc.
Art Director: Jim Swan
Designer: Jim Swan
Illustrator: Jim Swan

Client: Kuo Design Group
Design Firm: Kuo Design Group
Art Director: Samuel Kuo
Designer: Samuel Kuo

6. PHOTOGRAPHY

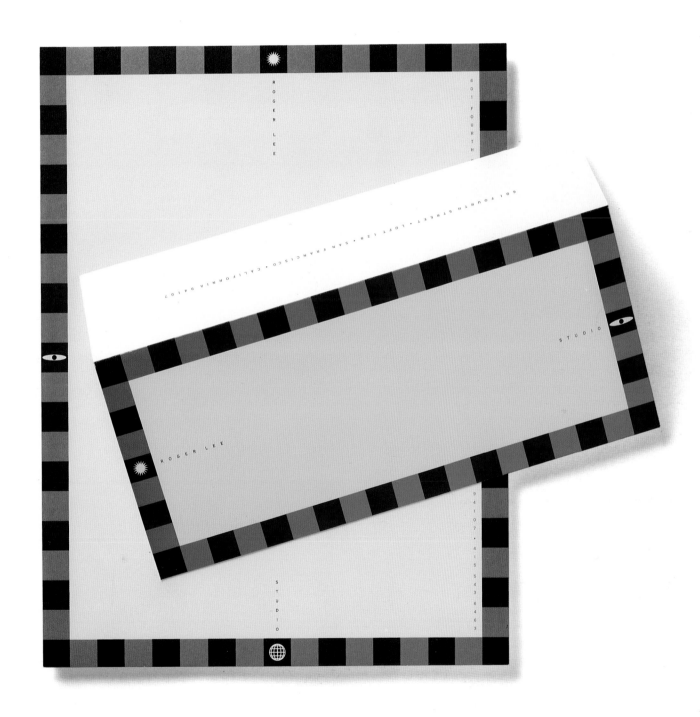

Client: Roger Lee Studio
Design Firm: Vanderbyl Design
Designer: Michael Vanderbyl
Paper/Printing: Two colors on Starwhite Vicksburg

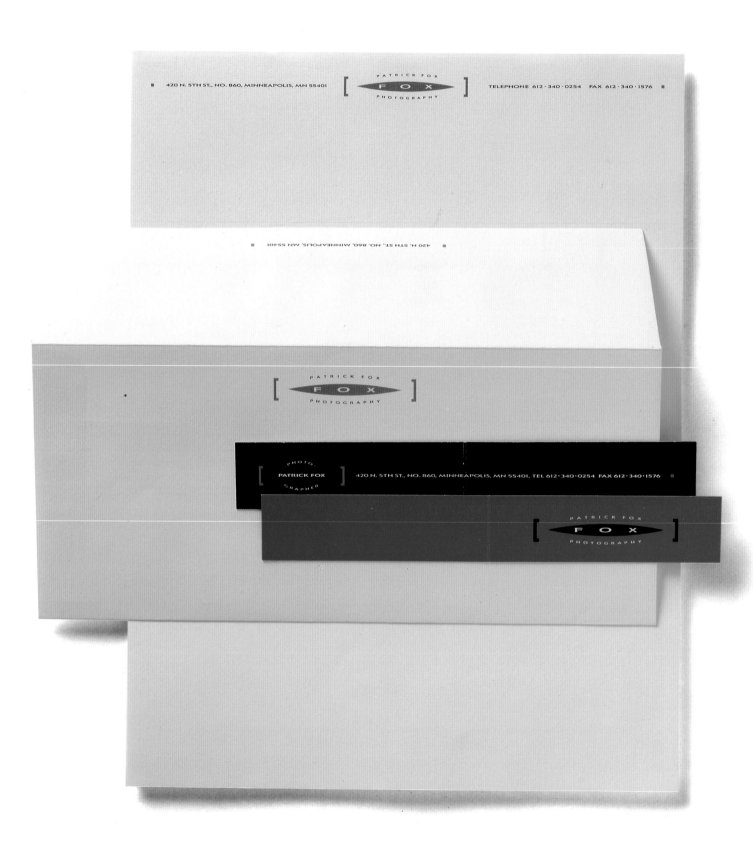

Client: Patrick Fox Photography
Design Firm: William Homan Design
Art Director: William Homan
Designer: William Homan
Paper/Printing: Two colors

Client: Franklin Avery
Design Firm: Tharp Did It • Los Gatos/San Francisco
Art Director: Rick Tharp
Designers: Kim Tomlinson, Rick Tharp
Paper/Printing: Two colors on Simpson Starwhite Vicksburg

UNDERWATER
PHOTOGRAPHY

UNDERWATER
PHOTOGRAPHY

JOSEPH DIETER
VISUAL COMMUNICATIONS
3021 LINWOOD AVENUE
BALTIMORE, MARYLAND 21234 USA
301-661-3021

UNDERWATER
PHOTOGRAPHY

JOSEPH DIETER
VISUAL COMMUNICATIONS
3021 LINWOOD AVENUE
BALTIMORE, MARYLAND 21234 USA

JOSEPH DIETER
VISUAL COMMUNICATIONS
3021 LINWOOD AVENUE
BALTIMORE, MARYLAND 21234 USA
301-661-3021

Client: Joseph Dieter Visual Communications
Design Firm: Joseph Dieter Visual Communications
Art Director: Joseph M. Dieter, Jr.
Designer: Joseph M. Dieter, Jr.
Paper/Printing: Two colors on Strathmore Writing

Client: Chris Callis
Design Firm: M & Co.
Designers: Emily Oberman, Tibor Kalman

Client: James Frederick Housel
Design Firm: Hornall Anderson Design Works
Art Director: Jack Anderson
Designers: Jack Anderson, Raymond Terada
Paper/Printing: Eight colors on Strathmore Writing

Client: Adams Photography
Art Director: Laurel Bigley
Designer: Laurel Bigley
Illustrator: Laurel Bigley
Paper/Printing: Letterhead - Three colors on Evergreen Kraft,
Envelopes - Wausau Vellum Opaque

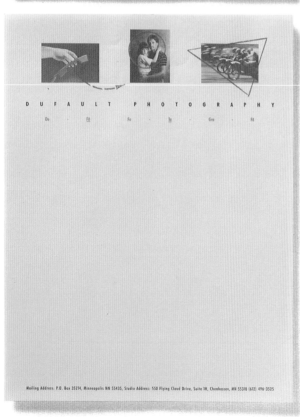

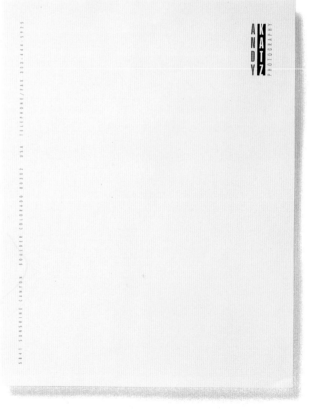

Client: Kent DuFault
Design Firm: Steve Lundgren Graphic Design
Art Director: Steve Lundgren
Designer: Steve Lundgren
Illustrator: Steve Lundgren
Paper/Printing: Two colors on Neenah Classic Crest

Client: Andy Katz Photography
Design Firm: Communication Arts Inc.
Art Director: Richard Foy
Designer: Hugh Enockson

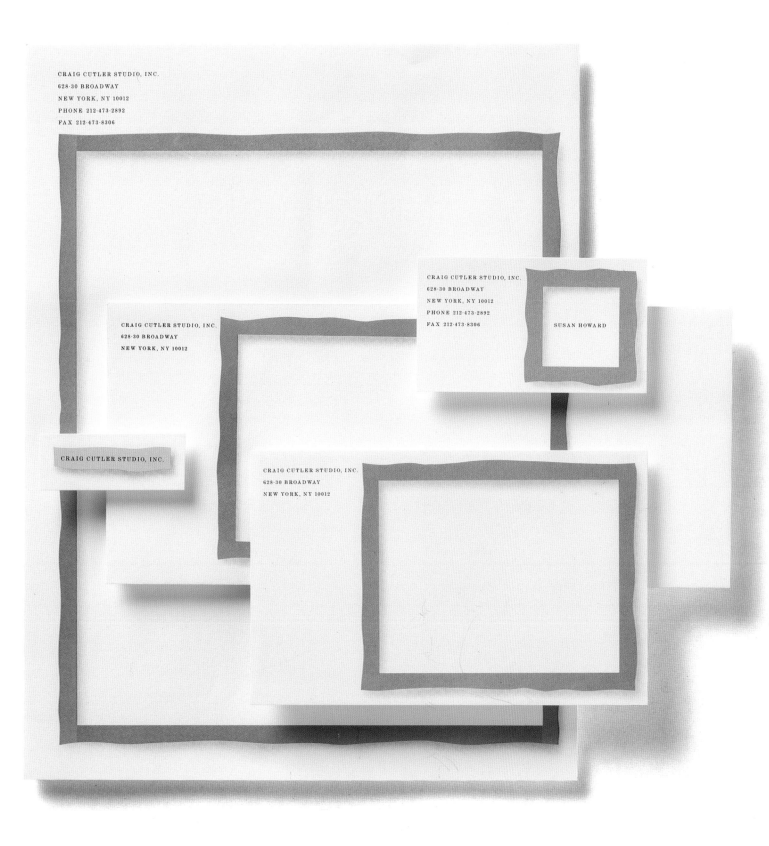

CRAIG CUTLER STUDIO, INC.
628-30 BROADWAY
NEW YORK, NY 10012
PHONE 212-473-2892
FAX 212-473-8306

CRAIG CUTLER STUDIO, INC.
628-30 BROADWAY
NEW YORK, NY 10012

CRAIG CUTLER STUDIO, INC.
628-30 BROADWAY
NEW YORK, NY 10012
PHONE 212-473-2892
FAX 212-473-8306

SUSAN HOWARD

CRAIG CUTLER STUDIO, INC.

CRAIG CUTLER STUDIO, INC.
628-30 BROADWAY
NEW YORK, NY 10012

Client: Craig Cutler Studio, Inc.
Design Firm: The Pushpin Group
Designer: Greg Simpson

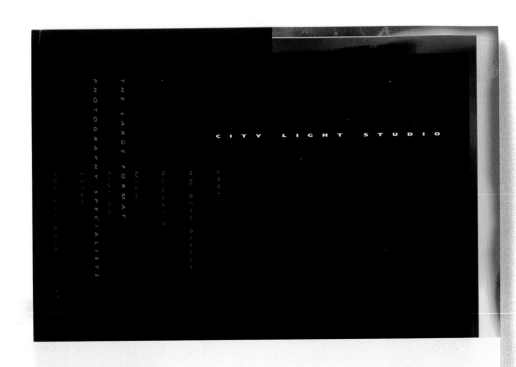

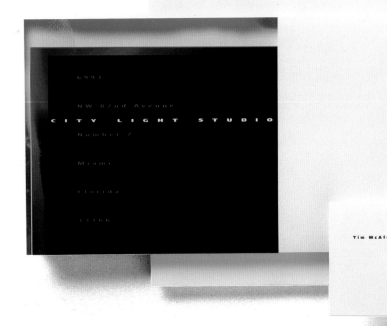

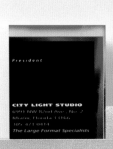

Client: City Light Studio
Design Firm: Urban Taylor & Associates
Art Director: Alan Urban
Designer: Alan Urban
Illustrator: Alan Urban
Paper/Printing: Four color process on Consolidated Frostbite

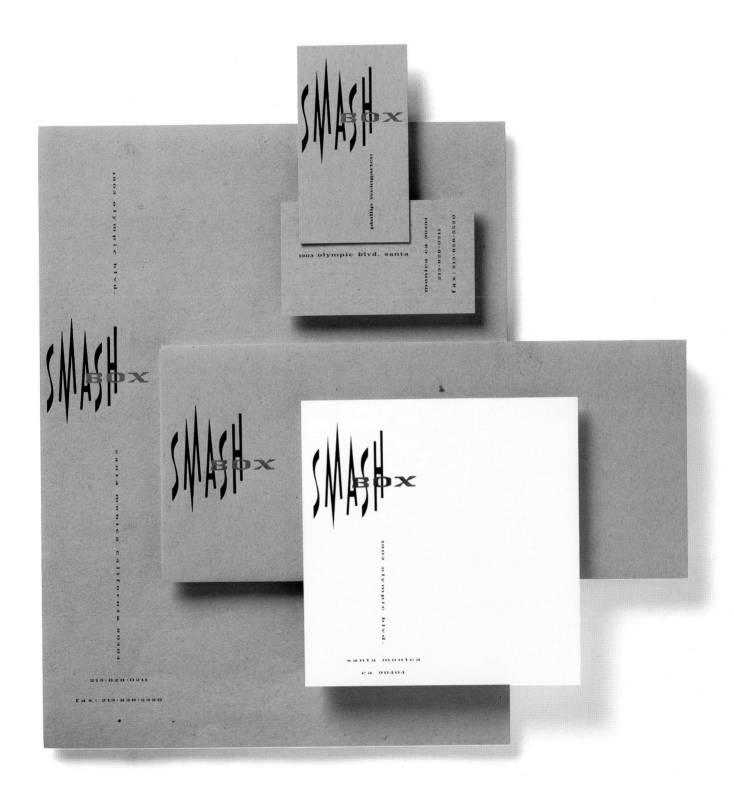

Client: Smashbox
Design Firm: Margo Chase Design
Art Director: Margo Chase
Designer: Margo Chase
Paper/Printing: Two colors and foil on Speckletone Chipboard

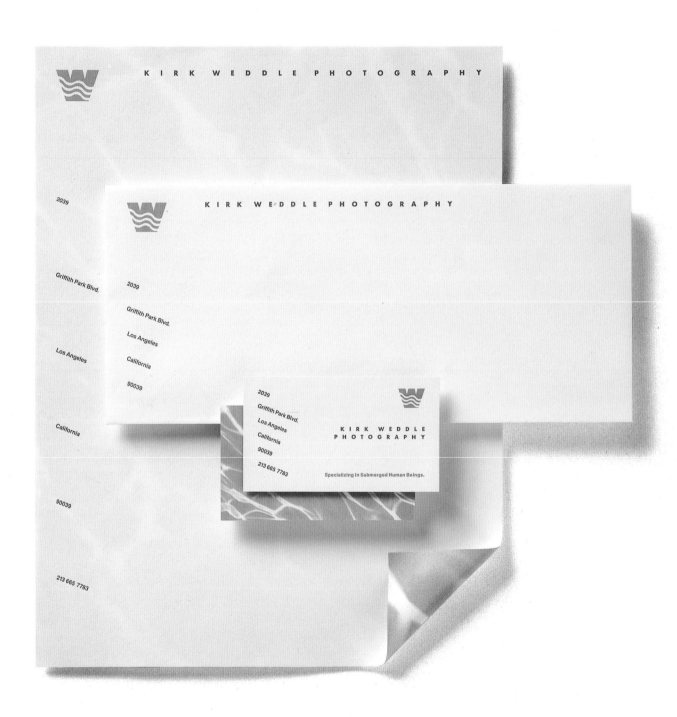

Client: Kirk Weddle Photography
Design Firm: Tracy Mac Design
Art Director: Tracy McGoldrick
Designer: Tracy McGoldrick
Paper/Printing: Two colors on Crane's Crest

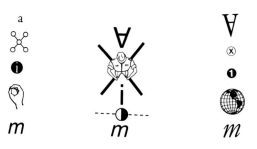

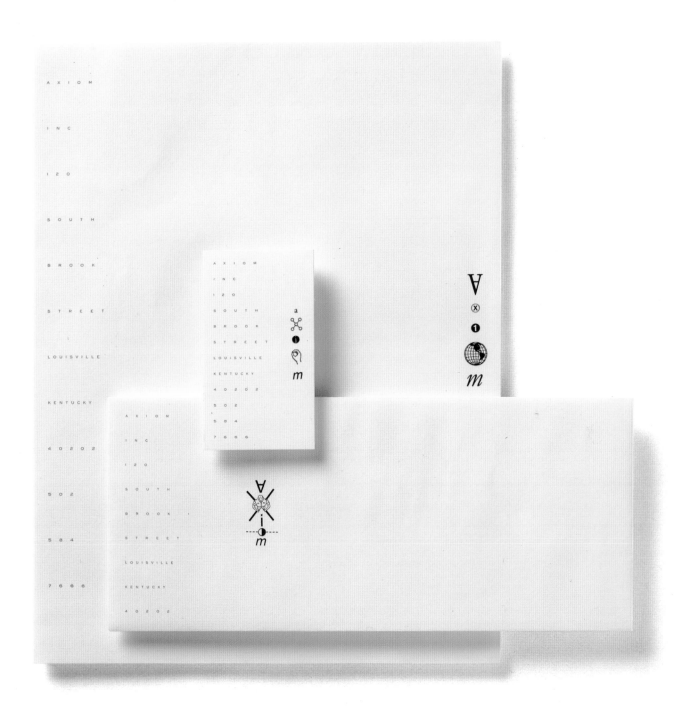

Client: Axiom, Inc.
Design Firm: McCord Graphic Design
Art Director: Walter McCord
Designer: Walter McCord
Illustrator: Walter McCord
Paper/Printing: Two colors on Simpson Protocol

7. ARCHITECTS

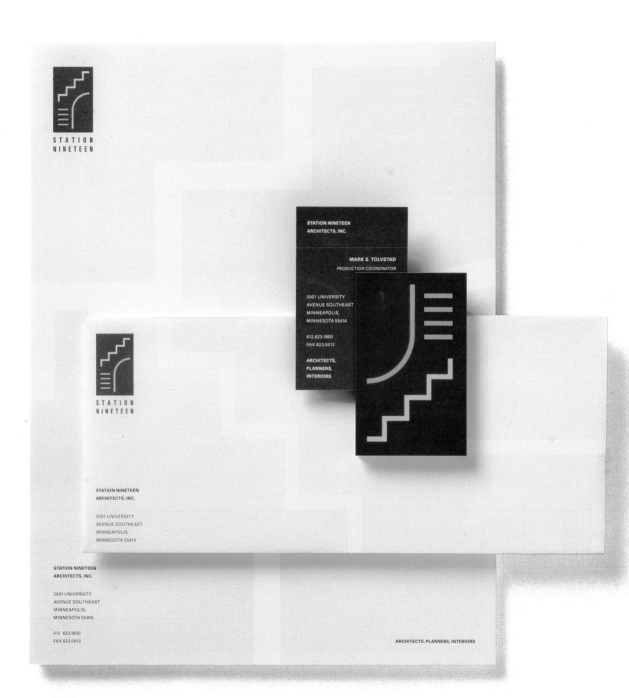

Client: Station 19
Design Firm: Design Center
Art Director: John Reger
Designer: Kobe
Paper/Printing: Four colors

D'AGOSTINO IZZO QUIRK ARCHITECTS
432 COLUMBIA STREET CAMBRIDGE, MA 02141 TELEPHONE 617 547 3935 FAX 617 547 0990

Client: DAIQ Architects
Design Firm: Communication Arts, Inc.
Art Director: Richard Foy
Designer: David A. Shelton
Paper/Printing: Two colors on Strathmore Writing White Laid

ARCHITECTS
ENGINEERS
PLANNERS

LIOLLIO

LIOLLIO ASSOCIATES INC.
400 WAPPOO CENTRE
147 WAPPOO CREEK DRIVE
CHARLESTON, SC 29412
(803) 762-2222

ARCHITECTS
ENGINEERS
PLANNERS

LIOLLIO

LIOLLIO ASSOCIATES INC.
400 WAPPOO CENTRE
147 WAPPOO CREEK DRIVE
CHARLESTON, SC 29412

ARCHITECTS
ENGINEERS
PLANNERS

LIOLLIO

LIOLLIO ASSOCIATES INC.
400 WAPPOO CENTRE
147 WAPPOO CREEK DRIVE
CHARLESTON, SC 29412

ARCHITECTS
ENGINEERS
PLANNERS

LIOLLIO

LIOLLIO ASSOCIATES INC.
400 WAPPOO CENTRE
147 WAPPOO CREEK DRIVE
CHARLESTON, SC 29412
(803) 762-2222

C. DINOS LIOLLIO AIA
PRESIDENT

Client: Liollio Associates
Design Firm: Rousso+Associates, Inc.
Art Director: Steve Rousso
Designer: Steve Rousso
Paper/Printing: Two colors on Strathmore Writing

Client: CYP, Inc.
Design Firm: Davies Associates
Art Director: Noel Davies
Designers: Meredith Kamm, Cathy Tetef
Paper/Printing: Two colors and clear foil on Gilbert Neu-Tech Kromekote

Client: Lineage Homes
Design Firm: Puccinelli Design
Art Director: Keith Puccinelli
Designer: Keith Puccinelli
Illustrator: Keith Puccinelli
Paper/Printing: Four colors on Strathmore Writing

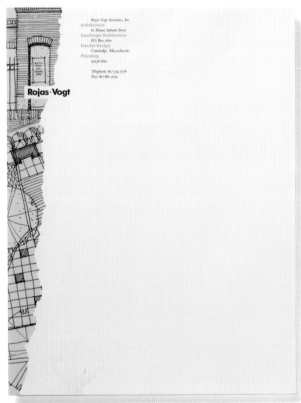

Client: Rojas•Vogt Associates Inc.
Design Firm: Kevin P. Sheehan Design
Art Director: Kevin Sheehan
Designer: Kevin Sheehan
Paper/Printing: Two colors on Curtis Brightwater

Client: Snyder Wick Associates
Design Firm: Michael Stanard Inc.
Art Director: Michael Stanard
Designers: Michael Stanard, Marcos Chavez
Paper/Printing: Two colors on Strathmore Writing

INTĚGRUS
ARCHITECTURE

WEST 244 MAIN AVENUE
SPOKANE, WA 99201
P.O. BOX 1482 (99210)

FAX 509.838.2194
509.838.8681

INTĚGRUS
ARCHITECTURE

915 SEATTLE TOWER
1218 THIRD AVENUE
SEATTLE, WA 98101-3018

The WMFL & ECI traditions continue.

INTĚGRUS
ARCHITECTURE

The WMFL & ECI traditions continue.

Larry D. Hurlbert
William A. James
Gary D. Joralemon
Bruce F. Mauser
George H. Nachtsheim
Arthur A. Nordling
John Plimley
Gordon E. Ruehl
Thomas M. Shine
Bruce M. Walker
Gerald A. Winkler
Kirklund S. Wise

INTĚGRUS
ARCHITECTURE

JOHN PLIMLEY, P.E.
STRUCTURAL ENGINEER, PRINCIPAL

WEST 244 MAIN AVENUE
SPOKANE, WA 99201
P.O. BOX 1482 (99210)

FAX 509.838.2194
509.838.8681

The WMFL & ECI traditions continue.

The WMFL & ECI traditions continue.

Client: Integrus
Design Firm: Hornall Anderson Design Works
Art Director: John Hornall
Designers: John Hornall, Paula Cox, Brian O'Neill
Paper/Printing: Two colors on Neenah Environment

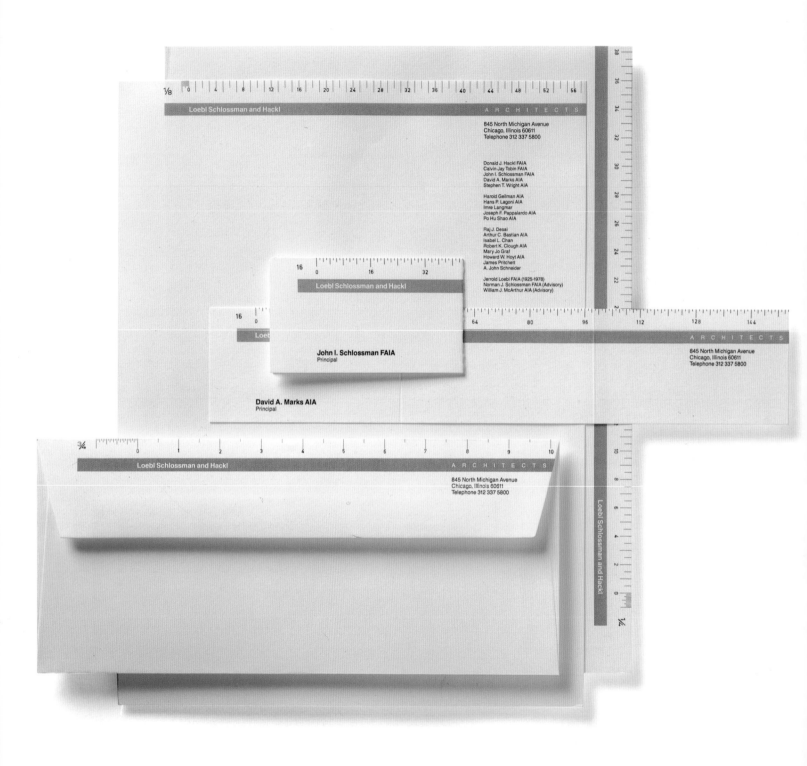

Client: Loebl Schlossman & Hackl
Design Firm: Rick Eiber Design (RED)
Art Director: Rick Eiber
Designer: Rick Eiber
Paper/Printing: Two colors on Classic Crest

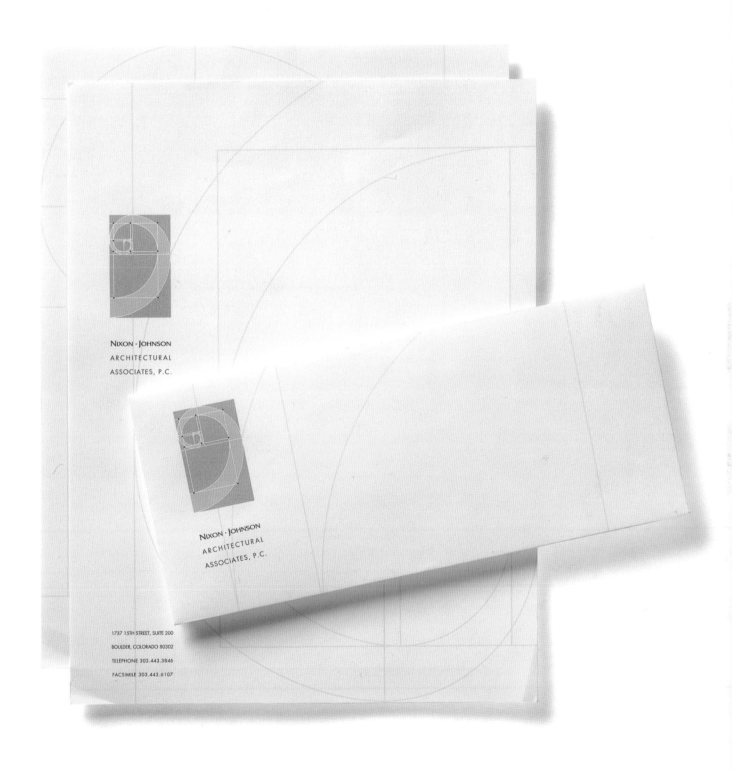

Client: Nixon Johnson Architectural Associates
Design Firm: Pollman Marketing Arts, Inc.
Art Director: Jennifer Pollman
Designer: Jennifer Pollman
Paper/Printing: Two colors on Tiara High-tech 80# text Vicksburg

SILBERSTANG ARCHITECTS PC

19 West 21st Street

New York NY 10010

212 242 3234

SILBERSTANG ARCHITECTS PC

19 West 21st Street

New York NY 10010

SILBERSTANG ARCHITECTS PC

19 West 21st Street

New York NY 10010

212 242 3234

Alan Barry Silberstang AIA NCARB

Client: Silberstang Architects
Design Firm: Barry David Berger + Associates, Inc.
Art Director: Barry Berger
Designer: Heidi Broecking
Paper/Printing: One color

ARCHITECTS

COLLINS·HANSEN

ARCHITECTS

COLLINS·HANSEN

Michael P. Collins

Suite 305

126 Third Street North

Minneapolis, MN 55401

612·338·8181

Suite 305, 126 Third Street North, Minneapolis, MN 55401

ARCHITECTS

COLLINS · HANSEN

Suite 305, 126 Third Street North

Minneapolis, MN 55401

COLLINS·HANSEN

ARCHITECTS

Suite 305, 126 Third Street North, Minneapolis, MN 55401 612·338·8181

Client: Collins-Hansen Architects
Design Firm: Steve Lundgren Graphic Design
Art Director: Steve Lundgren
Designer: Steve Lundgren
Illustrator: Steve Lundgren
Paper/Printing: Two colors on Simpson Protocol 100

8. MASS MEDIA

C U M B E R L A N D G A P

P R O D U C T I O N S

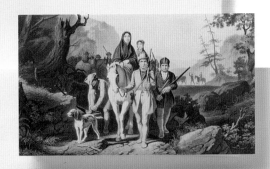

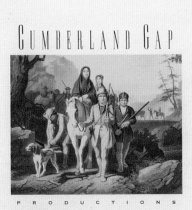

C U M B E R L A N D G A P

P R O D U C T I O N S

C U M B E R L A N D G A P
P R O D U C T I O N S

ELEANOR BINGHAM MILLER

635 WEST MAIN STREET

THIRD FLOOR

LOUISVILLE, KENTUCKY 40202

(502) 587-7348

635 WEST MAIN STREET THIRD FLOOR LOUISVILLE, KENTUCKY 40202 (502) 587-7348

Client: Cumberland Gap
Design Firm: McCord Graphic Design
Art Directors: Walter McCord, Eleanor Miller
Designer: Walter McCord
Illustrator: George Caleb Bingham
Paper/Printing: Four colors on Simpson EverGreen Birch

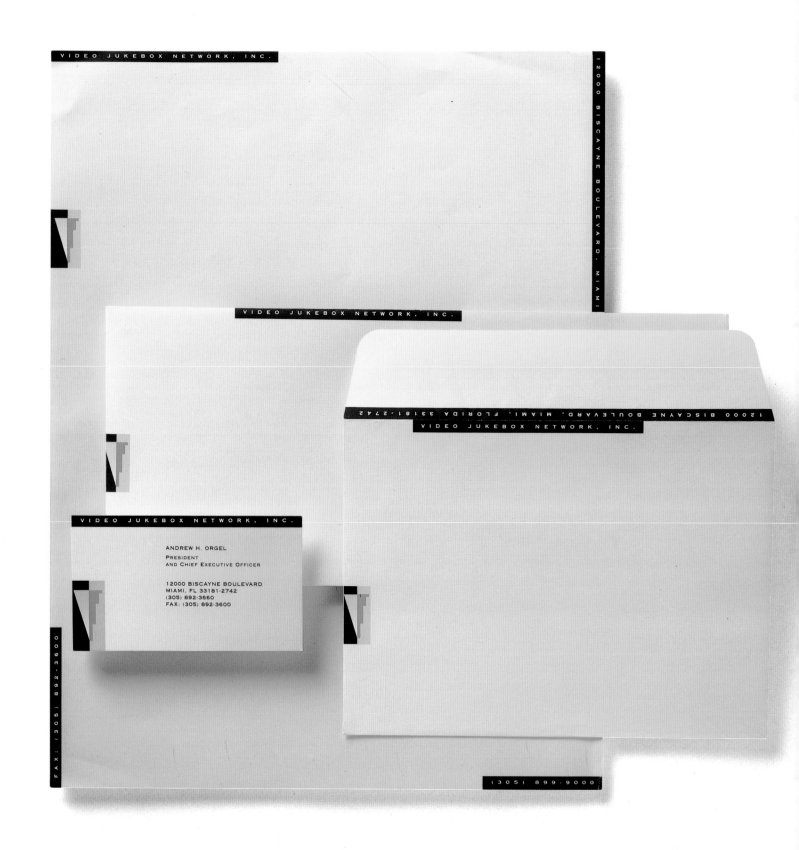

Client: Video Jukebox Network Inc.
Design Firm: Urban Taylor & Associates
Art Director: Alan Urban
Designer: Alan Urban
Paper/Printing: Three colors on Simpson Starwhite Vicksburg

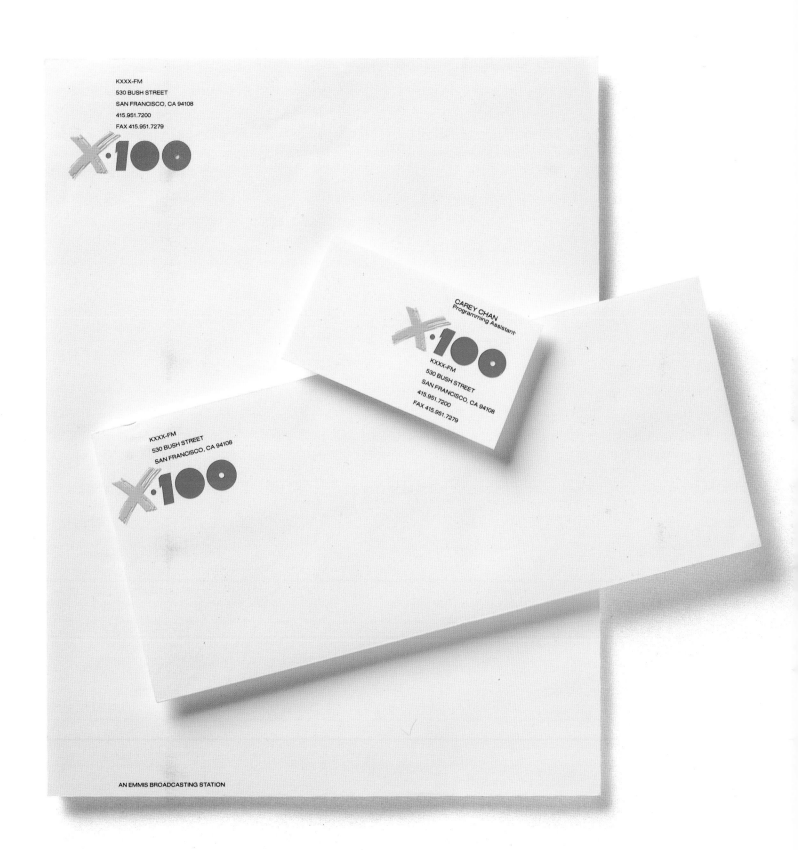

KXXX-FM
530 BUSH STREET
SAN FRANCISCO, CA 94108
415.951.7200
FAX 415.951.7279

X·100

CAREY CHAN
Programming Assistant

X·100
KXXX-FM
530 BUSH STREET
SAN FRANCISCO, CA 94108
415.951.7200
FAX 415.951.7279

KXXX-FM
530 BUSH STREET
SAN FRANCISCO, CA 94108

X·100

AN EMMIS BROADCASTING STATION

Client: Emmis Broadcasting Corporation
Design Firm: Tharp Did It • Los Gatos/San Francisco
Art Director: Rick Tharp
Designers: Rick Tharp, Kim Tomlinson
Paper/Printing: Three colors and embossing on Simpson Starwhite Vicksburg

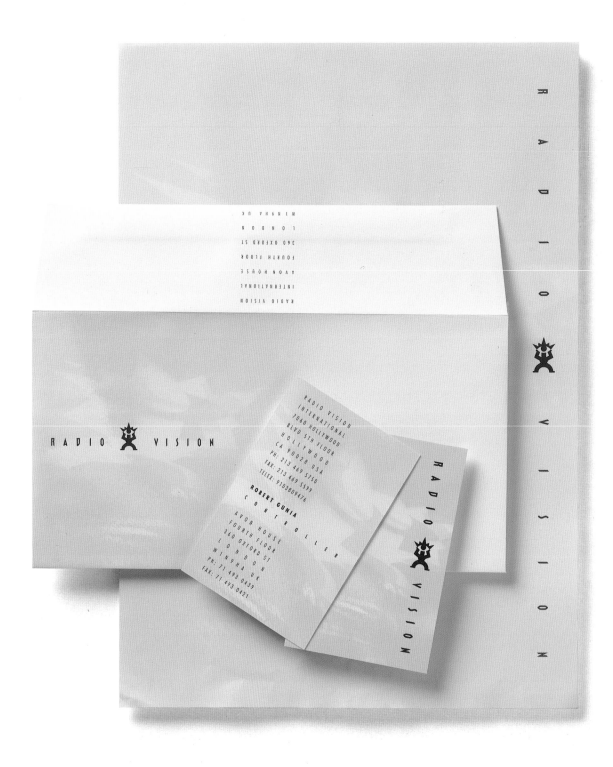

Client: Radio Vision International
Design Firm: Margo Chase Design
Art Director: Margo Chase
Designer: Margo Chase
Paper/Printing: Three colors on Mountie Matte White

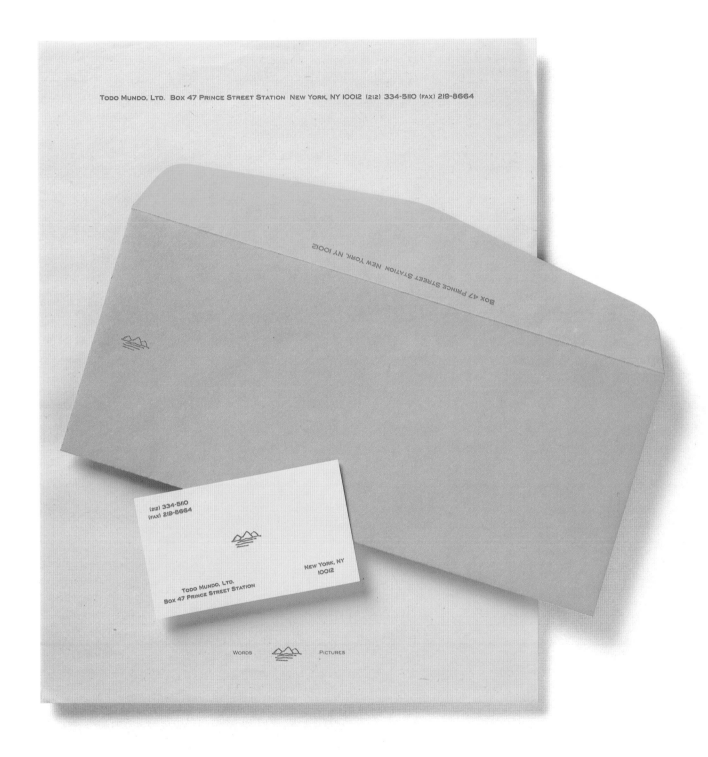

Client: Todo Mundo
Design Firm: M & Co.
Designers: Tibor Kalman, Emily Oberman
Illustrator: Maira Kalman

Client: Inside Productions
Design Firm: Unlimited Swan, Inc.
Art Director: Jim Swan
Designer: Jim Swan
Illustrator: Jim Swan
Paper/Printing: Three colors on Strathmore Writing

Client: New York Television Inc.
Design Firm: Katz Wheeler Design
Art Director: Alina R. Wheeler
Designer: Jody Marx
Paper/Printing: Two colors on Strathmore Writing

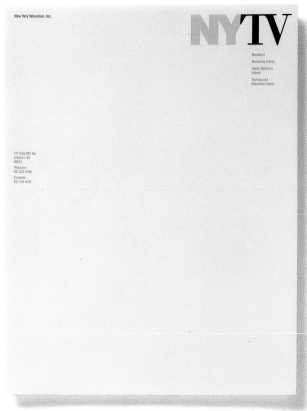

Client: Pulse Of The Planet
Design Firm: Louise Fili Ltd.
Art Director: Louise Fili
Designer: Louise Fili
Illustrator: Anthony Russo
Paper/Printing: Two colors on Strathmore Writing

Client: Newbury Film Works
Design Firm: Marc English: Design
Art Director: Marc English
Designer: Marc English
Paper/Printing: Three colors on French Speckletone

HOUSTON WINN FILMS

Marge Vance

43 West 24th Street
New York City 10010
Phone 212•807•7500
Fax 212•206•7120
a Division of
Balstarr Ent. Ltd.

HOUSTON WINN FILMS

43 West 24th Street
New York City 10010
a Division of
Balstarr Ent. Ltd.

43 West 24th Street
New York City 10010
Phone 212•807•7500
Fax 212•206•7120
a Division of
Balstarr Ent. Ltd.

Client: Houston Winn Films
Design Firm: Unlimited Swan, Inc.
Art Director: Jim Swan
Designer: Jim Swan
Illustrator: Jim Swan
Paper/Printing: Three colors and clear foil stamp

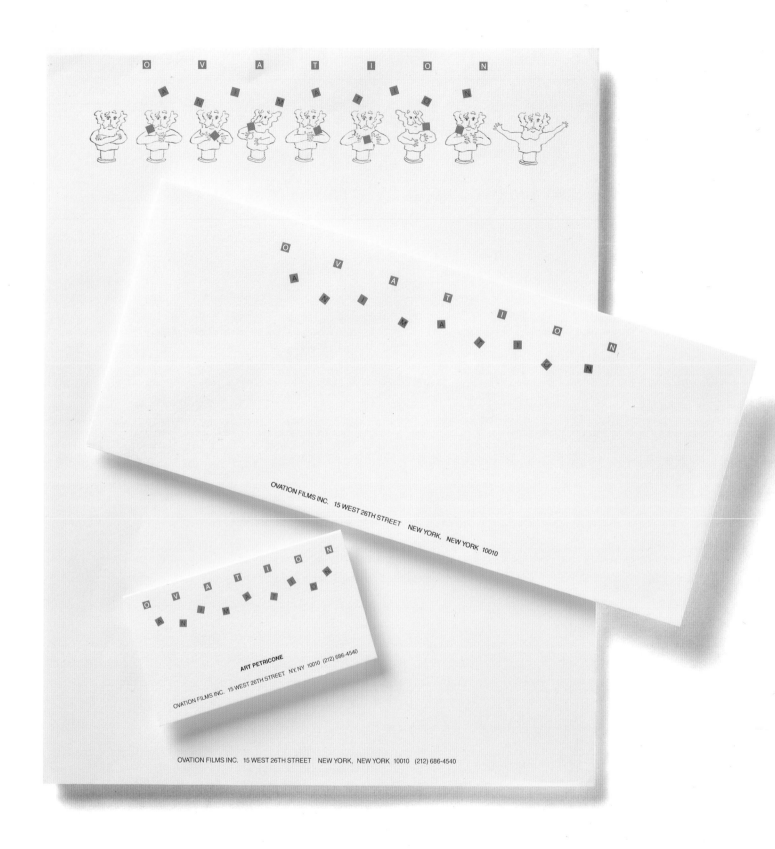

Client: Ovation Animation
Design Firm: Frank D'Astolfo Design
Art Director: Frank D'Astolfo
Designer: Frank D'Astolfo
Paper/Printing: Two colors on Strathmore Writing

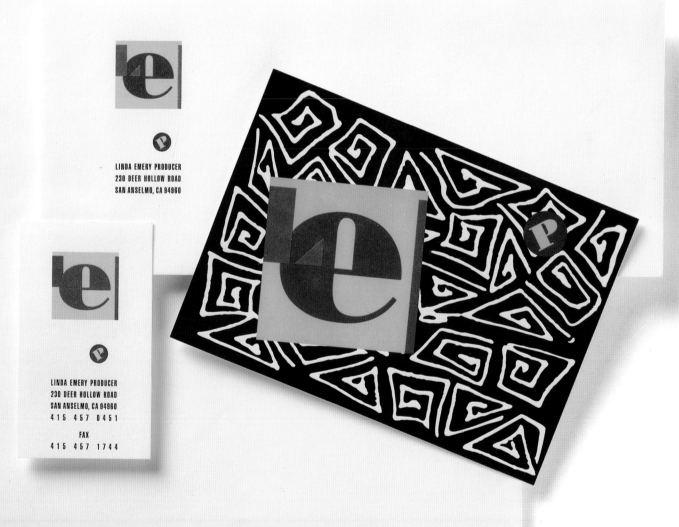

Client: Linda Emery Producer
Design Firm: Emery/Poe Design
Art Director: David Poe
Designer: David Poe
Illustrator: David Poe
Paper/Printing: Four colors on Strathmore Writing

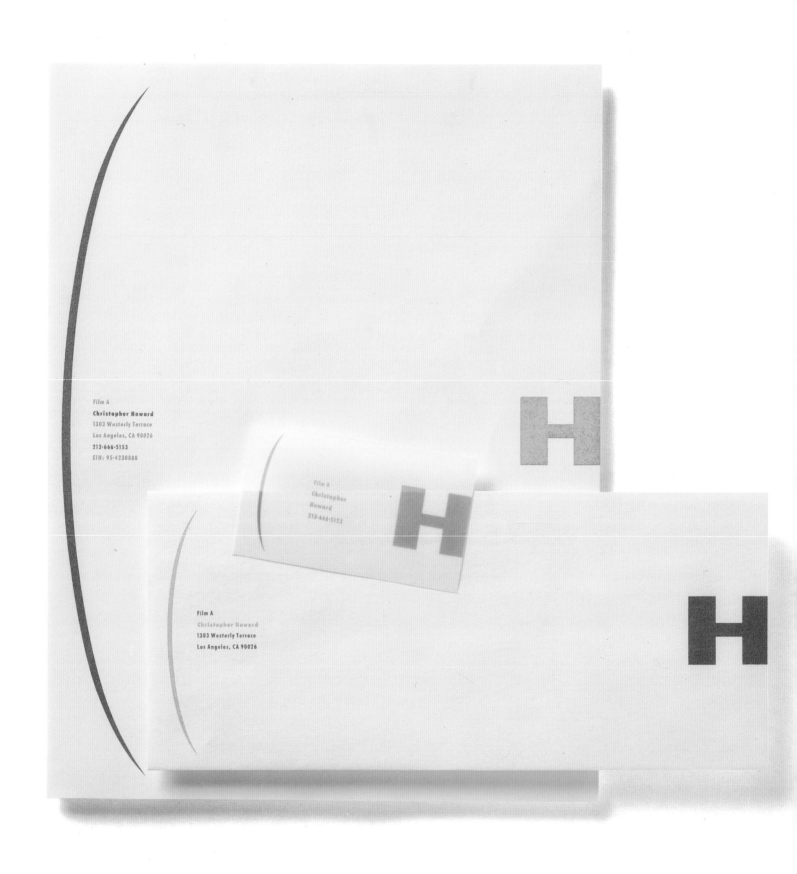

Film A
Christopher Howard
1303 Westerly Terrace
Los Angeles, CA 90026
213·666·5153
EIH: 95·4230888

Film A
Christopher Howard
1303 Westerly Terrace
Los Angeles, CA 90026

Film A
Christopher
Howard
213·666·5153

Client: Christopher Howard
Design Firm: Margo Chase Design
Art Director: Margo Chase
Designer: Margo Chase
Paper/Printing: Three colors on Vellum

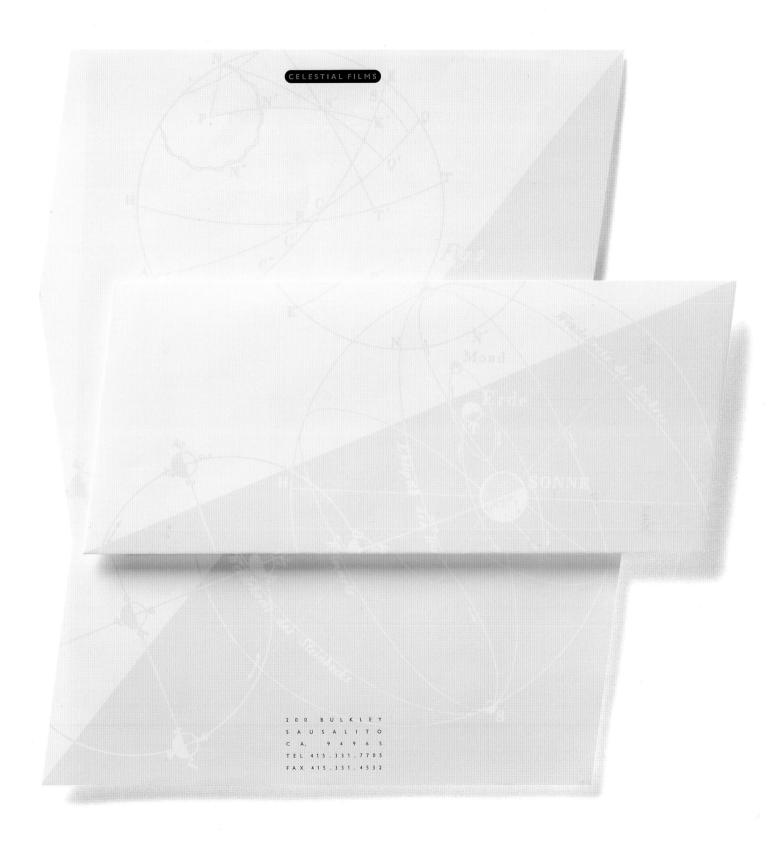

CELESTIAL FILMS

200 BULKLEY
SAUSALITO
CA. 94965
TEL 415.331.7705
FAX 415.331.4532

Client: Celestial Films
Design Firm: Vanderbyl Design
Designer: Michael Vanderbyl
Paper/Printing: Karma

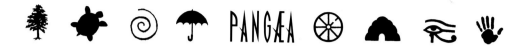

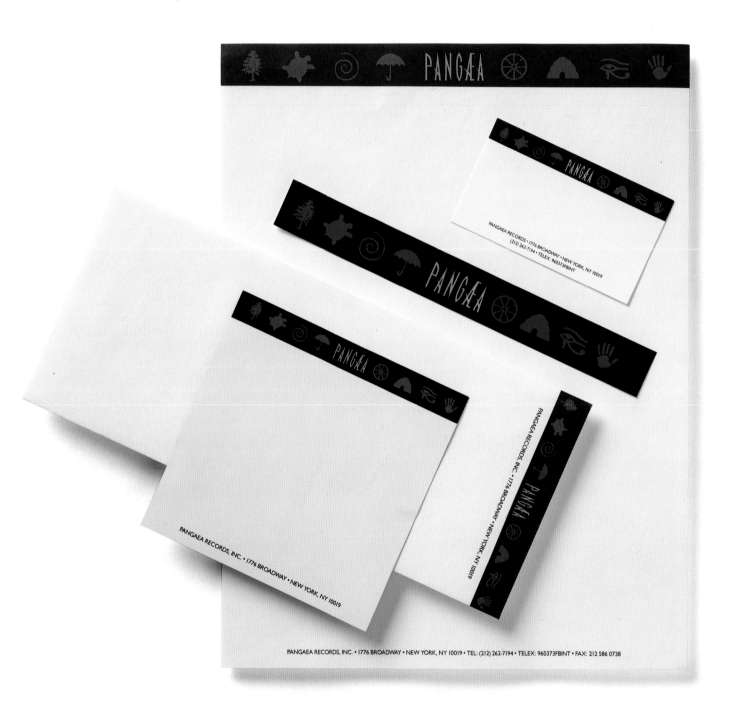

Client: Pangaea Records
Design Firm: Manhattan Design
Designers: Pat Gorman, Frank Olinsky
Paper/Printing: Three colors

HB&B PRODUCTIONS, INC.
219 EAST 49TH STREET
NEW YORK CITY 10017

DAVID BUSKIN

HB&B PRODUCTIONS, INC.
219 EAST 49TH STREET
NEW YORK CITY 10017
PHONE: 212 758 4120
FAX: 212 758 7304

HB&B PRODUCTIONS, INC.
219 EAST 49TH STREET
NEW YORK CITY 10017
PHONE: 212 758 4120
FAX: 212 758 7304

Client: HB&B
Design Firm: Unlimited Swan, Inc.
Art Director: Jim Swan
Designer: Jim Swan
Illustrator: Jim Swan
Paper/Printing: Three colors on Strathmore Writing

Client: Film Fox
Design Firm: Ashby Design
Art Director: Neal M. Ashby
Designer: Neal M. Ashby
Paper/Printing: One color on Kraft Speckletone

Client: Unicorn Studios
Design Firm: LeeAnn Brook Design
Art Director: LeeAnn Brook
Designer: LeeAnn Brook
Paper/Printing: Two colors on Gilcrest Laid

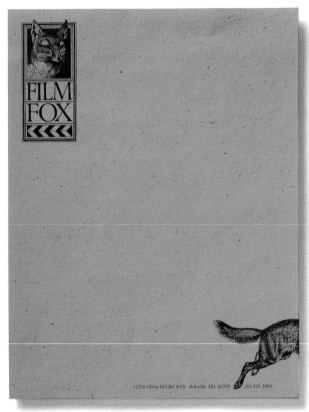

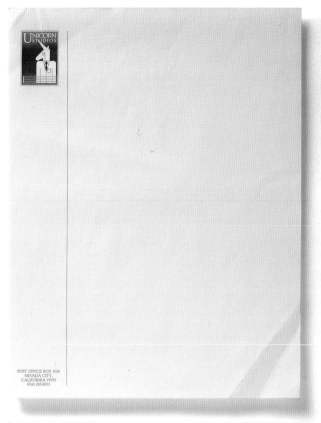

Client: XYZ Productions
Design Firm: Frank D'Astolfo Design
Art Director: Frank D'Astolfo
Designer: Frank D'Astolfo
Paper/Printing: Three colors on Strathmore Writing

Client: Cotts Films
Design Firm: Unlimited Swan, Inc.
Art Director: Jim Swan
Designer: Jim Swan
Illustrator: Jim Swan
Paper/Printing: Two colors on Strathmore Bond

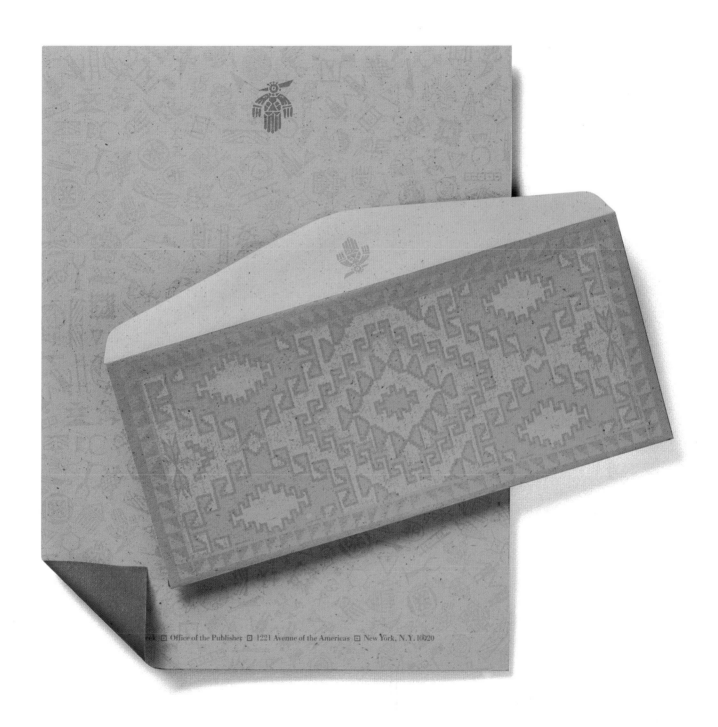

...ek ☐ Office of the Publisher ☐ 1221 Avenue of the Americas ☐ New York, N.Y. 10020

Client: Business Week Magazine
Design Firm: Design Center
Art Director: John Reger
Designers: D.W. Olson, Kobe
Paper/Printing: Two colors

BusinessWeek
Office of the Publisher
1221 Avenue of the Americas
New York, N.Y. 10020

Client: Business Week Magazine
Design Firm: Design Center
Art Director: John Reger
Designer: D.W. Olson

9. CREATIVE SERVICES

Client: Marsha Fogel
Design Firm: Anthony McCall Associates
Art Director: Anthony McCall
Designer: Wing Chan
Paper/Printing: Two colors on Strathmore Ultimate White

Art*fact*

Art*fact*

Artfact, Inc.
1130 Ten Rod Road, Suite E104
North Kingstown, RI
02852

Art*fact*

Stephen J. Abt III
President

401.295.2656

Artfact, Inc.
1130 Ten Rod Road, Suite E104
North Kingstown, RI
02852

Artfact, Inc.
1130 Ten Rod Road, Suite E104
North Kingstown, RI
02852

401.295.2656

Client: Artfact
Design Firm: Thomas Nielsen Design
Art Director: Thomas Nielsen
Designer: Thomas Nielsen
Paper/Printing: Two colors on Poseidon Perfect White

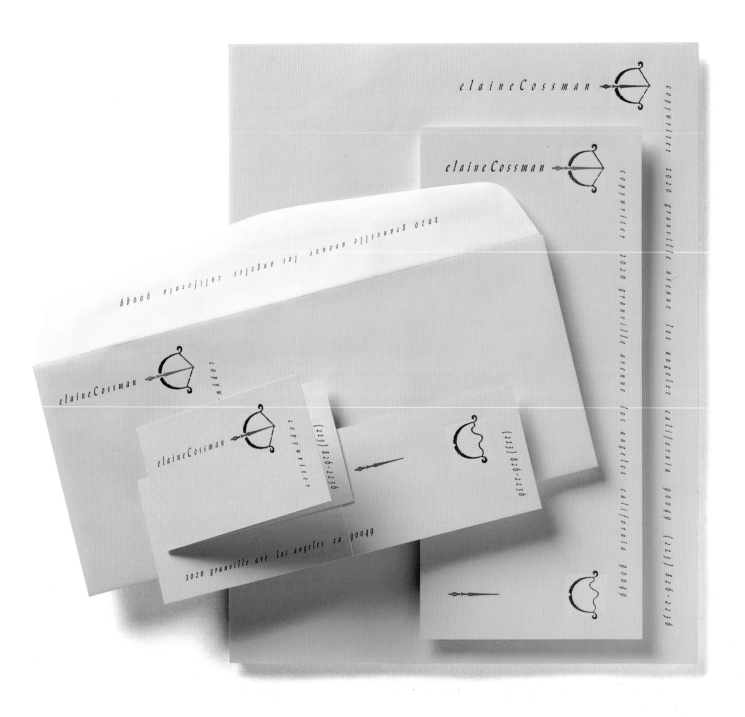

Client: Elaine Cossman
Design Firm: Margo Chase Design
Art Director: Margo Chase
Designer: Margo Chase
Paper/Printing: Three colors on Simpson Protocol

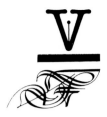

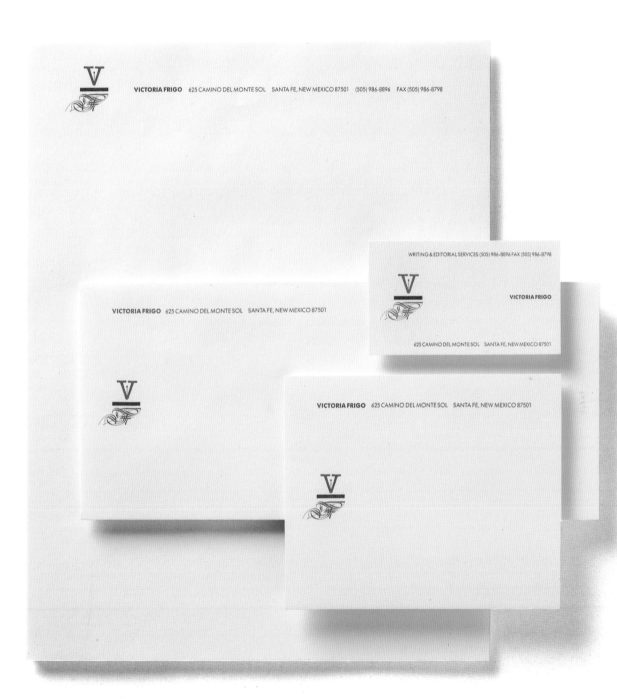

Client: Victoria Frigo
Design Firm: Porter/Matjasich & Associates
Art Director: Allen Porter
Designer: Robert Rausch
Illustrator: Robert Rausch
Paper/Printing: Two colors on Strathmore Writing

Client: El Dorado Ranch
Design Firm: Lawrence Bender & Associates
Art Director: Lawrence Bender
Designer: Margaret Hellmann
Illustrator: Margaret Hellmann
Paper/Printing: Two colors on Neenah Classic Crest Dorian Grey

Client: Arts & Interiors
Design Firm: Douglas + Voss Group
Paper/Printing: Three colors on Curtis Brightwater Writing

Client: The Copy-Cats
Design Firm: J.T. Taverna Associates, Inc.
Designer: Tom Taverna
Paper/Printing: Two colors on Strathmore Writing

Client: Glassworks
Design Firm: Hornall Anderson Design Works
Art Director: Jack Anderson
Designers: Jack Anderson, David Bates
Illustrator/Calligrapher: Tim Girvin
Paper/Printing: Two colors on Starwhite Vicksburg

per∫ephone

ENTERPRISES, LTD.

330 EAST 75TH STREET, SUITE 23C

NEW YORK, NY 10021

TEL: 212.772.2433

FAX: 212.628.5448

330 EAST 75TH STREET, SUITE 23C, NEW YORK, NY 10021
TEL: 212.772.2433, FAX: 212.628.5448

per∫ephone

ENTERPRISES, LTD.

5 WEST 3RD STREET, COUDERSPORT, PA 16915
TEL: 814.274.9830, FAX: 814.274.0655

per∫ephone

ENTERPRISES, LTD.

330 EAST 75TH STREET, SUITE 23C

NEW YORK, NY 10021

5 WEST 3RD STREET

COUDERSPORT, PA 16915

TEL: 814.274.9830

FAX: 814.274.0655

Client: Persephone Enterprises, Ltd.
Design Firm: Reiner Design Consultants, Inc.
Art Director: Roger J. Gorman
Designer: Roger J. Gorman
Paper/Printing: Three colors on Strathmore Writing Bright White Wove

THE LASER WORKS
DESIGN & FABRICATION
WILDWOOD BEACH HANSVILLE WA 98340
2 0 6 6 3 8 2 1 3 1

JIM LASER

THE LASER WORKS
DESIGN & FABRICATION
WILDWOOD BEACH HANSVILLE WA 98340
2 0 6 6 3 8 2 1 3 1

THE LASER WORKS
DESIGN & FABRICATION
WILDWOOD BEACH HANSVILLE WA 98340
2 0 6 6 3 8 2 1 3 1

THE LASER WORKS
DESIGN & FABRICATION
WILDWOOD BEACH HANSVILLE WA 98340
2 0 6 6 3 8 2 1 3 1

Client: The Laserworks
Design Firm: Hornall Anderson Design Works
Art Director: Jack Anderson
Designers: Jack Anderson, Cliff Chung
Paper/Printing: Two colors on Strathmore

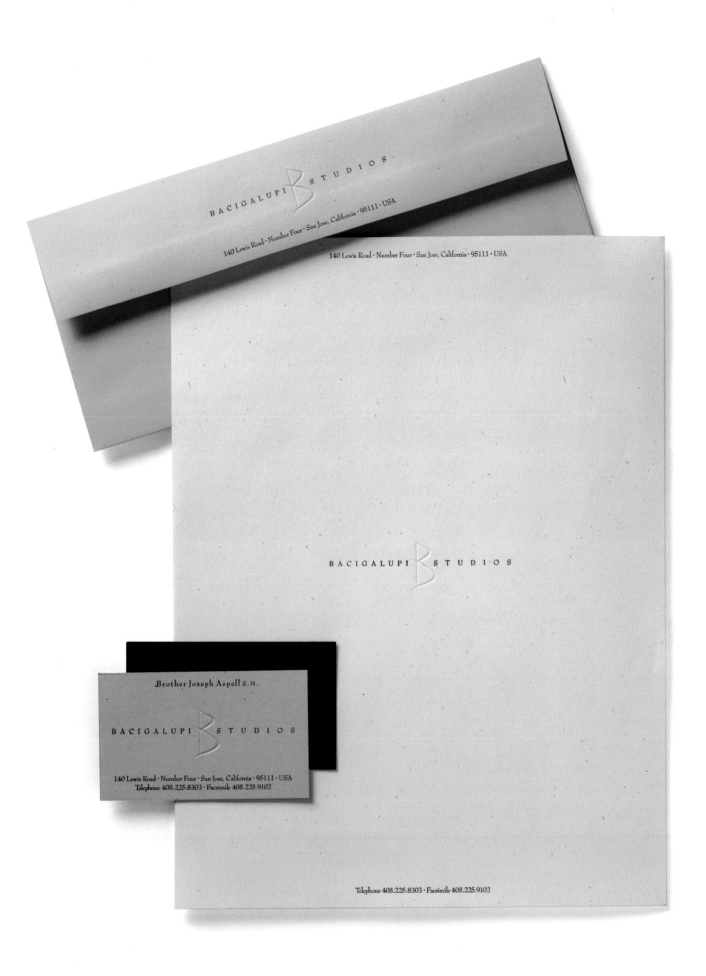

Client: Bacigalupi Studios
Design Firm: Tharp Did It • Los Gatos/San Francisco
Art Director: Rick Tharp
Designers: Rick Tharp, Jana Heer
Paper/Printing: One color and deboss on French Speckletone

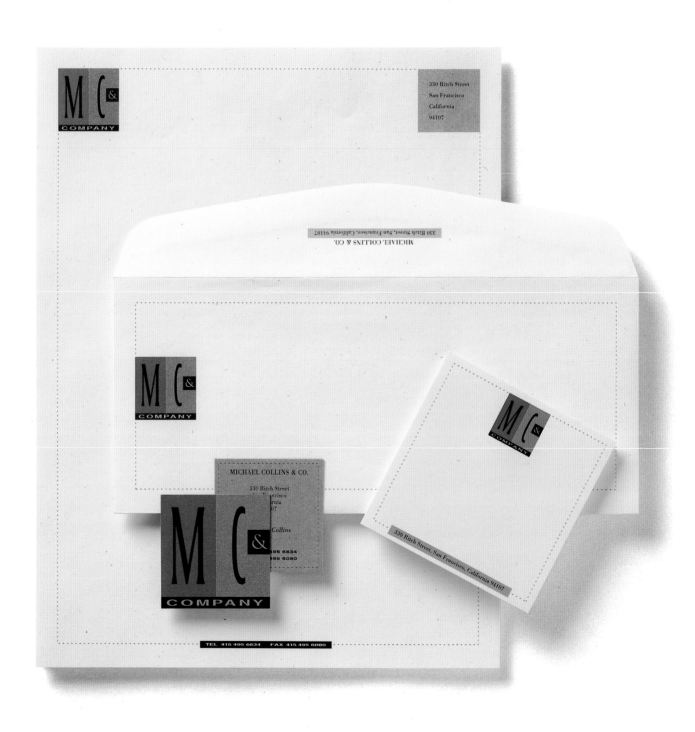

Client: Michael Collins & Co.
Design Firm: Emery/Poe Design
Art Director: David Poe
Designer: David Poe
Paper/Printing: Four colors on Neenah Environment

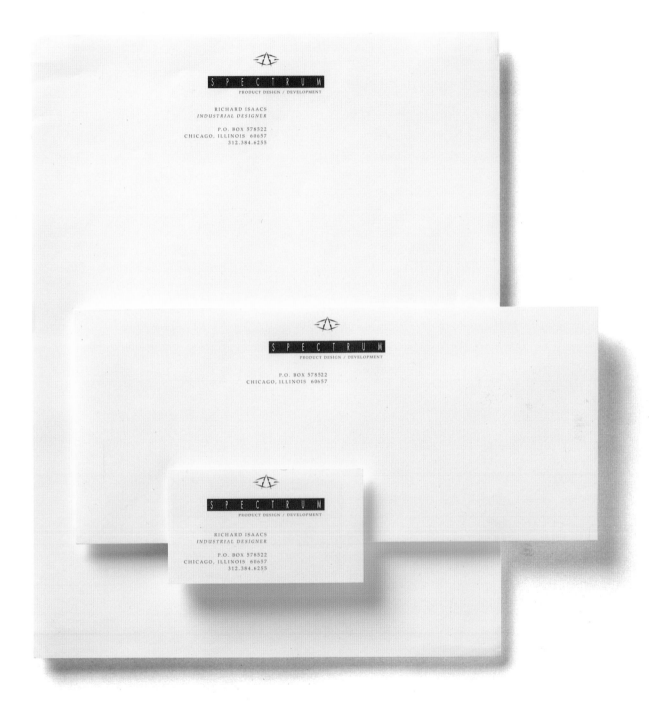

Client: Spectrum Design
Design Firm: CMC Design
Art Director: Chris Cacci
Paper/Printing: One color on Starwhite Vicksburg Natural

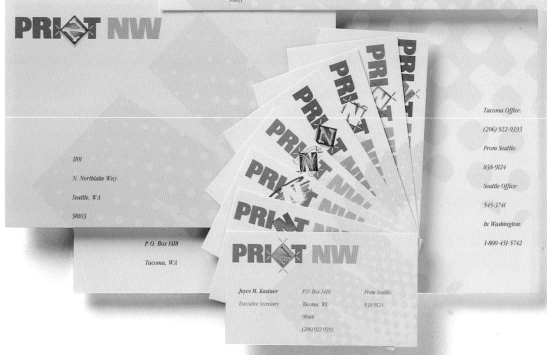

Client: Print Northwest
Design Firm: Hornall Anderson Design Works
Art Director: Jack Anderson
Designers: Jack Anderson, Heidi Hatlestad, Jani Drewfs
Airbrush Illustrator: Scott McDougall
Paper/Printing: Six colors on Bank Bond

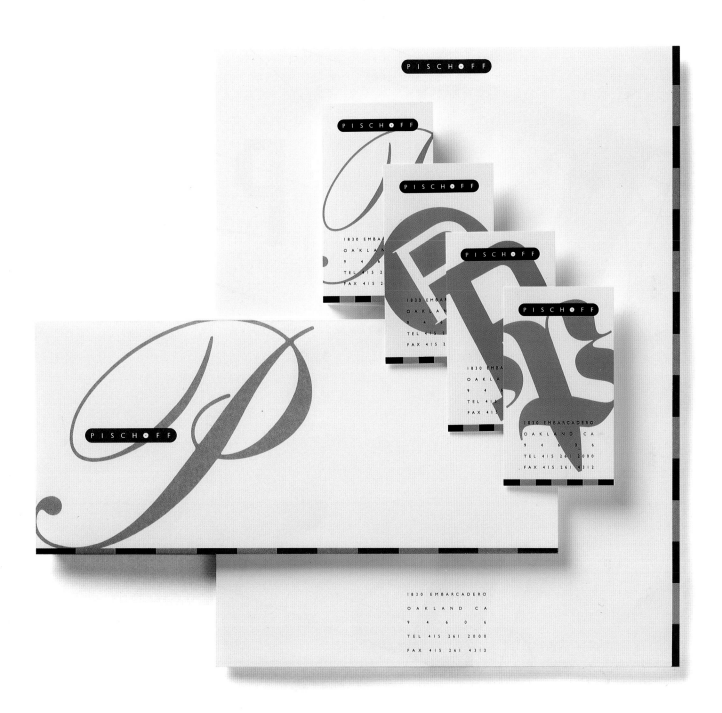

Client: Pischoff Company
Design Firm: Vanderbyl Design
Designer: Michael Vanderbyl
Paper/Printing: Starwhite Vicksburg

Client: MH Concepts International Ltd.
Design Firm: Unlimited Swan, Inc.
Art Director: Jim Swan
Designer: Jim Swan
Illustrator: Jim Swan
Paper/Printing: One color and pearl foil stamp on Classic Linen

Client: Chintz Decor Inc.
Design Firm: Unlimited Swan, Inc.
Art Director: Jim Swan
Designer: Jim Swan
Illustrator: Jim Swan
Paper/Printing: Three colors on Classic Linen

Client: Laura Smith Illustration
Design Firm: Michael Doret, Inc.
Art Director: Michael Doret
Designer: Michael Doret
Lettering: Michael Doret
Paper/Printing: Two colors on Gilcrest Laid

Client: Mathews Printing
Design Firm: Adam, Filippo & Associates
Art Director: Robert Adam
Designer: Barbara S. Peak
Paper/Printing: Two colors on Simpson Filare Script Natural White

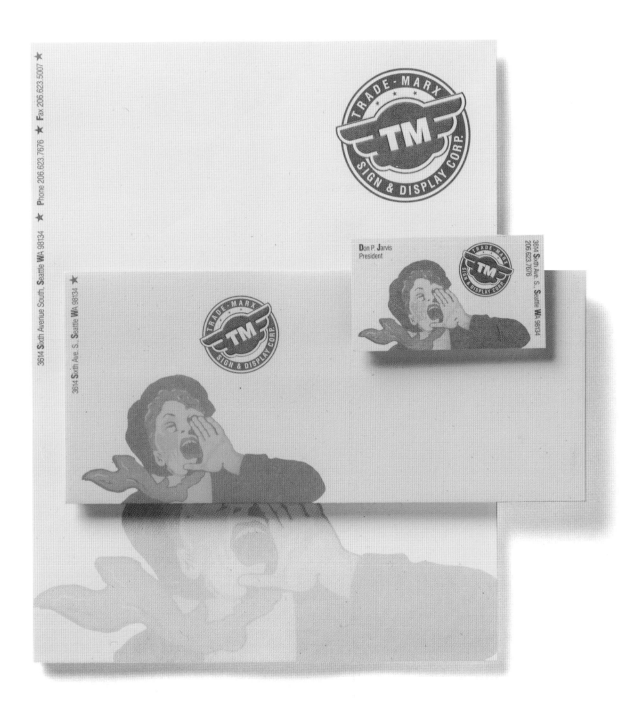

Client: Trade-Marx
Design Firm: Rick Eiber Design (RED)
Art Director: Rick Eiber
Designer: Rick Eiber
Illustrator: Norman Hathaway
Paper/Printing: Two colors and emboss on Speckletone

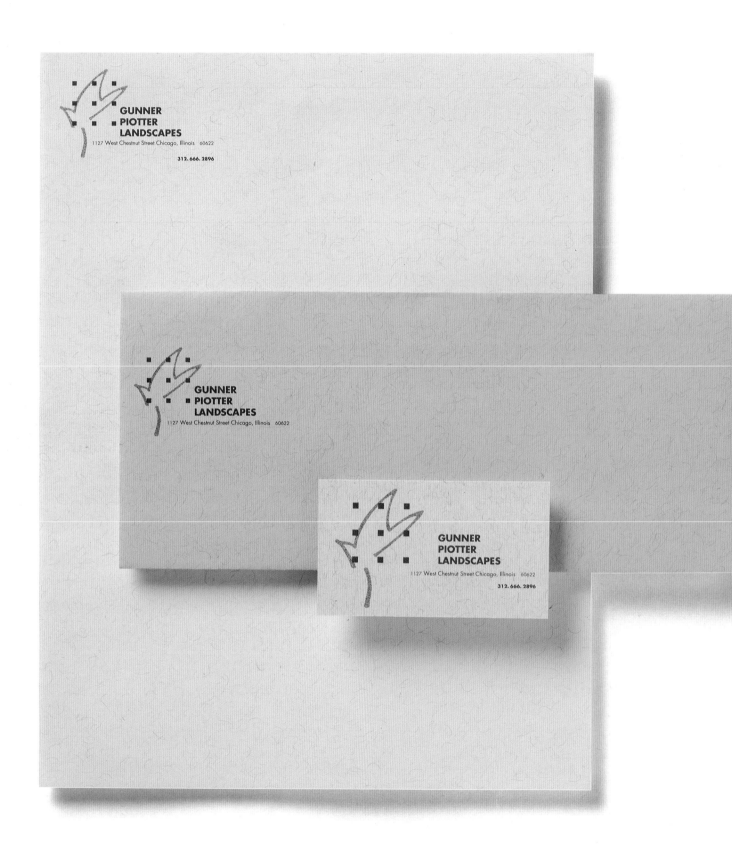

Client: Gunner Piotter Landscapes
Design Firm: Condon Norman Design
Art Director: Phylane Norman
Designer: Michael Golec
Paper/Printing: One color on French Speckletone

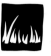

DISTINCTIVE LANDSCAPES

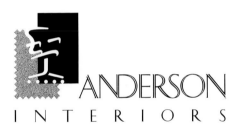

DIVISION of CAROL BARNHART, INC.

Client: Deadline Printing
Design Firm: Identity Center
Art Director: Wayne Kosterman
Designer: John Anderson

Client: Concept Unlimited, Inc.
Design Firm: Turpin Design Associates
Art Director: Tony F. Turpin
Designers: Greg Guhl, Riley Lawhorn, Tony F.
Turpin

Client: Distinctive Landscapes
Design Firm: Tollner Design Group
Art Director: Lisa Tollner
Designer: Kim Tucker
Illustrator: Kim Tucker

Client: Anderson Interiors
Design Firm: Adam, Filippo & Associates
Art Director: Ralph James Russini
Designers: Barabara S. Peak, Alyce Nadine
Hoggan, Sharon L. Bretz

Client: Carol Barnhart, Inc.
Design Firm: Greene Art Associates
Art Director: Hester Greene
Designer: Hester Greene

Client: Sacramento Valley Production
Theatre Company
Design Firm: Page Design, Inc.
Art Director: Paul Page
Designer: Paula Sugarman
Illustrator: Paula Sugarman

10. MANUFACTURING / INDUSTRY

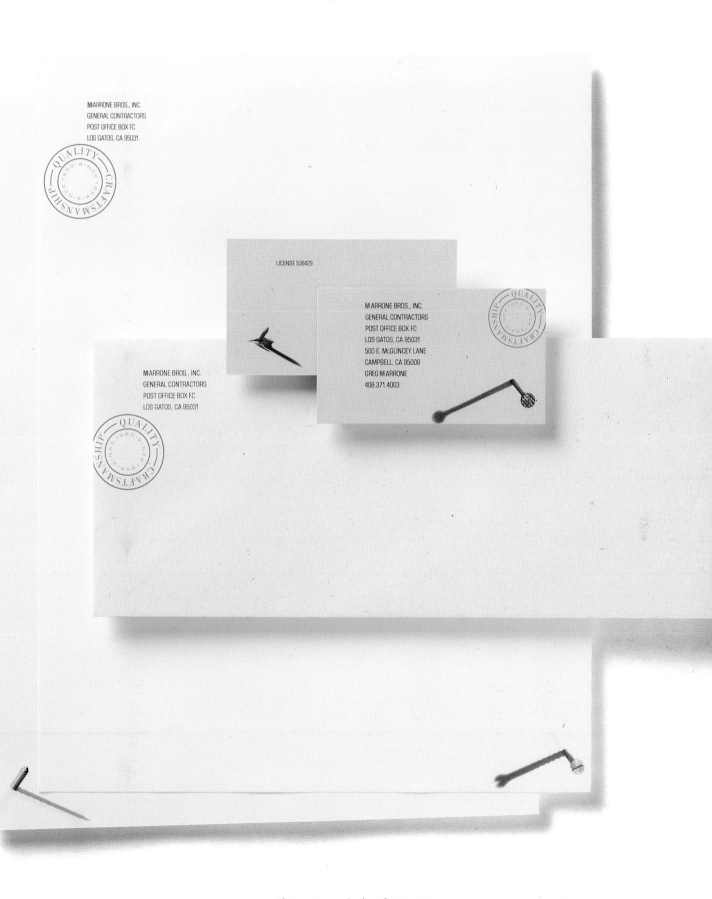

MARRONE BROS., INC.
GENERAL CONTRACTORS
POST OFFICE BOX FC
LOS GATOS, CA 95031

LICENSE 536429

MARRONE BROS., INC.
GENERAL CONTRACTORS
POST OFFICE BOX FC
LOS GATOS, CA 95031
500 E. McGLINCEY LANE
CAMPBELL, CA 95008
GREG MARRONE
408.371.4003

MARRONE BROS., INC.
GENERAL CONTRACTORS
POST OFFICE BOX FC
LOS GATOS, CA 95031

Client: Marrone Brothers Construction
Design Firm: Tharp Did It • Los Gatos/San Francisco
Art Director: Rick Tharp
Designer: Rick Tharp
Paper/Printing: Two colors on Simpson Protocol

167 Milk Street, Suite 185
Boston, Massachusetts
02109-4315

617 243 4383 Tel
617 737 8118 Fax

GREAT BRITISH KETTLES LTD

167 Milk Street, Suite 185
Boston, Massachusetts
02109-4315

GREAT BRITISH KETTLES LTD

J. GERARD CREGAN
Vice President

167 Milk Street, Suite 185
Boston, Massachusetts
02109-4315
617 243 4383 Tel
617 737 8118 Fax

GREAT BRITISH KETTLES LTD

167 Milk Street, Suite 185
Boston, Massachusetts
02109-4315

GREAT BRITISH KETTLES LTD

Client: Great British Kettles Ltd.
Design Firm: Fitch Richardson Smith
Art Director: Ann Gildea
Designer: Katie Murphy
Paper/Printing: Two colors on Champion Benefit Recycled

Radius, Inc.

404 E. Plumeria Drive

San Jose, CA

95134

(408) 434-1010

FAX: (408) 434-0770

radius

Linda Wilkin

Engineering Services Manager

Radius, Inc.

404 E. Plumeria Drive

San Jose, CA

95134

(408) 434-1010

FAX: (408) 434-0770

radius

Radius, Inc.

404 E. Plumeria Drive

San Jose, CA

95134

radius

Client: Radius, Inc.
Design Firm: Mortensen Design
Art Director: Gordon Mortensen
Designer: Gordon Mortensen
Paper/Printing: Three colors on Protocol 100 Ivory

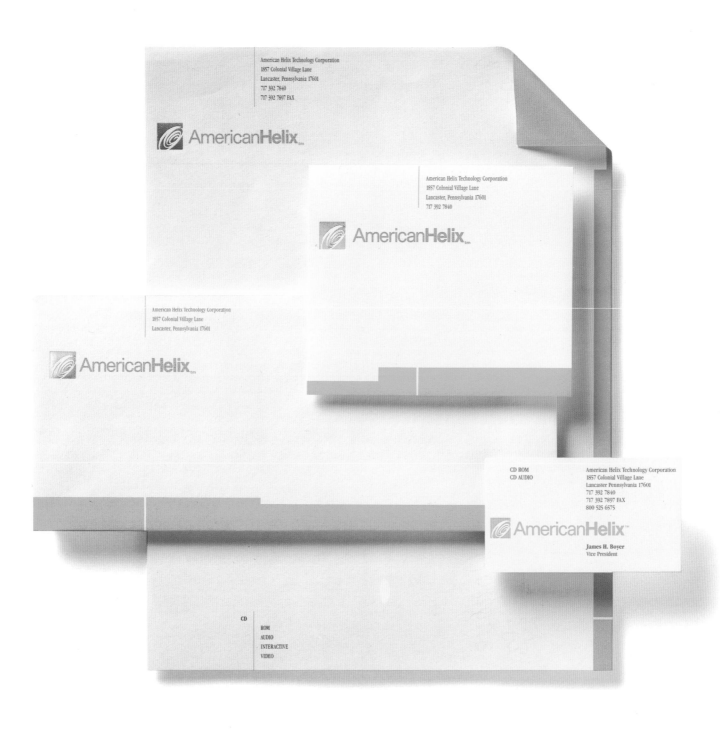

Client: American Helix Technology
Design Firm: Musser Design
Art Director: Musser
Designer: Musser
Paper/Printing: Three colors and foil on Neenah Opaque

BAYOIL

BAYOIL

BAYOIL (USA) INC.
10 SIGNAL ROAD STAMFORD, CT 06902

DAVID B. CHALMERS, JR.
PRESIDENT

BAYOIL

BAYOIL (USA) INC.
10 SIGNAL ROAD STAMFORD, CT 06902
203 359 6400 FAX: 203 359 6975 TLX: 3730721

BAYOIL (USA) INC. 10 SIGNAL ROAD STAMFORD, CT 06902 203 359 6400 FAX: 203 359 6975 TLX: 3730721

Client: Bayoil (USA) Inc.
Design Firm: Unlimited Swan, Inc.
Art Director: Jim Swan
Designer: Jim Swan
Illustrator: Jim Swan
Paper/Printing: Two colors on Mohawk Superfine

Client: REBARN
Design Firm: F. Eugene Smith Design Management
Art Director: F. Eugene Smith
Designer: Carlo Piech
Paper/Printing: Two colors on French Speckletone Natural Text

Client: Ray's Welding Inc.
Design Firm: Lancaster Design & Art, Inc.
Art Director: Kevin Ranck
Designer: Carolyn Mosher
Paper/Printing: Two colors on Kilmory Script

Client: Procoil
Design Firm: Adam Filippo & Associates
Art Director: Robert Adam
Designer: Adam Filippo & Associates
Paper/Printing: Two colors on Strathmore Writing Bright White Laid

Client: Tektronix, Inc.
Design Firm: Robert Bailey Inc.
Art Director: Robert Bailey
Designer: Robert Bailey, Carolyn Coghlan
Paper/Printing: Five colors on Lustro Gloss

SUGARTREE

SUGARTREE

SUGARTREE

DAVID H. COLTON
President
SugarTree International

1035 PEARL STREET
BOULDER COLORADO USA 80302
303 447 3068 FAX 303 449 3095

1035 PEARL STREET 5TH FLOOR *BOULDER COLORADO USA 80302* *303 447 3068 FAX 303 449 2773*

Client: Astarte, Inc.
Design Firm: Communication Arts Inc.
Art Director: Richard Foy
Designer: Hugh Enockson
Paper/Printing: Two color on Starwhite Vicksburg Archiva

John H. Bishop
Vice President of Engineering

2610 Huntington Dr.
Aptos, CA 95003
408/662-0176
Fax
408/662-0181

2610 Huntington Dr.
Aptos, CA 95003

2610 Huntington Dr.
Aptos, CA 95003
408/662-0176
Fax
408/662-0181

Client: Cubi Clip
Design Firm: Tollner Design Group
Art Director: Lisa Tollner
Designer: Kim Tucker
Illustrator: Kim Tucker

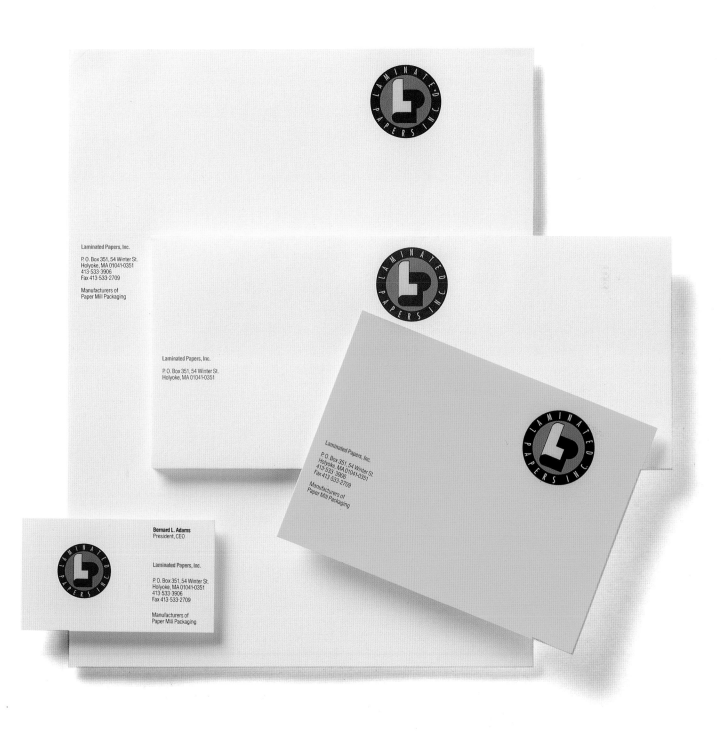

Client: Laminated Papers Inc.
Design Firm: Cipriani Kremer Design
Art Director: Robert Cipriani
Paper/Printing: Three colors on Crane's Crest

OCULON

OCULON

Canal Place
130 Nickerson Street
Seattle, WA 98109

206.283.6533
206.285.6571 FAX

OCULON

OCULON

Canal Place
130 Nickerson Street
Seattle, WA 98109

OCULON

Karen Auditore-Hargreaves, Ph.D.
Vice President
Research and Development

Canal Place
130 Nickerson Street
Seattle, WA 98109

206.283.6533
206.285.6571 FAX

Client: Oculon, Inc.
Design Firm: Rick Eiber Design (RED)
Art Director: Rick Eiber
Designer: Eric Janssen
Paper/Printing: Two colors on Classic Crest

NAMBU

NAMBU

Client: Nambu International, Inc.
Design Firm: Donovan and Green
Art Director: Nancye Green
Designers: Clint Morgan, Dennis Favello
Paper/Printing: Two colors on Crane's Crest Fluorescent White Opaque Wove

KINEO
DESIGN BY F·A·PORSCHE

KINEO
DESIGN BY F·A·PORSCHE

KINEO
DESIGN BY F·A·PORSCHE

Gerald Berton
President

*Kineo USA Ltd
141 East Boston Post Road
Mamaroneck, New York
10543*

*Telephone 914 381 5100
Fax 914 698 3893*

*Kineo USA Ltd
141 East Boston Post Road
Mamaroneck, New York
10543*

*Telephone 914 381 5100
Fax 914 698 3893*

Client: Kineo
Design Firm: Donovan and Green
Art Directors: Michael Green, Nancye Green
Designer: Clint Morgan
Paper/Printing: Three colors on Strathmore Writing

26 Landsdowne Street
Cambridge
Massachusetts
02139 4234
U.S.A.

Telephone
617 494 0171
Facsimile
617 494 9263

Alkermes

26 Landsdowne Street
Cambridge
Massachusetts
02139 4234
U.S.A.

Alkermes

Laura A. McCarroll, M.S.
Senior Research Associate
and Laboratory Manager

Alkermes

26 Landsdowne Street
Cambridge
Massachusetts
02139 4234
U.S.A.

Telephone
617 494 0171
Facsimile
617 494 9263

26 Landsdowne Street
Cambridge
Massachusetts
02139 4234
U.S.A.

Alkermes

Client: Alkermes, Inc.
Design Firm: Katz Wheeler Design
Art Director: Joel Katz
Designer: Annette Chang Vander
Paper/Printing: One color and embossing on Strathmore Writing

Client: A.G. Heinze Inc.	**Client:** National Steel Corporation
Design Firm: Mark Palmer Design	**Design Firm:** Adam, Filippo & Associates
Art Director: Mark Palmer	**Art Director:** Robert Adam
Designer: Mark Palmer	**Designers:** Robert Adam, Ralph James Russini
Computer Production: Curtis Palmer	**Paper/Printing:** Two colors on Simpson Filare Script Bianco White
Paper/Printing: Two colors on Strathmore Writing Wove	

Client: Consumer Connection	**Client:** Rodgers Instrument Corp.
Design Firm: Mark Palmer Design	**Design Firm:** Robert Bailey Inc.
Art Director: Mark Palmer	**Art Director:** Robert Bailey
Designer: Mark Palmer	**Designer:** Carolyn Coghlan
Computer Production: Curtis Palmer	**Paper/Printing:** Simpson Protocol Writing
Paper/Printing: Simpson Gainsborough	

ADVANCE
FIRE EXTINGUISHER COMPANY

P.O. BOX 478

ISSAQUAH, WA 98027-0478

747.3008 • 1.800.427.6818

ADVANCE
FIRE EXTINGUISHER COMPANY

P.O. BOX 478

ISSAQUAH, WA

98027-0478

ADVANCE
FIRE EXTINGUISHER COMPANY

BOB VESELY, OPERATIONS MANAGER
P.O. BOX 478 • ISSAQUAH, WA 98027 • 747.3008 • 1.800.427.6818

Client: Advance Fire Extinguisher Co.
Design Firm: G.T. Rapp & Company
Art Director: Liz Kearney
Designer: Margo Christianson
Paper/Printing: Two colors on Gilbert Neu-Tech Ultra White Wove

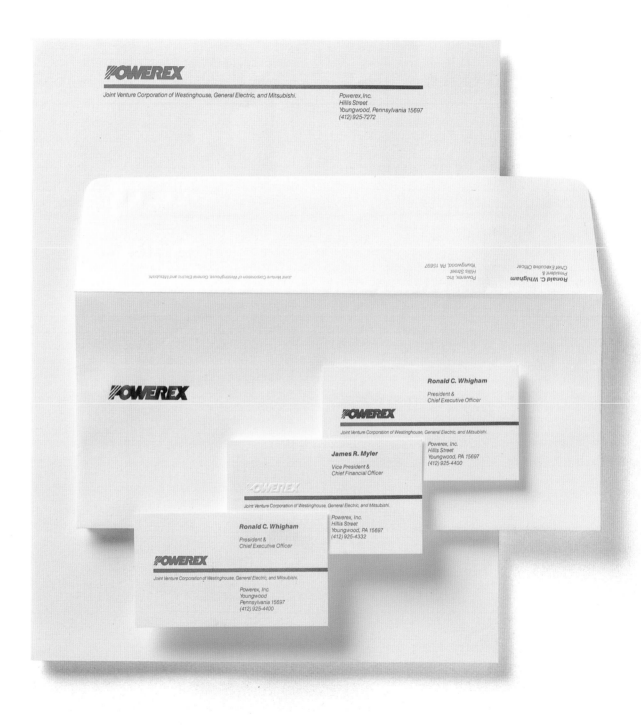

Client: Powerex, Inc.
Design Firm: Adam, Filippo & Associates
Art Director: Adam, Filippo & Associates
Designer: Adam, Filippo & Associates
Paper/Printing: Two colors on Simpson Filare Script Bianco White

ESMARK

DANSKIN
DANSKIN PLUS
DANCE FRANCE
REPETTO
CUSTOM COLLECTION
ROUND THE CLOCK
GIVENCHY

Edwin W. Dean
EXECUTIVE VICE PRESIDENT
GENERAL COUNSEL
(212) 930-9173

ESMARK

DANSKIN
DANSKIN PLUS
DANCE FRANCE
REPETTO
CUSTOM COLLECTION
ROUND THE CLOCK
GIVENCHY

ESMARK

DANSKIN
DANSKIN PLUS
DANCE FRANCE
REPETTO
CUSTOM COLLECTION
ROUND THE CLOCK
GIVENCHY

ESMARK APPAREL, INC.
111 WEST 40TH STREET
NEW YORK, N.Y. 10018
(212) 764-4630

TELEX: 177328 DNSKU
FAX: 212 764 7265

ESMARK APPAREL, INC. · 111 WEST 40TH STREET · NEW YORK, N.Y. 10018 · (212) 764-4630 · TELEX: 177328 DNSKU · FAX: 212 764 7265

Client: Esmark Apparel, Inc.
Design Firm: Barry David Berger + Assoc., Inc.
Art Director: Barry Berger
Designers: Sharon Reiter, Cheryl Oppenheim
Paper/Printing: One color

**LEONARD'S
METAL, INC.**

P.O. Box 678
St. Charles, MO
63302•0678

314 946•6525
FAX 314 723•7130

204 "H" Street N.W.
Auburn, WA
98001

206 838•3233
FAX 206 833•2779

**LEONARD'S
METAL, INC.**

Duane Hahn
General Manager
Auburn Plant

**LEONARD'S
METAL, INC.**

P.O. Box 678
St. Charles, MO
63302•0678

Headquarters
St. Charles, MO
Production
St. Charles, MO
Wichita, KS
Auburn, WA

Client: Leonard's Metal, Inc.
Design Firm: Intelplex
Art Director: Alan Sherman
Designer: Neil Koenig
Production: Studio One

GEORGETOWN UNIMETAL

Charles A. Cameron
Regional Sales Manager

GEORGETOWN UNIMETAL

(803) 546-0239

Georgetown Unimetal Sales
Marketing Unimetal and Georgetown Steel
Corporation Wire Rods in the U.S.A.

Georgetown Unimetal Sales
1901 Roxborough Rd. Suite 220
Charlotte, NC 28211

GEORGETOWN UNIMETAL

Marketing Unimetal and	Georgetown Unimetal Sales	Phone:	(704) 365-2205
Georgetown Steel Corporation	1901 Roxborough Rd. Suite 220		(800) 327-0558
Wire Rods in the U.S.A.	Charlotte, NC 28211	Fax:	(704) 365-1733

Client: Georgetown Unimetal Sales
Design Firm: Design/Joe Sonderman, Inc.
Designer: Tim Gilland
Paper/Printing: Three colors

Client:	Rafn
Design Firm:	Hornall Anderson Design Works
Art Director:	Jack Anderson
Designers:	Jack Anderson, Jani Drewfs, David Bates, Brian O'Neill
Illustrator:	Brian O'Neill

Client:	Astor Construction
Design Firm:	Greene Art Associates
Art Director:	Hester Greene
Designer:	Peter Greene

Client:	Climatech, Inc.
Design Firm:	Adam, Filippo & Associates
Art Director:	Adam, Filippo & Associates
Designer:	Ralph James Russini

Client:	Minko Construction Co.
Design Firm:	Design Center
Art Director:	John Reger
Designer:	Todd Spichke

Client:	Transtar, Inc.
Design Firm:	Adam, Filippo & Associates
Art Director:	Robert Adam
Designer:	Barbara S. Peak

Client:	E.I. duPont de Nemours & Co., Inc.
Design Firm:	Richard Danne & Associates Inc
Art Director:	Richard Danne
Designer:	Gary Skeggs

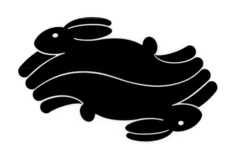

Client: Valley Papers
Design Firm: J. Brelsford Design, Inc.
Art Director: Jerry Brelsford
Designer: Jerry Brelsford

Client: Valsan
Design Firm: Rowe & Ballantine
Art Director: Edward L. Rowe, Jr.
Designer: John H. Ballantine

Client: 3M Company
Design Firm: Design Center
Art Director: John Reger

Client: SmithKline Corporation
Design Firm: Frank D'Astolfo Design
Art Director: Frank D'Astolfo
Designer: Frank D'Astolfo

Client: Rebo Research, Inc.
Design Firm: M Plus M Incorporated
Art Directors: Michael McGinn, Takaaki Matsumoto
Designer: Michael McGinn
Illustrator: Jack Tom

Client: KRW Energy Systems, Inc.
Design Firm: Adam, Filippo & Associates
Art Director: Adam, Filippo & Associates
Designer: Adam, Filippo & Associates

11. HEALTH CARE

Deutsches Altenheim

2222 Centre Street
West Roxbury, MA 02132
(617) 325-1230

Deutsches Altenheim

2222 Centre Street
West Roxbury, MA 02132
(617) 325-1230

Deutsches Altenheim

Capital Campaign Office
165 Newbury Street
Boston, MA 02116
(617) 266-6411

Heinrich Brinkhaus
President

Deutsches Altenheim 2222 Centre Street
West Roxbury, MA 02132
(617) 325-1230

Client: Deutsches Altenheim (German Home for the Aged)
Design Firm: Fitch Richardson Smith Inc.
Art Director: Patty O'Leary
Designer: Patty O'Leary
Illustrator: Patty O'Leary
Paper/Printing: Two colors on Champion Benefit

OPHTHALMIC INFORMATION SYSTEMS

34 Market Place, Suite 330
Baltimore, Maryland 21202
301-625-0565

OPHTHALMIC INFORMATION SYSTEMS

34 Market Place, Suite 330
Baltimore, Maryland 21202

Bert M. Glaser, M.D.

OPHTHALMIC INFORMATION SYSTEMS

34 Market Place, Suite 330
Baltimore, Maryland 21202
301-625-0565

Client: Opthalmic Information Systems
Design Firm: Joseph Dieter Visual Communications
Art Director: Joseph M. Dieter, Jr.
Designer: Joseph M. Dieter, Jr.
Paper/Printing: Two colors on Strathmore Writing

Surgical Design Corporation
4253 21st Street
L.I.C., New York 11101
(718) 392-5022
(800) 458-4344
Telex 141095 Surg Design

Setting the Standard
in Intraocular Microsurgery
Since 1968

Surgical Design Corporation
4253 21st Street
L.I.C., New York 11101

Setting the Standard
in Intraocular Microsurgery
Since 1968

Surgical Design Corporation
4253 21st Street
L.I.C., New York 11101
(718) 392-5022
(800) 458-4344
Telex 141095 Surg Design

Andrew P. Greenberg
Chief Financial Officer

Client: Surgical Design Corporation
Design Firm: Richard Danne & Associates, Inc.
Art Director: Richard Danne
Designer: Richard Danne
Paper/Printing: One color on Strathmore Writing

Client: Belton Dickinson
Design Firm: Ellis • Pratt Design
Art Director: Vernon Ellis
Designer: Tim Coletti
Paper/Printing: Three colors on Curtis Linen

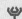

Ross F. Marchetta M.D.

Obstetrics and Gynecology of Bath, Inc
799 Wye Road
Akron, Ohio
44333-2268

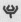

Ross F. Marchetta M.D.

Obstetrics and Gynecology of Bath, Inc
799 Wye Road
Akron, Ohio 44333
216/666/1166
800/443/7222
216/668/3919 FAX

Ross F. Marchetta M.D.

Obstetrics and Gynecology of Bath, Inc
799 Wye Road
Akron, Ohio 44333
216/666/1166
800/443/7222
216/668/3919 FAX

Client: Dr. Ross Marchetta
Design Firm: F. Eugene Smith Design Management, Inc.
Art Director: F. Eugune Smith
Designer: Carlo Piech
Paper/Printing: Two colors on Classic Crest Writing Classic Natural White

Client: Wyman Park Medical Center
Design Firm: Art As Applied To Medicine, Johns Hopkins Medical Institutions
Art Director: Joseph M. Dieter, Jr.
Designer: Joseph M. Dieter, Jr.
Paper/Printing: Two colors on Strathmore Writing

Client: Heartland Institute For Health
Design Firm: Turpin Design Associates
Art Director: Tony F. Turpin
Designer: Tony F. Turpin
Paper/Printing: Two colors on Strathmore Writing

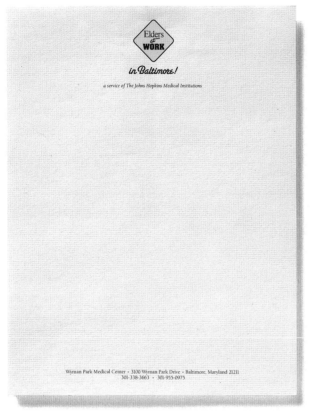

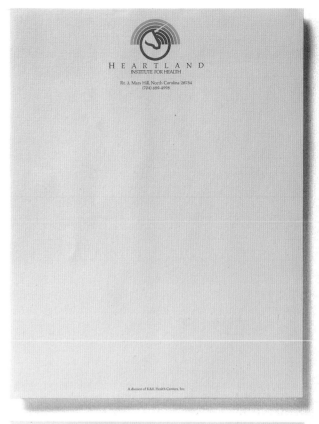

Client: LSA Family Health Service
Design Firm: Stillman Design Associates
Art Director: Linda Stillman
Designer: Carol Baxter
Illustrator: Connie Circosta
Paper/Printing: Two colors on Gilbert Writing Wove

Client: Maryland Society For The Prevention of Blindness
Design Firm: Joseph Dieter Visual Communications
Art Director: Joseph M. Dieter, Jr.
Designer: Joseph M. Dieter, Jr.
Paper/Printing: Four colors on Strathmore Writing

Medical Specialty Group, Inc.
Kerrigan's Corner
2 Reedsdale Road
Milton, MA 02186
(617) 698-0715
FAX: (617) 698-7559

1093 North Main Street
Randolph, MA 02368
(617) 961-1450

577 East Broadway
South Boston, MA 02127
(617) 698-0715

Richard M. Delany, M.D., F.A.C.C.
Cardiology
Internal Medicine

Scott B. Lutch, M.D.
Cardiology
Internal Medicine

George L. Barrett, M.D.
Gastroenterology
Internal Medicine

MEDICAL SPECIALTY
GROUP

Kerrigan's Corner
2 Reedsdale Road
Milton, MA 02186
(617) 698-0715
FAX: (617) 698-7559

1093 North Main Street
Randolph, MA 02368
(617) 961-1450

George L. Barrett, M.D.
Gastroenterology
Internal Medicine

577 East Broadway
South Boston, MA 02127
(617) 698-0715

MEDICAL SPECIALTY
GROUP

Kerrigan's Corner
2 Reedsdale Road
Milton, MA 02186

Client: Medical Specialty Group Inc.
Agency: Kennedy & Company
Design Firm: Letvin Design
Art Director: Carolyn Letvin
Designer: Carolyn Letvin
Paper/Printing: Two colors on Strathmore Writing

PENICK
MEMORIAL HOME

*The Episcopal Home for
the Ageing in the Diocese
of North Carolina, Inc.*

PENICK
MEMORIAL HOME

Saint Peter's Nursing Center
Kinder Elder Kare

East Rhode Island Avenue Extension
Post Office Box 2001
Southern Pines, NC 28388

Saint Peter's Nursing Center

Kinder Elder Kare

East Rhode Island Avenue Extension
Post Office Box 2001
Southern Pines, NC 28388
919•692•0300
Fax 919•692•8287

Client: Ruder•Finn
Design Firm: Sally Johns Design Studio
Art Director: Sally Johns
Designer: Jeff Dale
Illustrator: Jeff Dale
Paper/Printing: Two colors on Neenah Classic Laid

112 South 7th Street
Akron, PA 17501
717-859-2013

112 South 7th Street
Akron, PA 17501
717-859-2013

112 South 7th Street
Akron, PA 17501
717-859-2013

Client: Akron Family Dentist
Design Firm: Lancaster Design & Art, Inc.
Art Director: Drew Tyson
Designer: Kevin Ranck
Illustrator: Carolyn Mosher
Paper/Printing: Two colors on Neenah Classic Laid

ARTHUR H. SOMMER, D.M.D.

131 FOXSHIRE DRIVE
LANCASTER, PA 17601

717-560-9191

131 FOXSHIRE DRIVE, LANCASTER, PA 17601 717-560-9191

Client: Lancaster Periodontal Associates
Design Firm: Lancaster Design & Art
Art Director: Drew Tyson
Designer: Amelia Rockwell-Seton
Paper/Printing: Two colors on Gilbert Writing

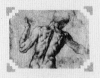

MASSAGE THERAPY CENTER OF WINNETKA

MASSAGE THERAPY CENTER OF WINNETKA

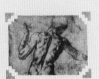

MASSAGE
THERAPY
CENTER
OF
WINNETKA

JOHN G. LOUIS, C.M.T.
DIRECTOR

40 GREEN BAY ROAD
WINNETKA, ILLINOIS 60093
708.446.5700

40 GREEN BAY ROAD
WINNETKA, ILLINOIS 60093
708.446.5700

Client: Massage Therapy Center of Winnetka
Design Firm: Michael Stanard Inc.
Art Director: Michael Stanard
Designer: Marcos Chavez
Paper/Printing: Two colors on Strathmore Writing

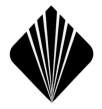

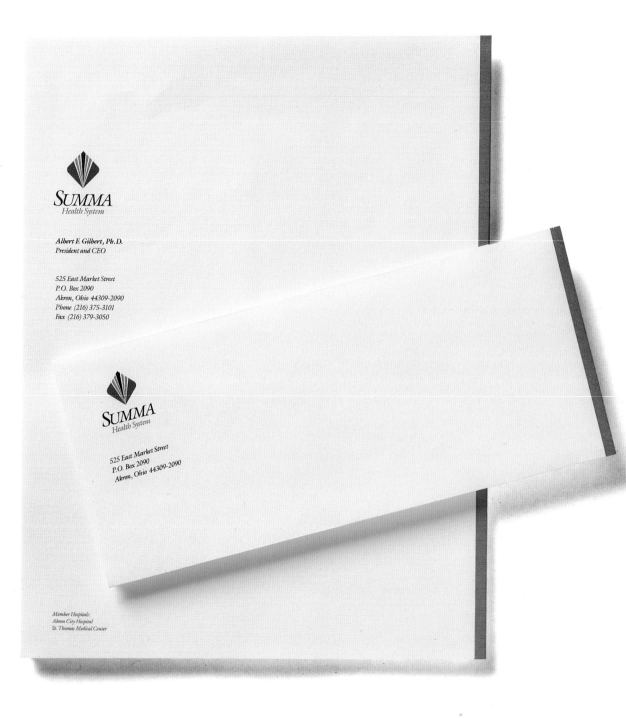

Client: Summa Health System
Design Firm: Adam, Filippo & Associates
Art Director: Robert Adam
Designer: Barbara S. Peak, Ralph James Russini
Paper/Printing: Three colors on Neenah Classic Laid

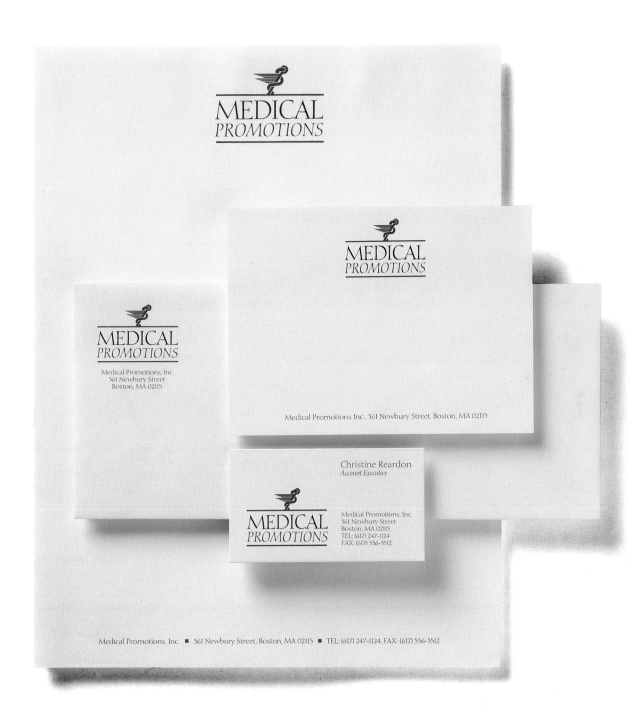

Client: Medical Promotions, Inc.
Agency: Kennedy & Company
Design Firm: Letvin Design
Art Director: Carolyn Letvin
Designer: Carolyn Letvin
Paper/Printing: Two colors on Strathmore Writing

Client: Hillhaven Corporation
Design Firm: Hornall Anderson Design Works
Art Director: Jack Anderson
Designers: Jack Anderson, Mary Hermes,
David Bates

Client: Victim Services
Design Firm: J. Brelsford Design, Inc.
Art Director: Jerry Brelsford
Designer: Jerry Brelsford

Client: Boston Eye Surgery & Laser Center
Agency: Kennedy & Company
Design Firm: Letvin Design
Art Director: Carolyn Letvin
Designer: Carolyn Letvin

Client: Catholic Healthcare West
Design Firm: Page Design, Inc.
Art Director: Paul Page
Designer: Paula Sugarman

Client: Mercy San Juan Hospital
Design Firm: Page Design, Inc.
Art Director: Paul Page
Designer: Paula Sugarman
Illustrator: Paula Sugarman

Client: American Association of Spinal
Cord Injury Nurses
Design Firm: Frank D'Astolfo Design
Art Director: Frank D'Astolfo
Designer: Frank D'Astolfo

12. EDUCATION / NON-PROFIT

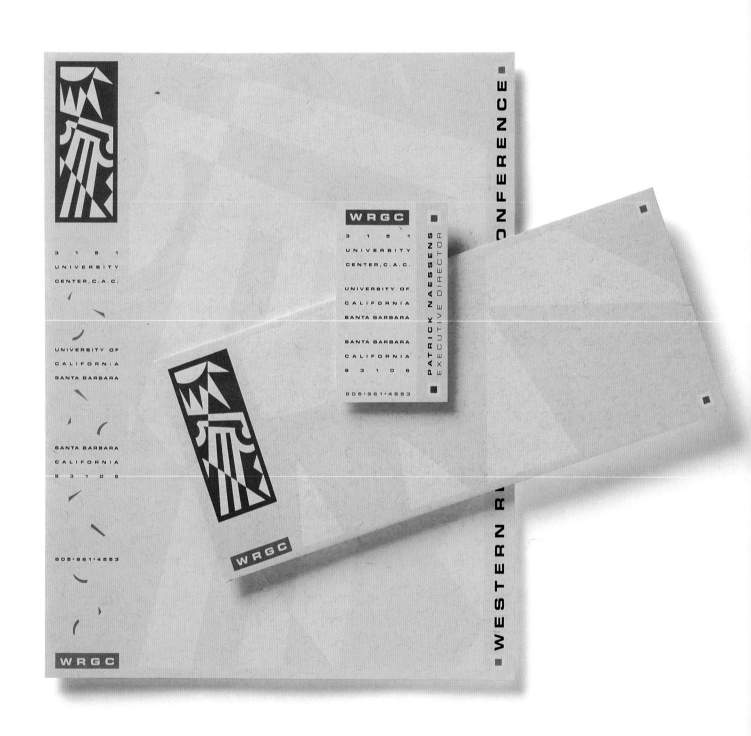

Client: Western Regional Greek Conference
Design Firm: Sayles Graphic Design
Art Director: John Sayles
Designer: John Sayles
Paper/Printing: Two colors on French Speckletone

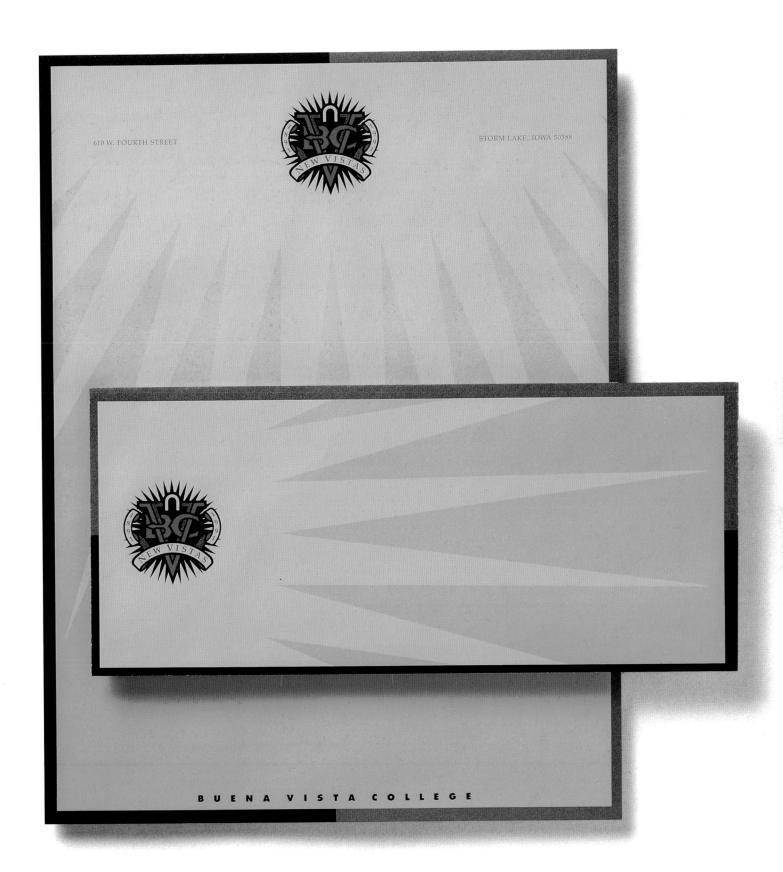

610 W. FOURTH STREET

STORM LAKE, IOWA 50588

BUENA VISTA COLLEGE

Client: Buena Vista College
Design Firm: Sayles Graphic Design
Art Director: John Sayles
Designer: John Sayles
Paper/Printing: Four colors on James River (Special Order)

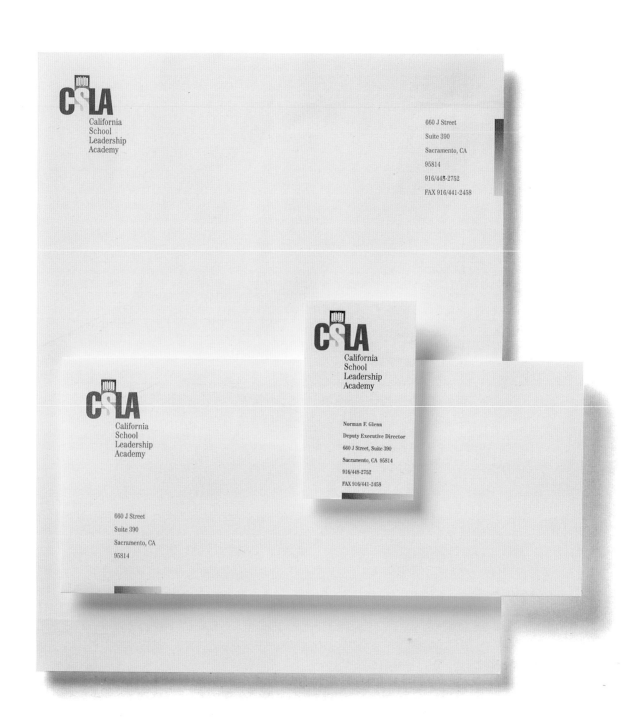

Client: California School Leadership Academy
Design Firm: Marketing By Design
Art Director: Joel Stinghen
Designer: Joel Stinghen
Illustrator: Joel Stinghen
Paper/Printing: Two colors on Classic Crest

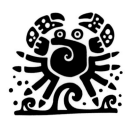

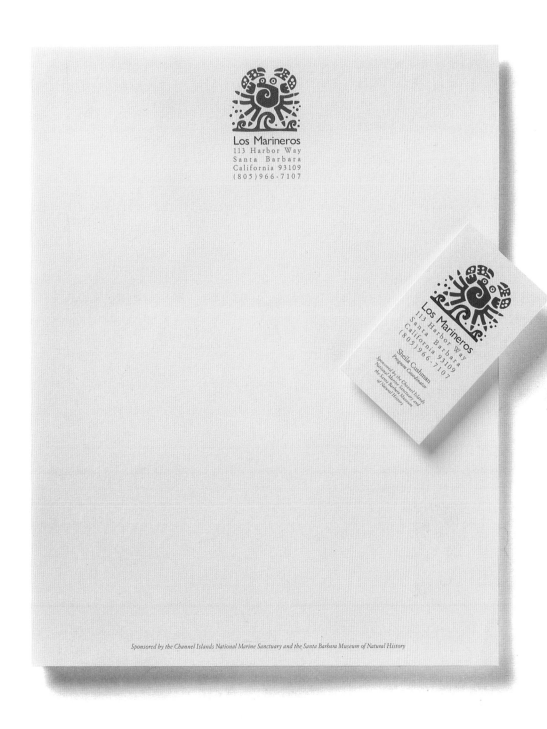

Client: Los Marineros
Design Firm: Puccinelli Design
Art Director: Keith Puccinelli
Designer: Keith Puccinelli
Illustrator: Keith Puccinelli
Paper/Printing: Two colors on Cross Pointe Bond

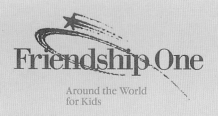

Friendship One

Around the World
for Kids

Made possible by the
generous support of
United Airlines.

Friendship One

Around the World
for Kids

Friendship Foundation
(A Non-Profit Corporation)

c/o The Museum of Flight
9404 E. Marginal Way S.
Seattle, Washington 98108

Friendship One

Around the World
for Kids

Friendship Foundation
(A Non-Profit Corp.)

Clay Lacy
President

c/o The Museum of Flight
9404 E. Marginal Way S.
Seattle, Washington 98108
(206) 764-5708
Fax # (206) 764-5707

Friendship Foundation
(A Non-Profit Corporation)

c/o The Museum of Flight
9404 E. Marginal Way S.
Seattle, Washington 98108
(206) 764-5708
Fax # (206) 764-5707

Client: Museum of Flight
Design Firm: Hornall Anderson Design Works
Art Director: Jack Anderson
Designers: Jack Anderson, Julie Tanagi-Lock
Paper/Printing: Four colors on Protocol Writing

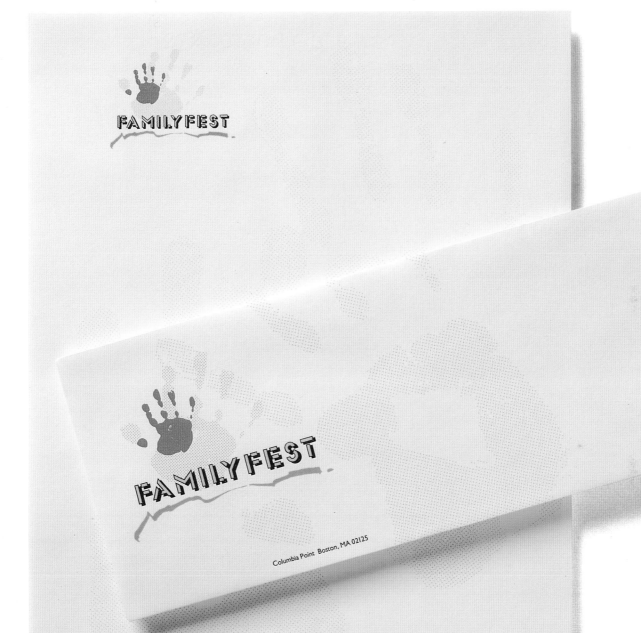

FAMILY FEST

FAMILY FEST

Columbia Point Boston, MA 02125

Family Fest, a family-oriented festival, benefits Ronald McDonald Children's Charities®, and is sponsored by
John F. Kennedy Library and Museum, McDonald's®, WMJX 106.7 FM, and WCVB-TV.

Client: JFK Library
Design Firm: WCVB TV Design
Art Director: Marc English
Designer: Marc English
Illustrator: Rebecka, Teena, Marc
Paper/Printing: Five colors on Strathmore Writing

Client: Chicago Historical Society
Design Firm: Donovan and Green
Art Director: Michael Donovan
Designer: Rose Biondi
Paper/Printing: Two colors on Strathmore Wove Bright White

Client: Prairie Fire Rural Action
Design Firm: Identity Center
Art Director: Wayne Kosterman
Designer: Wayne Kosterman
Paper/Printing: Two colors on Strathmore Writing

Client: Alan Keinberg
Design Firm: Anthony McCall Associates
Art Director: Anthony McCall
Designer: Wing Chan
Illustrator: Wing Chan
Paper/Printing: One color on Strathmore Natural White

Client: Queens College
Design Firm: Milton Glaser, Inc.
Art Director: Milton Glaser
Designer: Milton Glaser

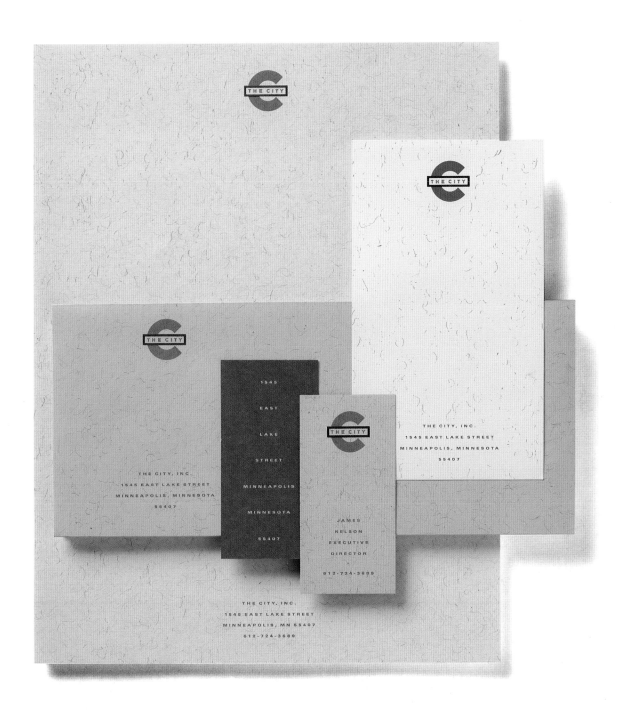

Client: The City, Inc.
Design Firm: William Homan Design
Art Director: William Homan
Designer: William Homan

George
Washington
Birthplace
National
Monument

Thomas
Stone
National
Historic
Site

NATIONAL
PARK
SERVICE

R R 1, Box 717
Washington's Birthplace
VA·22575
804 224 1732

George
Washington
Birthplace
National
Monument

Thomas
Stone
National
Historic
Site

NATIONAL
PARK
SERVICE

R R 1, Box 717
Washington's Birthplace
VA·22575

Client: George Washington Birthplace National Monument
Design Firm: Karen Schrader Design
Designer: Karen L. Schrader
Paper/Printing: Three colors on Strathmore Writing

Families and **Work** Institute

Families and **Work** Institute

330 Seventh Avenue, New York, New York 10001

Families and **Work** Institute

330 Seventh Avenue, New York, New York 10001

Families and **Work** Institute

330 Seventh Avenue
New York, New York 10001
(212) 465.2044
Fax (212) 465.8637

330 Seventh Avenue, New York, New York 10001 (212) 465.2044 Fax (212) 465.8637

Client: Families and Work Institute
Design Firm: Page, Arbitrio & Resen
Art Director: Kenneth Resen
Designer: Kenneth Resen
Paper/Printing: Three colors

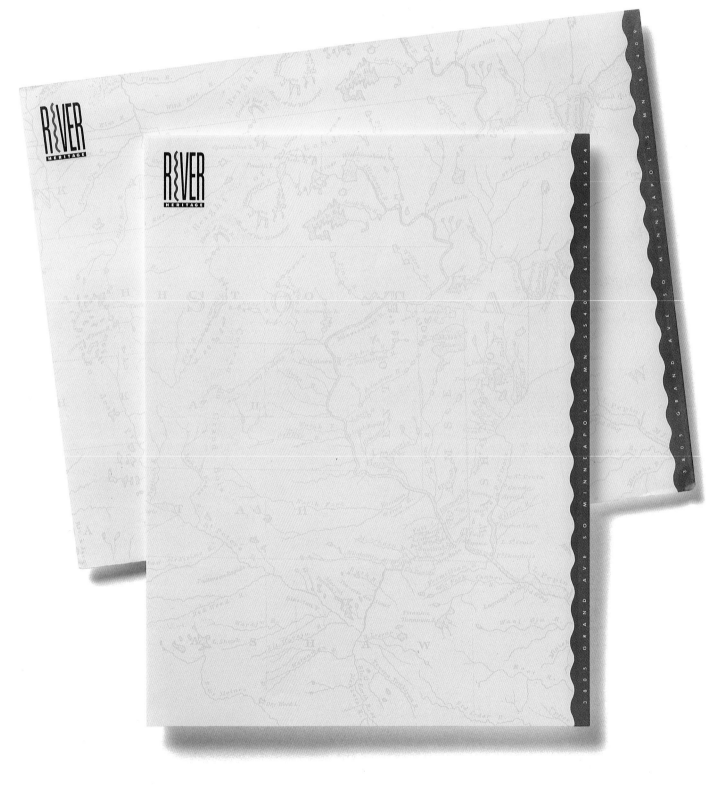

Client: River Heritage
Design Firm: William Homan Design
Art Director: William Homan
Designer: William Homan
Paper/Printing: Three colors

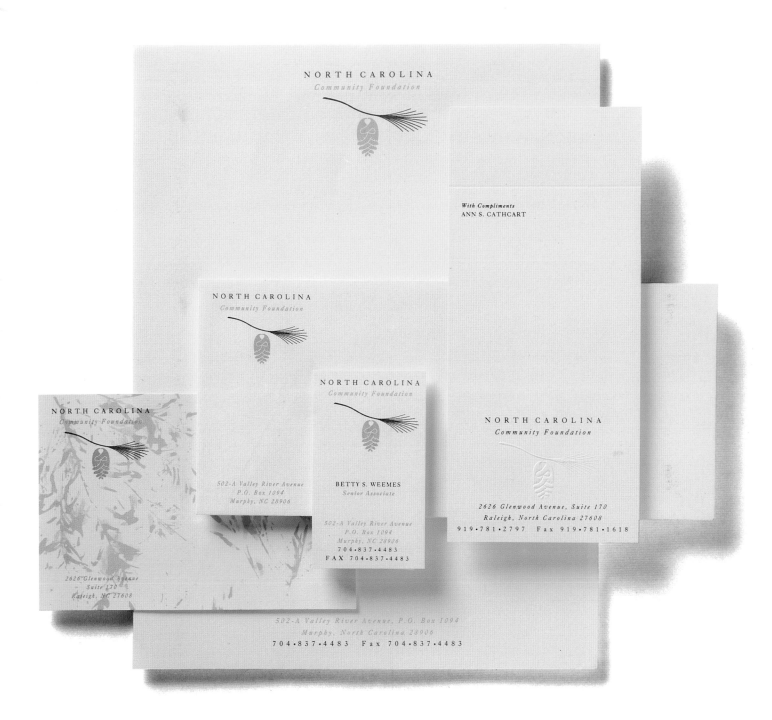

Client: Ruder • Finn
Design Firm: Sally Johns Design Studio
Art Director: Sally Johns
Designer: Jeff Dale
Illustrator: Jeff Dale
Paper/Printing: Two colors on Neenah Environment Recycled

CORPORATE COUNCIL FOR THE ARTS

Post Office Box 2925
1420 Fifth Avenue
Suite 475
Seattle, WA 98111-2925
206-682-9270
FAX 206-447-0954

CORPORATE COUNCIL FOR THE ARTS

Peter F. Donnelly
President

Post Office Box 2925
1420 Fifth Avenue Suite 475
Seattle, WA 98111-2925
206-682-9270
FAX 206-447-0954

CORPORATE COUNCIL FOR THE ARTS

PRESS RELEASE

CORPORATE COUNCIL FOR THE ARTS

Client:	Corporate Council For The Arts
Design Firm:	Rick Eiber Design (RED)
Art Director:	Rick Eiber
Designer:	Ken Shafer
Paper/Printing:	Two colors on Classic Crest

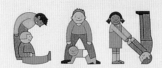

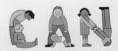

Children's AIDS Network
21 Washington Place, New York, NY 10003

Children's AIDS Network
21 Washington Place, New York, NY 10003, (212) 415-6515

Bryan Miskie, Founder, Chairman

Board of Directors: Elaine Herman Bob Roberts Mike Denhoff Jonathan Annis, M.D. Deanna Annis Maurice Cohen Ronald H. Miskie Armand DiCarlo

Advisory Board: James M. Oleske, M.D., M.P.H. Margaret C. Heagarty, M.D. Louis Dell'Olio Irwin Kellner, Ph.D. Stephen Nicholas, M.D. John J. Hutchings, M.D.

Client:	Childrens Aids Network
Design Firm:	The Pushpin Group
Art Director:	Seymour Chwast
Designer:	Seymour Chwast
Illustrator:	Seymour Chwast

ELC
Executive
Leadership
Center

CHELSEA DAY SCHOOL

PULSE OF LOUISIANA

The FRIENDS *of the* BEVERLY HILLS PUBLIC LIBRARY

deci.mal

Client: California School Leadership
 Academy
Design Firm: Marketing By Design
Art Director: Joel Stinghen
Designer: Joel Stinghen
Illustrator: Joel Stinghen

Client: Chelsea Day School
Design Firm: Anthony McCall Associates
Art Director: Wing Chan
Designer: Wing Chan
Illustrator: Wing Chan

Client: Pulse Of Louisiana
Design Firm: Whitmer Design
Art Director: Robert H. Whitmer
Designer: Robert H. Whitmer

Client: Friends of the Beverly Hills Public
 Library
Design Firm: Westwood & Associates
Art Director: David Westwood
Designer: David Westwood

Client: Morris Scholarship Fund
Design Firm: J. Brelsford Design, Inc.
Art Director: Jerry Brelsford
Designer: Jerry Brelsford

Client: Society of Librarians
Design Firm: Kuo Design Group
Art Director: Samuel Kuo
Designer: Samuel Kuo

OREGON COAST
AQUARIUM

SOW
FOR
A DOUBLE HARVEST

UNCCHARLOTTE

ADOPT-A-HIGHWAY

Client: Oregon Coast Aquarium
Design Firm: Robert Bailey, Inc.
Art Director: Robert Bailey
Designers: Carolyn Coghlan, John Williams

Client: Wheat Ridge Foundation
Design Firm: Identity Center
Art Director: Wayne Kosterman
Designer: Wayne Kosterman
Illusrator: Wayne Kosterman

Client: Bay Area Discovery Museum
Design Firm: The Pushpin Group
Art Director: Seymour Chwast
Designer: Seymour Chwast

Client: University Of North Carolina at
Charlotte
Design Firm: Design/Joe Sonderman, Inc.
Art Director: Tim Gilland
Designer: Andy Crews

Client: Georgia Power Company
Design Firm: Rousso+Associates, Inc.
Art Director: Steve Rousso
Designer: Steve Rousso

Client: Caltrans
Design Firm: Page Design, Inc.
Art Director: Paul Page
Designer: Tracy Titus

DOME TO DELTA

CUSHING
ACADEMY

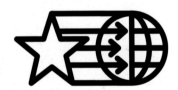

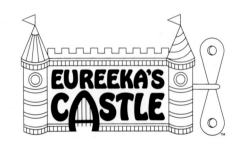

EUREEKA'S
CASTLE

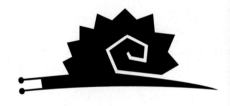

Client: SPACES (Saving and Preserving
American Cultural Environments)
Design Firm: Porter/Matjasich & Associates
Art Director: Allen Porter
Designer: Allen Porter

Client: Dome To Delta Run
Design Firm: Page Design, Inc.
Art Director: Paul Page
Designer: Brad Maur
Illustrator: Brad Maur

Client: Cushing Academy
Design Firm: Portfolio
Art Director: Bonnie Mineo
Designer: Busha Husak
Illustrator: Busha Husak

Client: Forbes Magazine
Design Firm: De Martino Design Inc.
Art Director: Erick De Martino
Designer: Erick De Martino
Illustrator: Erick De Martino

Client: Nickelodeon
Design Firm: The Pushpin Group
Art Director: Seymour Chwast
Designer: Seymour Chwast
Illustrator: Seymour Chwast

Client: Friends of the Islamorada Area
State Parks
Design Firm: M Plus M Incorporated
Art Directors: Michael McGinn, Takaaki
Matsumoto
Designer: Michael McGinn

13. MISCELLANEOUS

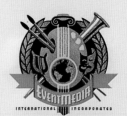

32 EAST 57TH STREET
NEW YORK, NY 10022

TELEPHONE: 212 308-6200
FACSIMILE: 212 308-6218

INTERNATIONAL INCORPORATED

INTERNATIONAL INCORPORATED

32 EAST 57TH STREET
NEW YORK, NY. 10022

TELEPHONE: 212 308-6200
FACSIMILE: 212 308-6218

MARTIN L. CHAISSON
CHAIRMAN OF THE BOARD AND
CO-CHIEF EXECUTIVE OFFICER

INTERNATIONAL INCORPORATED

32 EAST 57TH STREET
NEW YORK, NY 10022

INTERNATIONAL INCORPORATED

32 EAST 57TH STREET
NEW YORK, NY 10022

MARTIN L. CHAISSON

Client:	EventMedia International, Inc.
Design Firm:	Michael Doret, Inc.
Art Director:	Michael Doret
Designer:	Michael Doret
Lettering:	Michael Doret
Paper/Printing:	Five colors on Crane's Crest

THOMAS J. SHOOK
Director of Promotional Events

2445 Belmont Avenue
P. O. Box 2186 • Youngstown, OH
44504-0186 • (216) 747-2661

2445 Belmont Avenue
P. O. Box 2186
Youngstown, OH 44504-0186

2445 Belmont Avenue
P. O. Box 2186 • Youngstown, OH
44504-0186 • (216) 747-2661

Client: The Cafaro Company
Design Firm: May Design Associates
Art Director: Frederick Mozzy
Designer: Frederick Mozzy
Illustrator: Frederick Mozzy
Paper/Printing: Two colors on Strathmore Writing

SAN FRANCISCO
OPERA GUILD

WAR MEMORIAL OPERA HOUSE
SAN FRANCISCO, CA 94102
(415) 565-6432

SAN FRANCISCO
OPERA GUILD

FIFTIETH ANNIVERSARY CELEBRATION

Client: San Francisco Opera Guild
Design Firm: Cognata Associates
Art Director: Richard Cognata
Designer: Richard Cognata
Paper/Printing: Two colors

Performing New Music
And Music of The Baroque

Christopher Erede
Music Director

P.O. Box 2256
400 West 43rd Street
Suite 37-N
New York, NY 10036
212 967 7210

Concerto New York Limited

400 West 43rd Street
Suite 37-N
New York, NY 10036

Concerto New York Limited

Client: Concerto NY Ltd.
Design Firm: Lieber Brewster Corporate Design
Art Director: Anna Lieber
Designer: Anna Lieber
Illustrator: Anna Lieber
Paper/Printing: Two colors on Strathmore Writing

Stratton

Mountain Inn

Stratton

Stratton Mountain Inn
Stratton Mountain, VT 05155
802/297-2500

Client:	Stratton Resort
Design Firm:	Design/Joe Sonderman, Inc.
Art Director:	Tim Gilland
Designer:	Mary Head
Paper/Printing:	Three colors on Classic Crest

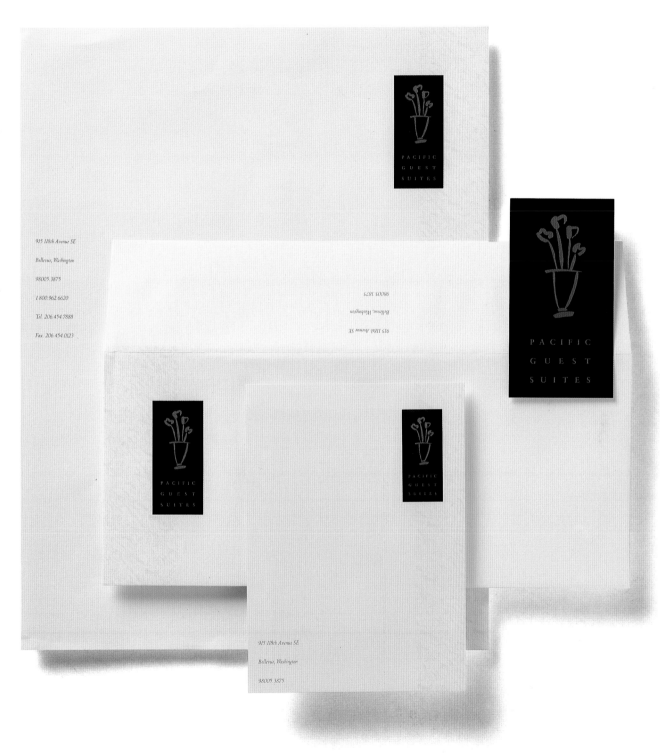

Client: Pacific Guest Suites
Design Firm: Hornall Anderson Design Works
Art Director: Julia LaPine
Designer: Julia LaPine
Illustrator: Julia LaPine
Paper/Printing: Two colors on Crane's Crest

American Pavilion

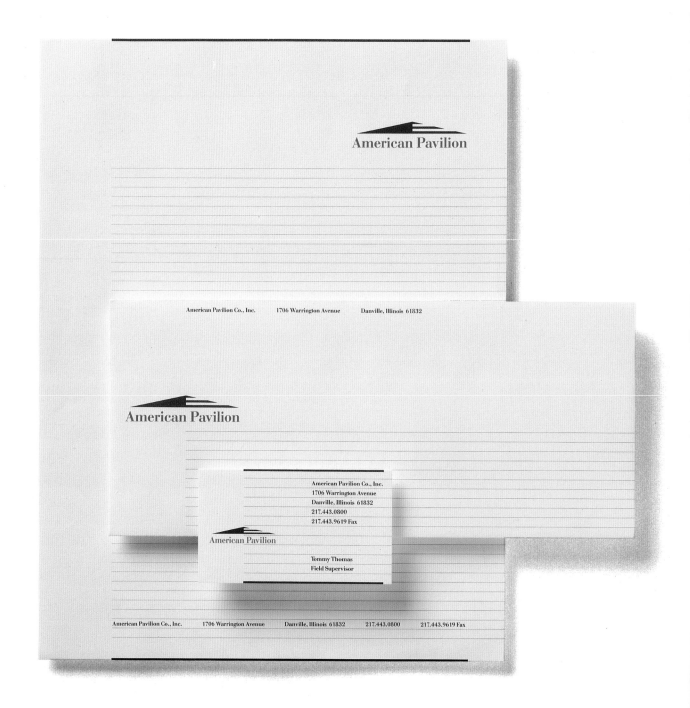

Client: Danville Tent & Awning
Design Firm: Sequel, Inc.
Art Director: Denise Olding
Designer: Denise Olding
Illustrator: Denise Olding
Paper/Printing: Two colors on Kimberly Writing Titanium White Wove

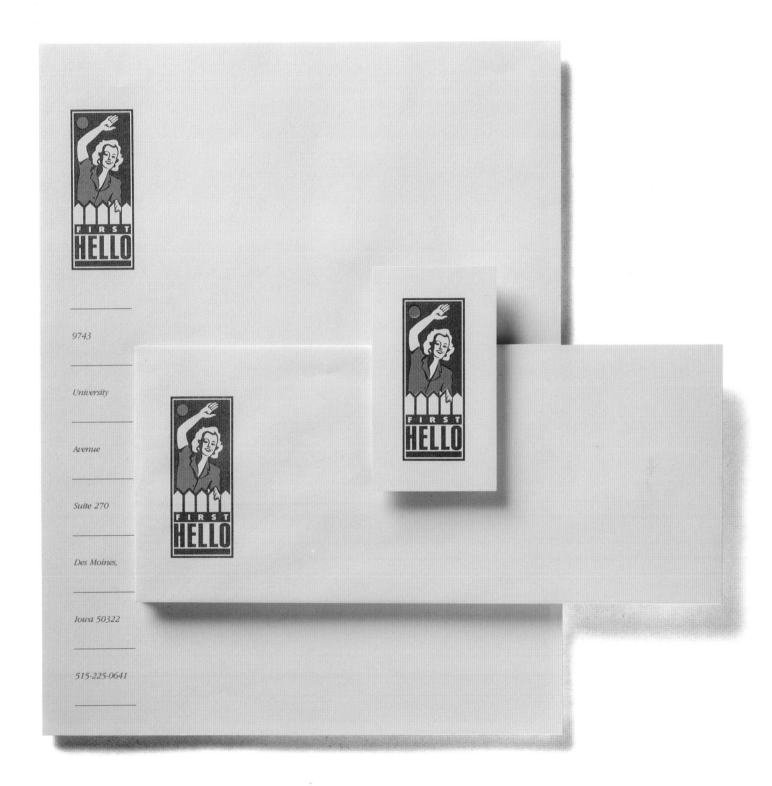

9743

University

Avenue

Suite 270

Des Moines,

Iowa 50322

515-225-0641

Client: First Hello
Design Firm: Sayles Graphic Design
Art Director: John Sayles
Designer: John Sayles
Paper/Printing: Two colors on Neenah Classic Crest

Client: Sarah Hall Clark
Design Firm: Clark Keller Inc.
Art Director: Jane Keller
Designer: Jane Keller
Illustrator: Frank Rawlings
Paper/Printing: Two colors on Speckletone

Client: Robert Heinrich
Design Firm: Steve Lundgren Graphic Design
Art Director: Steve Lundgren
Designer: Steve Lundgren
Paper/Printing: Two colors on Neenah Classic Crest

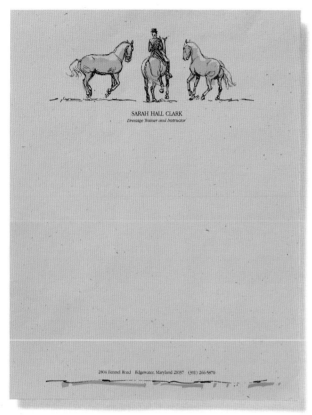

Client: Stacey Enterprises
Design Firm: Perich + Partners
Art Director: Ernie Perich
Designer: Janine Thielk, Carol Austin
Illustrator: Lyn Boyer-Penington
Calligraphy: Susan Skarsgard
Paper/Printing: Three colors on French Speckletone

Client: Crenshaw & Associates
Design Firm: Ashby Design
Art Director: Neal M. Ashby
Designer: Neal M. Ashby
Paper/Printing: Two colors on Simpson EverGreen Ash

ROWLAND AND ELEANOR BINGHAM MILLER

ROWLAND AND ELEANOR BINGHAM MILLER

3 Mockingbird Place
Louisville, Kentucky 40207
(502) 893-2262 (502) 587-6970

Client: Roland & Eleanor Bingham Miller
Design Firm: McCord Graphic Design
Art Director: Walter McCord and Eleanor Miller
Designer: Walter McCord
Illustrations: (ca. 1870) Courtesy Filson Club Archives
Paper/Printing: Four color process on Strathmore Alexandra Brilliant

P.O. Box 388
Clements
California 95227

209 759 3315

P.O. Box 388
Clements
California 95227

P.O. Box 388
Clements
California 95227

209 759 3315

Chris R. Dryden
Stallion Manager

Client: Blooming Hills Farm
Design Firm: Emery/Poe Design
Art Director: David Poe
Designer: David Poe
Illustrator: David Poe
Paper/Printing: Four colors on Strathmore Writing

AMADOR
LAND &
CATTLE
480 SAINT JOHN
SUITE 110
PLEASANTON,
CA 94566
415 462 4100
FAX 415 462 4397

Client: Amador Land & Cattle
Design Firm: Communication Arts Inc.
Art Director: Henry Beer
Designer: David A. Shelton
Paper/Printing: Two colors on Speckletone Ivory White Text

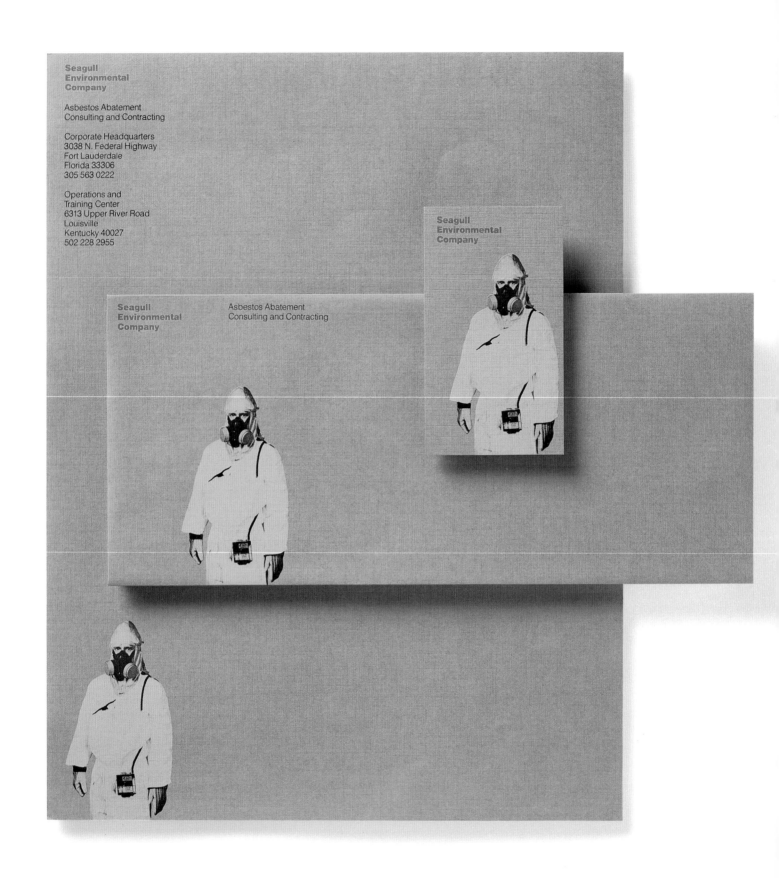

Seagull
Environmental
Company

Asbestos Abatement
Consulting and Contracting

Corporate Headquarters
3038 N. Federal Highway
Fort Lauderdale
Florida 33306
305 563 0222

Operations and
Training Center
6313 Upper River Road
Louisville
Kentucky 40027
502 228 2955

Seagull
Environmental
Company

Asbestos Abatement
Consulting and Contracting

Seagull
Environmental
Company

Client: Seagull Environmental Co.
Design Firm: McCord Graphic Design
Art Director: Walter McCord
Designer: Walter McCord
Paper/Printing: Three colors on Strathmore Rhododendron Smoke Grey

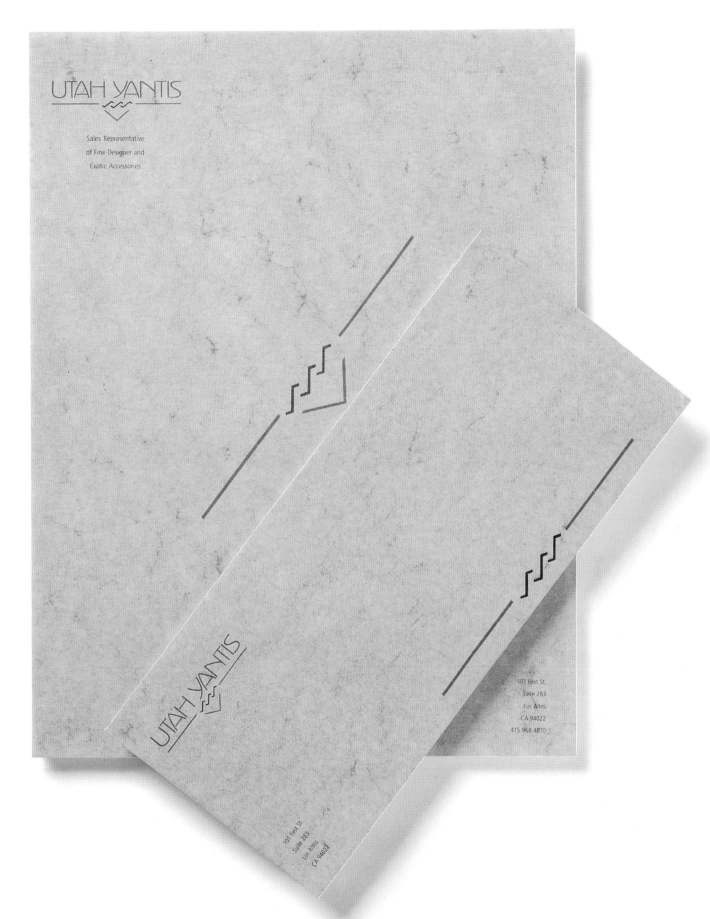

Client: Utah Yantis
Design Firm: Tollner Design Group
Art Director: Lisa Tollner
Designer: Kim Tucker
Illustrator: Kim Tucker
Paper/Printing: Two colors on Zanders Elephant Hide

CLEMENTE
McKAY
Funeral Homes

CLEMENTE
McKAY
Funeral Homes

CYNTHIA M. CLEMENTE
FUNERAL DIRECTOR

700 Fifth St.
Struthers, OH 44471
(216) 755-1401

10170 Main St.
New Middletown, OH 44442
(216) 542-2060

CLEMENTE
McKAY
Funeral Homes

Main Office
700 Fifth St. Struthers, OH 44471

700 Fifth St. Struthers, OH 44471
(216) 755-1401

10170 Main St. New Middletown, OH 44442
(216) 542-2060

Client: Clemente-McKay Funeral Homes
Design Firm: May Design Associates
Art Director: Frederick Mozzy
Designer: Frederick Mozzy
Illustrator: Frederick Mozzy
Paper/Printing: One color Strathmore Writing

D·L·P

CLASSICO

DIVISION

D·L·P

CLASSICO

DIVISION

D·L·P

CLASSICO

DIVISION

DLP INTERNATIONAL INC
333 NORTH AVENUE WAKEFIELD MA 01880 USA
617·246·5420 TWX 5106011217

Client: DLP International Inc.
Design Firm: Marc English: Design
Art Director: Marc English
Designer: Marc English
Paper/Printing: One color and embossing on Simpson Gainsborough

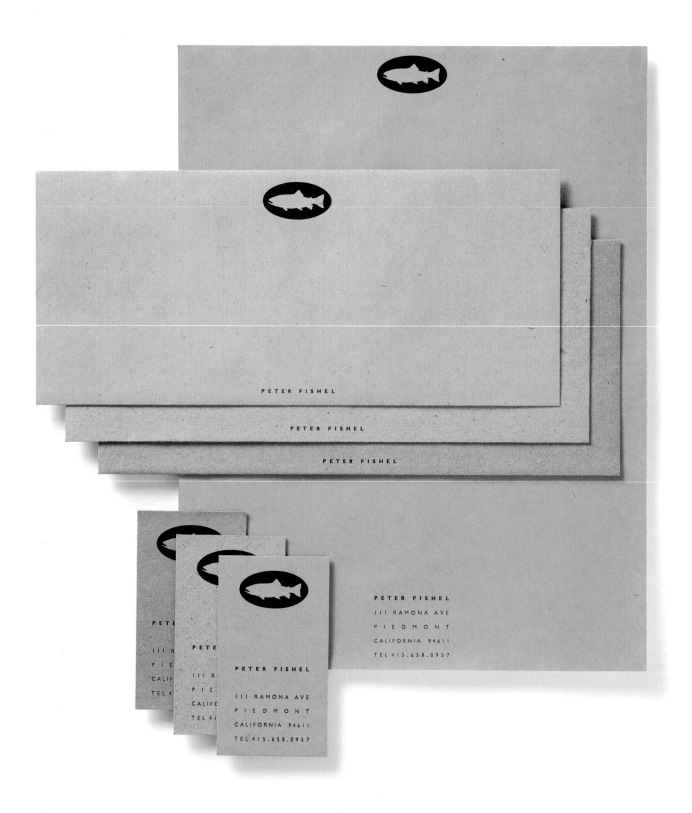

Client: Peter Fishel
Design Firm: Fishel Design
Art Director: Peter Fishel
Designer: Peter Fishel
Paper/Printing: Black (Xerox) on used grocery bags, butcher paper, etc.

Client: Comdates
Design Firm: Kuo Design Group
Art Director: Samuel Kuo
Designer: Samuel Kuo

Client: Charlotte Heat
Design Firm: Design/Joe Sonderman, Inc.
Art Director: Joe Sonderman
Designer: Andy Crews

Client: Heitkamp Farms
Design Firm: Design Center
Art Director: Todd Spichke
Designer: Todd Spichke

Client: Video Jukebox Network
Design Firm: Ron Kellum Design
Designer: Ron Kellum
Illustrator: Ron Kellum

Client: Fox Broadcasting
Design Firm: Jerry Cowart Designers
Art Director: Jerry Cowart
Designer: David Westwood

Client: Rancho Encantado
Design Firm: Design Forum
Designer: Renae Roberts
Illustrator: Renae Roberts

14. INDEX

DESIGN FIRMS

DESIGN FIRM DIRECTORY

Adam, Fillippo & Associates
1206 Fifth Avenue
Pittsburgh, PA 15219

Alexander Isley Design
361 Broadway
Suite #111
New York, NY 10013-3903

Anthony McCall Associates
11 Jay Street
New York, NY 10013

Ashby Design
144 Duke of Gloucester Street
#4A
Annapolis, MD 21403

Barry David Berger + Associates
9 East 19th Street
New York, NY 10003

Bob Korn Design
370 1/2 Pacific Street
Brooklyn, NY 11217

Burns Connacher & Waldron
59 West 19th Street
Suite 4A
New York, NY 10011

CMC Design Associates
900 North Franklin
Suite 505
Chicago, IL 60610

Cipriani Kremer Design
2 Copley Place
Boston, MA 02116

Clarion Marketing and Communication
340 Pemberwick Road
Greenwich, CT 06927

Clark Keller Inc.
1160 Spa Road
Annapolis, MD 21403

Clifford Selbert Design
2067 Massachusetts Avenue
3rd Floor
Cambridge, MA 02140

Cognata Associates
1001 Bridge Way
#220
Sausalito CA 94965

Communication Arts Inc.
1112 Pearl Street
Boulder, CO 80302

Condon Norman Design
954 West Washington Blvd.
Chicago, IL 60607

Cordella Design
855 Boylston Street
Boston, MA 02116

Creative Works
631 U.S. Highway One
Suite 300
North Palm Beach, FL 33408

Culver & Associates
533 North 86th Street
Omaha, NE 68114

Davies Associates
5817 Uplander Way
Culver City, CA 90230

De Martino Design Inc.
584 Broadway
New York, NY 10012

Design Center
15119 Minnetonka Boulevard
Minnetonka, MN 55345-1508

Design Forum
3484 Far Hills Avenue
Dayton, OH 45429

Design/Joe Sonderman, Inc.
PO Box 35146
Charlotte, NC 28235-5146

Designed to Print + Associates, Ltd.
130 West 25th Street
New York, NY 10001

Designframe Inc.
One Union Square West
New York, NY 10003

Dinosaur Group Inc.
107 East 36th Street
New York, NY 10016

Donovan and Green
One Madison Avenue
New York, NY 10010

Douglas + Voss Group
201 East 16th Street
5th Floor
New York, NY 10003

Ellis • Pratt Design
452 Park Drive
Suite 20
Boston, MA 02215

Emery/Poe Design
330 Ritch Street
San Francisco, CA 94107

F. Eugene Smith Design Management
641 W. Market Street
Akron, OH 44303

Fishel Design
111 Ramona Avenue
Piedmont, CA 94611

Fitch Richardson Smith
139 Lewis Wharf
Boston, MA 02110

Flagg Brothers Inc.
Darien Executive House
397 Post Road
Darien, CT 06820

Frank D'Astolfo Design
80 Warren Street
#32
New York, NY 10007

Friday Saturday Sunday, Inc.
210 East 15th Street
New York, NY 10003

G.T. Rapp & Company
2815 Second Avenue
Suite 393
Seattle, WA 98121

George Tscherny, Inc.
238 East 72nd Street
New York, NY 10021

Greene Art Associates
216 West 18th Street
12th Floor
New York, NY 10011

Gunnar Swanson Design Office
739 Indiana Avenue
Venice, CA 90291-2728

Hafeman Design Group
935 West Chestnut
Suite 203
Chicago, IL 60622

Hornall Anderson Design Works
1008 Western Avenue
Floor 6
Seattle, WA 98104

Identity Center
1340 Remington Road
Suite Q
Schaumburg, IL 60173

Integrate, Inc.
503 South High Street
Columbus, OH 43215

Intelplex Design
12215 Dorsett Road
Maryland Heights, MO 63043

J. Brelsford Design, Inc.
1125 High Street
Des Moines, IA 50309

J.T. Taverna Associates Inc
344 M40 South
Allegan, MI 49010

Jack Tom Design
80 Varick Street
Suite 3B
New York, NY 10013

Janell Genovese Design
328 Washington Street
Somerville, MA 02143

Jerry Cowart Designers
22273 Del Valle Street
Woodland Hills, CA 91364

Jones Design & Advertising
31726 Rancho Viejo Road
Suite 207
San Juan Capistrano, CA 92675

Joseph Dieter Visual Communications
3021 Linwood Avenue
Baltimore, MD 21234

Josh Freeman/Associates
4222 Glencoe Avenue
Marina Del Ray, CA 90292-5612

Karen Schrader Design
10 Elm Road
Kings Park, NY 11754

Katz Wheeler Design
1219 Spruce Street
Philadelphia, PA 19107

Kevin P. Sheehan Design
8 Westland Avenue
Boston, MA 02115

Kollberg/Johnson Associates Inc.
7 West 18th Street
New York, NY 10011

Kuo Design Group
95 Fifth Avenue
New York, NY 10003

Lancaster Design & Art Inc.
10 Greenfield Road
Lancaster, PA 17602

Laurel Bigley Design
165 Diamond Street
Auburn, CA 95603

Lawrence Bender & Associates
512 Hamilton Avenue
Palo Alto, CA 94301

LeeAnn Brook Design
PO Box 1788
Nevada City, CA 95959

Letvin Design
119 Bellingham Avenue
Revere, MA 02151

Lewin/Holland Inc.
230 West 17th Street
New York, NY 10011

Lieber Brewster Corporate Design
324 West 87th Street
New York, NY 10024

Louise Fili Ltd.
22 West 19th Street
9th Floor
New York, NY 10011

M & Co.
50 West 17th Street
New York, NY 10011

M Plus M Incorporated
17 Cornelia Street
New York NY10014

McCord Graphic Design
2014 Cherokee Parkway
Louisville, KY 40204

Mace Messer Design Associates
311 Great Road
Littleton, MA 01460

Manhattan Design
47 West 13th Street
New York, NY 10011

Mark English: Design
57 Exeter Street
Arlington, MA 02174-3427

Margo Chase Design
2255 Bancroft Avenue
Los Angeles, CA 90039

Mark Palmer Design
41-994 Boardwalk
Suite A-1
Palm Desert, CA 92260

Marketing by Design
2212 K Street
Sacramento, CA 95816

May Design Associates
47 Federal Plaza
Youngstown, OH 44503

Michael Aron & Company
20 West 20th Street
New York, NY 10011

Michael Doret, Inc.
12 East 14th Street
New York, NY 10003

Michael Standard Inc.
1000 Main Street
Evanston, IL 60202

Milton Glaser Inc.
207 East 32nd Street
New York, NY 10016

Mortensen Design
627 Emerson Street
#200A
Palo Alto, CA 94301

Musser Design
558 Race Street
Harrisburg, PA 17104

Notovitz Design Inc.
47 East 19th Street
New York, NY 10003

Page, Arbitrio & Resen Ltd.
305 East 46th Street
New York, NY 10017

Page Design Inc.
1900 29th Street
Sacramento, CA 95816

Peggy Lauritsen Design
26 Hennepin Avenue
#209
Minneapolis, MN 55401

Perich + Partners Ltd.
552 South Main Street
Ann Arbor, MI 48104

Pollman Marketing Arts Inc.
2060 Broadway
#210
Boulder, CO 80302

Porter/Matjasich & Associates
154 West Hubbard
Suite 504
Chicago, IL 60610

Portfolio
38 Newbury Street
Boston, MA 02116

Puccinelli Design
114 East De la Guerra Street
Studio #5
Santa Barbara, CA 93101

Pushpin Group
215 Park Avenue South
New York, NY 10003

Qually & Company Inc.
30 East Huron
#2502
Chicago, IL 60611

Reiner Design
26 East 22nd Street
8th Floor
New York, NY 10010

Richard Danne & Asscoiates
126 Fifth Avenue
New York, NY 10011

Rick Eiber Design (RED)
4649 Sunnyside North
#242
Seattle, WA 98103

Robert Bailey Inc.
0121 SW Bancroft
Portland, OR 97201

Robert Cook Design
4803 Montrose Boulevard
Suite 11
Houston, TX 77006

Ron Kellum Design
1133 Broadway
Room 1214
New York, NY 10010

Rousso+Asociates, Inc.
5881 Glenridge Drive NE
K #200
Atlanta, GA 30328-5569

Rowe & Ballantine
8 Galloping Hill Road
Brookfield, CT 06804

Sally Johns Design Studio
1040 Washington Street
P.O. Box 10833
Raleigh, NC 27605

Sayles Graphic Design
308 Eighth Street
Des Moines, IA 50309

Sequel, Inc.
310 West Liberty
Louisville, KY 40202

Stark Design Associates
22 West 19th Street
9th Floor
New York, NY 10011

Steve Lundgren Graphic Design
6524 Walker Street
Suite 205
Minneapolis MN 55426

Stillman Design Associates
1556 Third Avenue
New York, NY 10128

Tharp Did It
50 University Avenue
Suite 21
Los Gatos, CA 95030

Thomas Nielson Design
678 Center Street
Newton, MA 02158

Tollner Design Group
111 North Market Street
Suite 1020
San Jose, CA 95113

Tracy Mac Design
2039 Griffith Park Boulevard
Los Angeles, CA 90039

Traver & Associates
424 Riverside Drive
Suite 203
Battle Creek, MI 49015

Turpin Design Associates
1762 Century Boulevard
Atlanta, GA 30345

Unlimited Swan, Inc.
272 Riverside Avenue
Riverside, CT 06878

Urban Taylor & Associates
12250 SW 131 Avenue
Miami, FL 33186

Vanderbyl Design
539 Bryant
San Francisco, CA 94107

WCVB TV Design
5 TV Place
Needham, MA 02192

Westwood & Associates
1230 Stanford Street
Santa Monica, CA 90404-1602

Whitmer Design
527 40th Street
Des Moines, IA 50312

Whitney • Edwards Design
3 North Harrison
PO Box 2425
Easton, MD 21601

William Homan Design
1316 West 73rd Street
Richfield, MN 55423-3007

Wilsonworks
1811 18th Street, NW
Washington, DC 20009